Paul Griffiths
born in 1947 and educated at
Lincoln College, Oxford, is Music Critic of the *New Yorker*.
He is acknowledged as one of the leading authorities on
twentieth-century music and has published books on Cage,
Boulez, Messiaen, Ligeti
and Stravinsky.

WORLD OF ART

This famous series
provides the widest available
range of illustrated books on art in all its aspects.
If you would like to receive a complete list
of titles in print please write to:
THAMES AND HUDSON
30 Bloomsbury Street, London WC1B 3QP
In the United States please write to:
THAMES AND HUDSON INC.
500 Fifth Avenue, New York, New York 10110

Printed in Malta

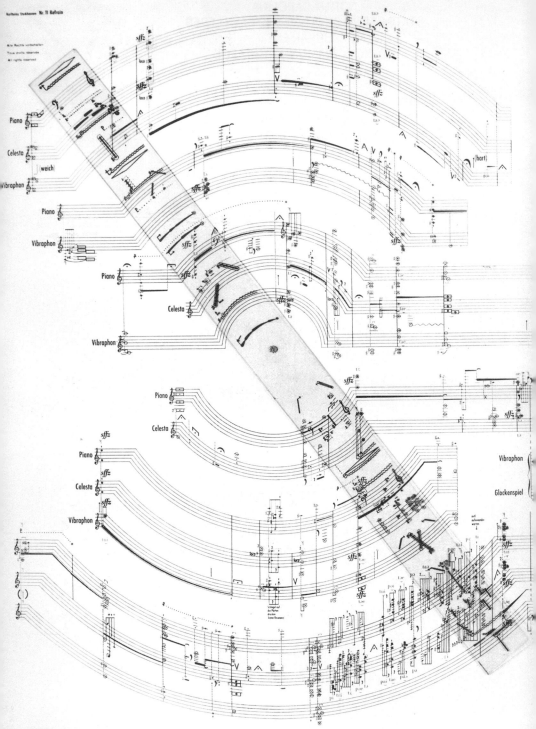

Paul Griffiths

modern music

A concise history

Revised edition

134 illustrations

Thames and Hudson

For my father
and in memory of my mother

Title Page: The complete score of Karlheinz Stockhausen's *Refrain* for piano, celesta and percussion (1959). The "refrain" is printed on a transparent strip which can be rotated to different positions for different performances.

© 1978 and 1994 Paul Griffiths

Originally published as
A Concise History of Avant-Garde Music

Published in the United States of America in 1985 by Thames and Hudson Inc., 500 Fifth Avenue, New York, New York 10110

Revised edition 1994

Library of Congress Catalog Card Number 94–60288
ISBN 0–500–20278–8

Printed and bound in Malta

Contents

Prelude

If modern music may be said to have had a definite beginning, then it
started with this flute melody, the opening of the *Prélude à 'L'après-
midi d'un faune'* by Claude Debussy (1862–1918).

Perhaps it is necessary to justify the description 'modern' for music
created more than ninety years ago and in a different century, espe-
cially if one considers that other new music of the period when the
Prélude was composed, between 1892 and 1894, included Dvořák's
'New World' Symphony and Tchaikovsky's 'Pathétique'. But of
course, in the context of the arts, 'modern' implies more about
aesthetics and technique than about chronology. It is reasonable,
therefore, that a 'concise history of modern music', itself a seeming
contradiction, should cast back almost a century, and equally reason-
able that it should ignore music more modern in date but less so in
method and feeling.

One of the principal characteristics of modern music, in the not
strictly chronological sense, is its lack of dependence on the system of
major and minor keys which had provided motivation and coherence
for most western art music since the seventeenth century. In this
respect Debussy's *Prélude* undoubtedly heralds the modern era. Gently
it shakes loose from roots in diatonic (major–minor) tonality, which is
not to say that it is atonal, or keyless, but merely that the old harmonic
relationships are no longer of binding significance. At times Debussy
leaves the key in doubt, as he does in the first two bars of the flute
melody quoted above, where he fills in the space between C sharp
and G: all the notes are included, and not just the selection which
would point to a particular major or minor key. Moreover, the out-

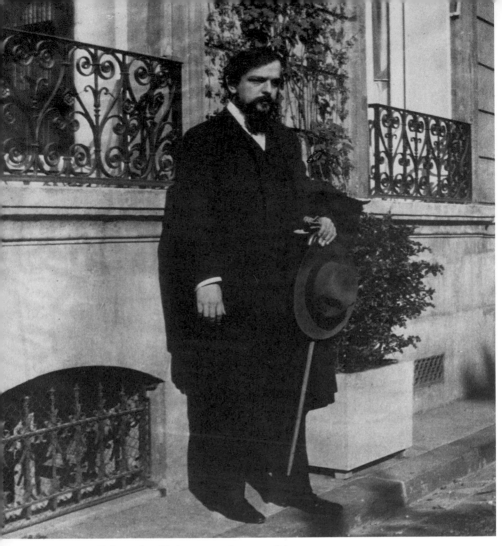

Debussy in a Paris street at the turn of the century.

line interval, a tritone, is that most inimical to the diatonic system, the 'diabolus in musica' as it was called by medieval theorists. Debussy does not go on in that way, for his third bar indicates an arrival in the key of B major. But diatonic harmony is now only one possibility among many, not necessarily the most important and not necessarily determinant of form and function.

With regard to form, the *Prélude* again sows the seeds of innovation. Instead of choosing a distinctive theme and developing it in consecutive fashion, Debussy takes an idea which is hesitant, turning back on itself twice before opening out, unassertive and so unsuitable for 'logical' elaboration in the orthodox manner. This flute theme is the subject almost throughout the *Prélude*, though it may be expanded by embellishment or split into independent fragments; there are repeated excursions from the theme and returns to it. Debussy does not, however, engage his principal idea in a long-term progressive development. The effect is rather that of an improvisation.

The spontaneity of the *Prélude* is not just a matter of harmonic ambiguity and formal freedom; it depends also on the fluctuating tempos and irregular rhythms, and on the subtle colouring of the piece. Traditional thematic working had demanded a certain regularity and homogeneity of rhythm in order that attention might be focused on matters of harmony and melodic shape, and the tempos had to be chosen to ensure the goal-directed force of the music. Debussy's music, wayward in harmony and form, is correspondingly less constrained in its measurement of time.

As for colour, Debussy was a master of delicate orchestral shadings, and a pioneer in consistently making instrumentation an essential feature of composition. More than any earlier music (except perhaps that of Berlioz), Debussy's works suffer loss when arranged for other media: one has only to hear a piano version of the *Prélude*, for instance, to be convinced of that. The flute theme of the piece is very definitely a theme for the flute, and it becomes something significantly different when heard on another instrument. Acknowledging this, Debussy in the *Prélude* restricts his theme to the flute, except for brief appearances once each on clarinet and oboe, appearances which have structural importance: the clarinet sets the theme on its most far-reaching development, and the oboe attempts to prolong movement when the stillness of the opening has returned. Thus the orchestration has its part in establishing both ideas and structure; it is more than an ornament or a means for enhancing rhetoric.

Debussy could take a fresh approach to orchestration because his kind of musical formation was quite new. He had little time for the thorough, continuous, symphonic manner of the Austro-German tradition, the 'logical' development of ideas which gives music the effect of a narrative. For him, music was not the relayer of stories of personal emotion such as contemporary critics supposed for works of Beethoven, or such as contemporary composers, like Richard Strauss,

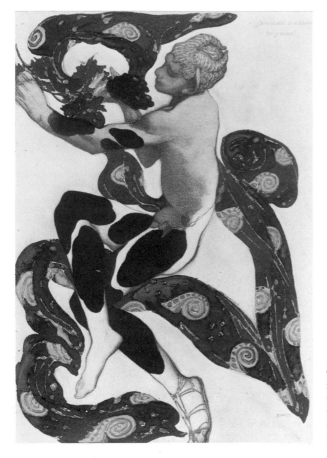

Costume design by Léon Bakst for the Faun in Nijinsky's ballet to Debussy's *Prélude*. The ballet was first given by the Diaghilev company in Paris in 1912, with Nijinsky as the Faun.

made explicit in their symphonic poems. Debussy's music had abandoned the narrative mode, and with it the coherent linkage projected by the conscious mind; its evocative images and its elliptical movements suggest more the sphere of free imagination, of dream. As Debussy himself wrote, 'music alone has the power to evoke as it will the improbable places, the unquestionable and chimerical world which works secretly on the mysterious poetry of the night, on those thousand anonymous sounds made when leaves are caressed by the rays of the moon.' The prose is typically enigmatic and replete with images, but the reference to dreaming is clear enough.

An analogy with dreams, or more generally with spontaneous associations of ideas in the mind, is more revealing than the long-established comparison of Debussy's music with Impressionist paint-

ing. It is true that he sometimes chose subjects which appealed also to the Impressionists: 'Reflets dans l'eau', for instance, one of his *Images* for piano, has a title which might be affixed to many canvases by Monet. Yet music differs essentially from painting in that it is an art which takes place in time. Debussy's formal and rhythmic techniques may have weakened the sense of ongoing time, but movement was of the utmost importance to him. Again, he was not concerned just with painting sound pictures: 'I would like for music', he once wrote, 'a freedom which it can achieve perhaps more than any other art can, not being limited to a more or less exact reproduction of nature, but to the mysterious correspondences between Nature and Imagination.'

In the case of the *Prélude*, there is a strong suggestion of place, of woodland in the lazy afternoon heat, but Debussy's main concern is with the 'correspondences' (Baudelairean word) between this environment and the thoughts of the faun in the eclogue by Stéphane Mallarmé on which the music is based, to which it forms a 'prelude'. The work is, in Debussy's own words, a sequence of 'successive décors which bring forward the desires and dreams of the faun'.

Other works of Debussy, like the symphonic sketches *La mer* (1903–5), are probably based directly on nature, without the filtering of a poet's imagination; yet in these too nature is only a starting point, left behind in the eventual creation of 'mysterious correspondences' having more to do with the composer's interior world. Debussy suggested as much when writing about 'the secret of musical composition': 'The sound of the sea, the curve of a horizon, wind in leaves, the cry of a bird leave manifold impressions in us. And suddenly, without our wishing it at all, one of these memories spills from us and finds expression in musical language.' The stimulus is not the original natural phenomenon, the 'impression', but the secondary mental phenomenon, the 'memory'. 'I want', Debussy wrote in the same essay, 'to sing my interior landscape with the simple artlessness of a child.'

In Debussy's view the established techniques stood in the way of such expression; they imposed cliché and artifice, and they had been developed for different purposes, chiefly to express and to stimulate emotional reactions. The freer flow which he achieved, in feeling as much as in technique (the two being inseparable), had more chance of mirroring the mind's elusive and allusive internal workings. It also brought a seductive ambience to his music, and to some extent this clouded appreciation of its technical and aesthetic newness. The *Prélude* met with immediate popularity, not the violent rejection

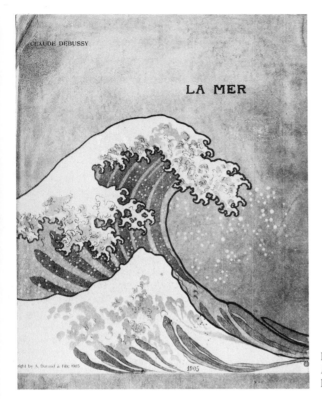

Front cover of the first edition of
La mer, for which Debussy chose
Hokusai's print *The Wave.*

which greeted the first radical works of Schoenberg, Stravinsky and others; scandal came only two decades after the first performance, when Nijinsky's dancing exposed the erotic languor in the piece. Debussy had opened the paths of modern music – the abandonment of traditional tonality, the development of new rhythmic complexity, the recognition of colour as an essential, the creation of a quite new form for each work, the exploration of deeper mental processes – but he had done so by stealth.

The late Romantic background

The nature and the consequences of Debussy's revolution were not to be recognized fully until after the second world war, and his immediate influence was limited, if widespread: his evocative titles, his harmonic practices and his orchestral innovations were abundantly imitated, but his freedom of movement, his lightness of touch and his impalpable coherence could not be matched. And his near contemporaries, particularly in Austria and Germany, were concerned to bolster and continue the nineteenth-century Romantic tradition rather than to explore fundamentally new directions. But there was a problem. Wagner and Liszt had greatly increased the scope of permissible harmony and the rate of harmonic change, and it was difficult to find ways of accommodating the new chromaticism within forms which depended for their life on coherent harmonic schemes. Debussy had answered the difficulty by abandoning both harmonic and structural orthodoxy; but if the old models of continuous development were to be retained, then new binding elements were needed, if only to satisfy the composer's sense of form bequeathed by tradition.

Many composers found the template they required in a literary programme, as Liszt had in his virtual invention of the principal genre of literary instrumental music, the symphonic poem. Richard Strauss (1864–1949) composed a series of symphonic poems in the nineties, including *Also sprach Zarathustra* and *Ein Heldenleben*, which brought the genre to an extravagant culmination. Strauss was unrivalled in his ability to create musical 'translations' of narrative images, so that, with some knowledge of the subject, his symphonic poems can be 'decoded' as stories while they are being heard. There could be no more striking instances of how far music had become a medium for emotional or action narrative in the nineteenth century, nor could there be any continuation along this road: Strauss himself turned his skills to opera.

However, programmes of a psychological kind can fairly be assumed to lie behind the symphonies of Gustav Mahler (1860–1911),

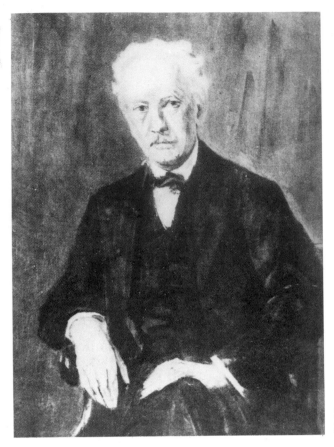

Richard Strauss; oil portrait by Max Liebermann.

even where they are not made explicit by texts or titles: Mahler's correspondence indicates as much. If Strauss's symphonic poems are emotional histories related from outside, Mahler's symphonies are confessions of feeling vouchsafed from within. His themes are made to carry an unprecedented expressive load, and his forms are motivated more by the exigencies of expression than by harmonic function. At root the music is still diatonic, and the symphony is still for Mahler, as it was for Haydn, Mozart and Beethoven, a drama of relation and contrast. Now, however, the figures in the drama are not so much keys and themes as feelings and psychological characters.

Mahler was thus able to incorporate the lyrical mode – music as an almost purely expressive art, ignorant of large-scale form – within the dramatic structure of the symphony. Some of his symphonic

movements are songs with orchestra; others use material which had appeared originally in independent songs. The Second and Third Symphonies (1887–96) introduce solo and choral voices in their final movements to make clear the expressive intention after several movements for orchestra alone. And in the Eighth Symphony (1906–7), sometimes known as 'the symphony of a thousand', Mahler calls on an enormous array of soloists, choral voices and orchestral instruments all through.

The use of very large forces, common to most composers of the period except Debussy, can be seen as another means of assuring directional force at a time when this could no longer be entrusted to harmonic methods. A massive close, such as appears for example in Schoenberg's *Gurrelieder* (1900–11), would give a more decisive finality to a work than any return to a 'home' key, long forgotten if it had ever been clearly stated. Mahler and Strauss commonly called for an orchestra of treble the size of Beethoven's, so that it was possible for gigantic crescendos, outbursts of rhetoric and grand perorations to substantiate musical form in dynamic terms.

For Mahler, in particular, the large orchestra also made available a variety of smaller formations which could be used to add new characters or to emphasize contrasts. Mahler asked too for instruments not usually found in the orchestra and having references outside the world of traditional art music: cowbells for a sense of alpine pastures, or guitar and mandolin for a taste of popular dance. Even where these latter instruments are not included, Mahler's music now and then 'descends' towards café music. It was part of his ideal that the symphony should be a complete picture of the artist's emotional universe, his sentimentality and his ironic humour being included as much as more noble feelings. When Debussy made his ventures into the music hall, as he did in the piano piece 'Golliwog's Cake-Walk', it was within the context of a comic work. Mahler, on the other hand, strove to encompass a wide range of experience within a single composition; indeed, his symphonic structures depended on that, and it was demanded by his determination to expose his emotional self with the utmost truth.

There is, however, another aspect to Mahler's work: the religious and metaphysical. He was obsessed by the idea of death, particularly his own in his last years, and in many of his works human mortality is the occasion of profound sorrow, oppressed anguish or bitter sarcasm. But it may also be accepted with acquiescence, as it is in the finale of his orchestral song-cycle *Das Lied von der Erde* ('The song of the earth',

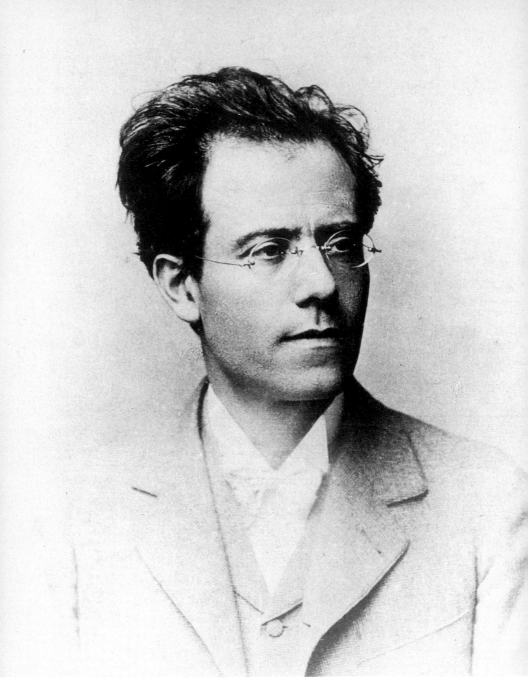

Gustav Mahler in 1896, the year in which he completed his Third Symphony.

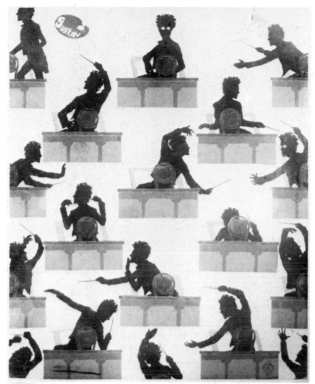

Mahler conducting; from a sheet of silhouettes by Otto Boehler.

1907–9), or with joy at the promise of new life, as in the Second and Eighth Symphonies.

Death and resurrection were the subject of a good deal of late Romantic music, including a symphonic poem by Strauss. Schoenberg's *Gurrelieder* relate a tale of ghostly resurrection as a punishment for the hero's sin of cursing God, but more commonly the rebirth is one into hope, death to the world being followed by an awakening to what is beyond the physical. This concern with the beyond may be related to contemporary occult movements, such as theosophy, and also to developments in the understanding of the mind. Just as Freud was suggesting how our actions and judgments are guided by a mental life of which we are largely unaware, so composers (and, of course, artists in other fields) looked beyond the reality of consciousness in the hope of glimpsing essentially higher truths. Debussy seems to have entered the subconscious world with intuitive

PELLÉAS ET MÉLISANDE

CLAUDE DEBUSSY
MAURICE MAETERLINCK

Frontispiece by Rochegrosse for the first edition of Debussy's opera. This rather inappropriately romanticized scene shows Pelléas and Mélisande discovered by Mélisande's husband Golaud.

ease: in his opera *Pelléas et Mélisande* (1892–1902), based on the play by Maurice Maeterlinck, the most important things remain for long unspoken and the music reveals elusive currents which shape human destiny from below the level of the conscious mind.

Arnold Schoenberg (1874–1951) was also at this time influenced by Maeterlinck's mystical beliefs, as too by the metaphysical Strindberg and the German symbolists. He composed a symphonic poem *Pelleas und Melisande* (1902–3) and another, unusually scored for string sextet, on the subject of Richard Dehmel's poem *Verklärte Nacht* ('Transfigured night', 1899), where love is seen as having the power to transfigure nature, the metaphysical world holding a greater significance than the physical. Such notions had one of their sources in Wagner, like the chromatic music used to embody them. But

Schoenberg, who held to the Austro-German tradition with uncompromising tenacity, could only unwillingly allow metaphysics and chromaticism to lead him away from structural coherence. It was his unique achievement at this time, in the two symphonic poems and the First Chamber Symphony (1906), to drive the new chords to function formally in a development as firmly directed as any in Brahms. Only in his songs and in the *Gurrelieder* did he rest on lyricism, though even here the music is full of those contrapuntal manœuvres by which he maintained forward movement in a world of harmonic diversity.

The renewal of counterpoint as a motive force can be seen also in the music of Max Reger (1873–1916), though in his case there is some stylistic dissonance between the busy Bachian polyphony and the weight of harmony it is expected to bear. He shunned programmes or poetic sources for his instrumental works, and, though he wrote a great many songs, he was primarily a composer for the orchestra, for chamber groupings and for the organ. Often he contained his densely worked music within variation forms, but he also revived the fugue

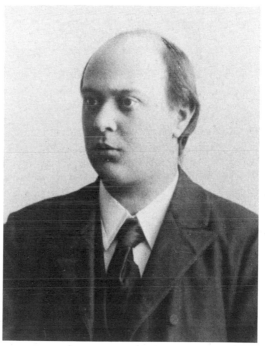

Arnold Schoenberg in 1910, shortly before he completed the *Gurrelieder*.

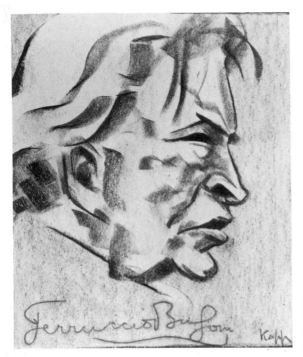

Ferruccio Busoni; drawing by Edmond X. Kapp. The portrait was made during a Beethoven performance in London in 1920.

and other Baroque models, all in an effort to stem the tide of formal anarchy impelled by chromaticism. The results, however, are more illustrations of the problem than, like Schoenberg's works, solutions.

Another musician who reached back to the Baroque for the means to order chromaticism was the Italo-German composer and pianist Ferruccio Busoni (1866–1924), whose wide horizons also stretched to Debussyan harmony, North American Indian music, Romantic rhetoric and the spirited zest of the Italian Renaissance. He was in some ways the reverse of Mahler, the man who opened himself to all experience but saw it from without; his masterpiece, the opera *Doktor Faust* (1916–24) is more parable and mystery play than autobiography, though undoubtedly Busoni sympathized with Faust's quest for universal knowledge. He was an immensely various composer, but he was never as daring in his music as he was in his *Sketch for a New Esthetic of Music* (1907, enlarged 1910), in which he speaks of the possibilities of radically new scales and even of electronic music, then hardly more than a vague dream.

Strauss, Mahler, Schoenberg, Reger and Busoni all lived and worked in the German-speaking heartland of musical tradition, and it

was natural that their responses to the crisis of tonal composition should have been as much restorative as exploratory. Schoenberg may have been the most aware of a need to establish a functional basis for expanded tonal harmony so that thorough musical development might continue. Busoni may have been the most open-minded, certainly in his manifesto. Mahler was perhaps the most audacious in looking within himself for the answers, opening music to full and intense expression of the personality. But all five, different though their aims and methods were, had to face the same problem of creating music in the absence of the old harmonic certainties.

The problem appears to have been felt less keenly by composers beyond Austria and Germany. It is significant, for instance, that since Mahler the great symphonists have come from outside the area which

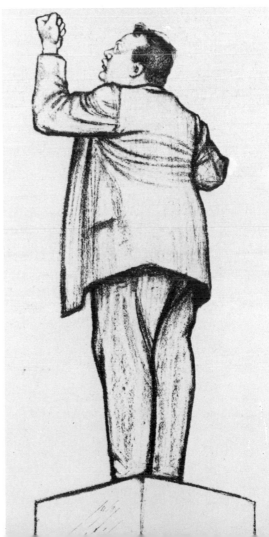

Max Reger conducting.

had been the home of the symphony since Haydn. And the works composed in the first decade of the twentieth century by Edward Elgar (1857–1934) or Carl Nielsen (1865–1931) show much less harmonic strain than do the works of their Austro-German contemporaries. There were also composers, like Jean Sibelius (1865–1957) and Ralph Vaughan Williams (1872–1958), who were able to develop new symphonic styles within the diatonic system.

Sibelius's long silence – he composed almost nothing in his last thirty years – may suggest the difficulty of maintaining tonal composition in the twentieth century, and yet such composers as William Walton (1902–83) and Samuel Barber (1910–81) found it possible to perpetuate late Romanticism into the century's last quarter. Indeed, it is one of the unusual features of music since 1900 that many composers have chosen to take a 'conservative' stance, working with materials and methods which might have seemed exhausted and outmoded by the current of advance in technique and sensibility. Of course, there have always been rifts and rivalries in the arts between 'conservatives' and 'radicals'. The difference in twentieth-century music is that so many options have remained open that there is no single stream of development, no common language such as usually existed in earlier times, but an ever-spreading delta of aims and means. And the beginning of the divergence may be traced to the years 1890–1910, the high point of late Romanticism; for it was the emphasis placed by the Romantics on individual temperament which prepared the breakdown of the agreed tonal boundaries.

Jean Sibelius; oil portrait by Akseli Gallen-Kallela, his friend and fellow Finn.

New harmony

Debussy's description of Wagner's music as 'a beautiful sunset which was mistaken for a dawn' contains the key to late Romanticism. Composers from all over Europe, including Debussy himself, had made the pilgrimage to Bayreuth and come away seduced by the powerful appeal of Wagner's chromatic harmony into supposing that it could stand as the cornerstone of a new musical art. But often it had led them instead into imitation and mannerism, since harmony was by now not the basis of a common language but a matter of personal style. Liszt had said that any new composition must contain at least one new chord, and this emphasis on harmonic innovation brought with it the weakening of the diatonic system, not least in Liszt's own late works. The most successful of the composers who, unlike Debussy, followed in a more or less direct line after Wagner – Mahler, Strauss and the young Schoenberg – found it necessary to go ever further from the simple triads on which diatonic harmony is based. And clearly that process could not continue without the foundations being undermined and the sunset succeeded by the new dawn of atonality.

The moment came in the summer of 1908, when Schoenberg was at work on various settings of poems by Stefan George: two for the final movements of his Second String Quartet (1907–8) and others for an eventual cycle of fifteen songs from the poet's *Das Buch der hängenden Gärten* ('The book of the Hanging Gardens', 1908–9). Writing in 1912, Schoenberg recalled that he had composed his George songs 'intoxicated by the first words in the text, . . . without in the least caring for the further development of the poem, without even noticing it in the ecstasy of composing'. Even so, it seems likely that George's images, images of still waiting, apartness from the everyday world and suspension in erotic feeling, had a part in leading him into a musical universe no longer bound by the gravitational attractions of and between keys. This becomes explicit in the quartet, where, after two movements in the old expanded diatonic style, the four instruments begin an atonal slow movement and in the finale a

soprano voice enters on George's words 'I feel the air of another planet'.

Schoenberg's writings suggest strongly that the breaking of the tonal barrier was undertaken not so much in the excitement of discovery as with difficulty and a sense of loss at what was being abandoned. For Schoenberg was no avant-garde experimenter: his venture into atonality he saw as an inevitable consequence of what had gone before, and he felt himself forced to go onward, even if it should be against his conscious will. He would have liked to spend more time investigating the rich diatonic style of the recent First Chamber Symphony, but not until the 1930s did he find himself able to do so. Moreover, to lose diatonic harmony was to lose the principal framework supporting the music he most venerated, that of the Austro-German tradition from Bach to Brahms. Without an intense compulsion he would perhaps have found it impossible to enter the realms of atonality; and indeed, after the first flush of atonal works he did fall almost silent for seven years. For the moment, however, the historical force was unavoidable, and deeply disturbing: 'Personally I had the feeling', Schoenberg remembered, 'as if I had fallen into an ocean of boiling water . . . it burned not only my skin, it burned also internally.'

The same force was felt by other composers at the same time, though without their being led thereby to join Schoenberg. Richard Strauss, in his operas *Salome* (1903–5) and *Elektra* (1906–8), pressed towards the brink of atonality, but his reaction was a retreat into the comfortable pastiche of *Der Rosenkavalier* (1909–10). Sibelius's Fourth Symphony (1910–11) is almost a study on the tonally disruptive interval of the tritone, but he too made no further advance into new territory. Mahler, in the Adagio which was the only completed movement of his Tenth Symphony (1909–10), came suddenly to the atonal chasm with a ten-note chord which makes an awesome point of punctuation, and it is impossible to imagine where he might have gone had he lived beyond the next year. Alexander Skryabin (1872–1915) also died when his music was on the point of abandoning tonality, and before he could bring the physical world to an end in an ecstasy of religious fulfilment at a ceremony of music, poetry, light, perfume and dance which he planned for a temple in the Himalayas.

Given what appears to have been a generally felt pressure, one might ask why it should have been Schoenberg who took the first step into atonality. His own answer was typical, that it had to be somebody:

the historical imperative was inescapable. But one may add other causes more directly concerned with Schoenberg himself. As his pre-atonal works show, he was acutely aware that the harmonic innovations of his time threatened the diatonic foundations of music, for his response had been to strengthen the formal, essentially the harmonic framework, forcing the new chords to function structurally. At a deep level, however, he appears to have acknowledged that this could be no more than a temporary solution, and that the imposition of diatonic propriety was becoming ever less justified by the chordal material being used: he once said that he had for some years been considering the step he took in *Das Buch der hängenden Gärten.*

It may also be that Schoenberg's final loosening of tonal ties bore some relation to events in his personal life. In the summer of 1908, at the very time of his first atonal compositions, his wife left him for a while to live with their friend, the painter Richard Gerstl. The experience of disillusionment, dejection and regret is certainly reflected in the Second String Quartet, and it may have hastened Schoenberg's move into a style bereft of foundations. But, even in expressive terms, it cannot have been the sole cause. The breach of atonality came as a necessary step in Schoenberg's increasingly penetrating revelation of interior emotions, for the exposure of the deepest springs of personality required musical means of an utterly personal kind, not those learned from tradition. Atonality was the only possible medium for musical Expressionism.

Schoenberg's first Expressionist works, the George settings of the Second Quartet and *Das Buch der hängenden Gärten,* contrast sharply with most of his earlier scores, and not just in terms of harmony. The texture is light, the movement fleeting; and the tone is more lyrical than dramatic, for drama had depended on the harmonic tensions now dissolved. But things soon changed. In two works of 1909, the Three Piano Pieces and the Five Orchestral Pieces, Schoenberg was able both to re-introduce dramatic forms and for the first time to compose atonally without the stimulus and support of a text. The third of the orchestral pieces was, however, based on a visual impression, that of early morning sunlight on the waters of a lake, which it interprets in subtle shifts of colour and harmony within an enigmatic stillness.

There is a quality here that recalls the wide-eyed gaze of the self-portraits which Schoenberg painted during the same period. He was never more than an amateur painter, but he did produce a large number of canvases during these Expressionist years, and his paintings earned the respect of Kandinsky and others in the Blaue Reiter group.

A Schoenberg self-portrait in oils, one of many he painted in the years around 1910, when he was beginning his exploration of atonality.

His sudden creative explosion in another medium may be understood in the light of a common feeling at the time that the artist was possessed of a vision which demanded expression in whatever form; what mattered was not the form but the vision, not technique but truth.

The most complex and universal visions might require several arts for their revelation, as Skryabin had intended in his projected ceremony of spiritual cataclysm. Such a combination of the arts, again a legacy from Wagner, was adumbrated by Skryabin in his *Prometheus* (1910), which is scored for piano, orchestra, organ, wordless chorus and 'clavier à lumières'. This last, an imaginary instrument, has a part in standard musical notation, but the idea was that its keys should bring

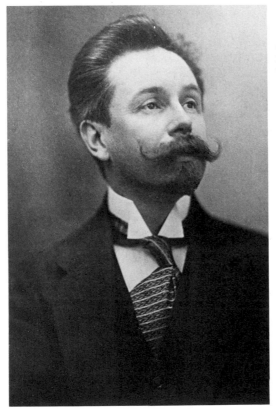

Alexandr Skryabin, whose mystical intentions led him to the brink of atonality.

Front cover by Jean > Delville for the first edition of Skryabin's *Prometheus*, a design which announces the apocalyptic nature of the contents.

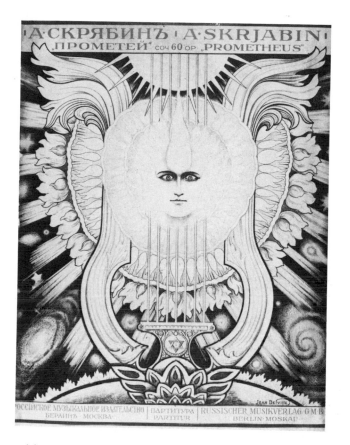

not sound but intense coloured light streaming into the concert hall, red for the note C, orange-pink for G, and so on.

From Skryabin the chain of influence passed through Kandinsky's amalgam of music, movement and light in *Der gelbe Klang* ('The yellow sound') to Schoenberg and his *Die glückliche Hand* ('The capable hand', 1910–13). This stage piece was conceived by Schoenberg in all its parts, with original words, music, scenic designs, costumes and detailed instructions for lighting to be closely allied with the music. The subject, treated in the symbolist manner of Kandinsky's work, is that of the creative artist who must renounce personal gratification in the world and instead devote himself to the expression of higher truths. It was a theme to which Schoenberg would return again and again.

Die glückliche Hand had been preceded by another short dramatic work of less personal significance yet of extraordinary psychological

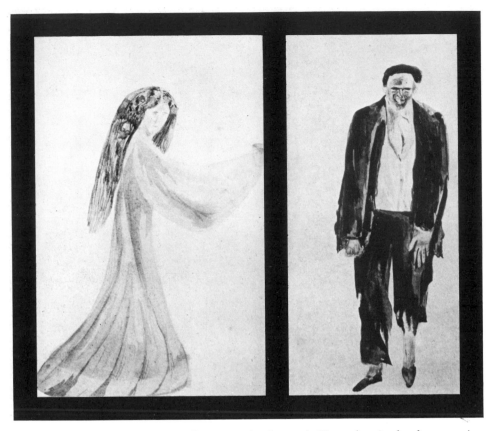

insight: *Erwartung* ('Expectation', 1909). Here the single character is a woman searching a forest for the lover who has left her, and the music, sensitive to every shift and surge of feeling, traces her fears, her jealous anger, her guilt and her tender memories. Schoenberg did the essential composition of this half-hour piece in seventeen days, and within another three weeks he had written out its complex and subtle orchestration. As often with him, the creative impulse must have been irresistible, forcing him to work 'like a mesmerized somnambulist who reveals secrets about things that he knows nothing about when he is awake', to quote what he described as Schopenhauer's 'wonderful insight' into the art of musical composition.

Not only *Erwartung* but all of Schoenberg's music of this early atonal period gives the impression of having arisen unwilled from a deep level of his mind, of being the product of an introspective psychoanalysis. So personal was this music, and so little filtered by the intellect, that

< Costume designs by
Schoenberg for the
Woman and the Man
in his dramatic work
Die glückliche Hand.

Design sketches by
Schoenberg for the
forest scene of his
monodrama *Erwartung.*

he did not feel able to teach atonal composition: probably he himself
had no conscious awareness of his methods. To the end of his life he
taught, and taught brilliantly, from the great Austro-German classics
of the eighteenth and nineteenth centuries; and in 1910–11, when he
had just finished such atonal masterpieces as *Erwartung* and the Five
Orchestral Pieces, he wrote a treatise on harmony where atonality
appears only as a postscript. He had no time for student composers
who came to him to learn the rudiments of revolution, and he did not
disparage others who felt unable to follow him into unknown ter-
ritory. Musical style was a matter for the individual, and the greatest
lesson of his teaching was that the artist had a moral responsibility to
be truthful to his own vision.

Even so, Schoenberg's first and most gifted pupils, Alban Berg
(1885–1935) and Anton Webern (1883–1945), did quickly follow him
into atonal composition. Both were close to him at the time of his first

atonal pieces, and it is possible that their support, which approached reverence, was invaluable when he came to take a course which he knew could meet only with hostility. Webern took up Schoenberg's lead exactly, approaching atonality through the poetry of George in fourteen songs of 1907–9, and Berg's first atonal work, a set of songs to poems by Hebbel and Mombert, followed in 1909–10. Yet these works are not just shadows of Schoenberg. Berg and Webern had felt the pressures towards atonality in their own earlier compositions, and the three proceeded in parallel, united but independent. The early atonal songs of both pupils are fully characteristic, Webern's concise and purely lyrical, Berg's looking with longing to the tonal past. Moreover, Berg and Webern owed as much to Mahler as they did to Schoenberg. Naturally this is most evident in their orchestral works: in terms of instrumentation and gesture, Webern's Six Orchestral Pieces (1909–10) and Berg's Three Orchestral Pieces (1914–15) are closer to Mahler's Sixth Symphony than to Schoenberg's set of 1909. Each work includes a Mahlerian march, and both have a public rhetoric which was very much a part of Mahler but quite foreign to Schoenberg in his profoundly self-searching form of Expressionism.

Outside the 'second Viennese school' of Schoenberg, Berg and Webern there were few composers who took to atonality, and those who did stood at some remove from the Vienna circle. Edgard Varèse was deeply impressed by Schoenberg's Five Orchestral Pieces, but his first important works, which date from after he left France for New York in 1916, depend as much on the experience of Debussy and Stravinsky. Other, native American composers, like Charles Ives, Carl Ruggles and Henry Cowell, appear to have reached atonality with little or no knowledge of what had been achieved in Europe and from a different point of view, ignoring tradition rather than developing from it. In Russia, in the years around the revolution of 1917, there were composers who came to atonality, not through Schoenberg, however, but under the influence of the late works of Skryabin. The Two Compositions for piano (1915) by Nikolay Roslavets (1880–1944), for example, are atonal and even presage Schoenberg's invention of serialism as a means for consciously controlling atonal form. But the rapidly growing political control of the arts in the Soviet Union after the death of Lenin soon put paid to progress along such lines, and the most adventurous Soviet composers were obliged to emigrate or, like Roslavets, to live in obscure neglect.

There were several reasons why the atonal music of Schoenberg, Berg and Webern had only limited immediate influence. Though

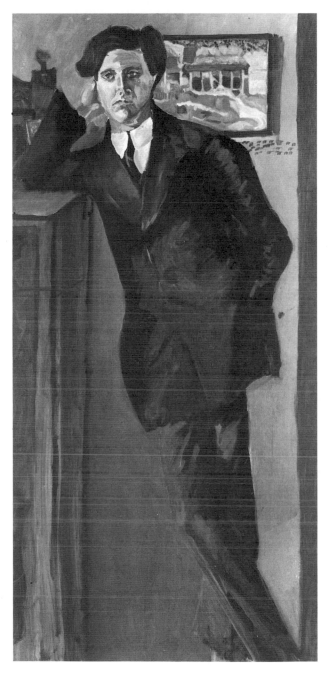

Alban Berg; oil portrait by his
teacher Schoenberg. Berg's
filial respect for Schoenberg
continued from the time of his
studies (1904–10) until his
death, and he dedicated four
important works to his master,
including the Three Orchestral
Pieces and the opera *Lulu*.

Schoenberg's scores were usually published within two or three years of their composition, most of Berg's and Webern's works remained in manuscript until the twenties. Then again, performances were few and, in Schoenberg's experience, usually bad. *Erwartung* was not put on until 1924, and Berg's Three Orchestral Pieces were not heard complete until 1930. Commercial recordings barely existed until the fifties. And when people did have the opportunity to hear music by Schoenberg and his pupils, the reaction was violently aggressive. In 1913 Schoenberg conducted a concert in Vienna including two atonal works, Webern's Six Orchestral Pieces and Berg's recent settings of poems by Peter Altenberg for soprano and orchestra. Such was the outcry that Berg's songs could not be completed and the police had to be called in.

Schoenberg came to understand this immoderate antipathy: 'It might have been the desire to get rid of this nightmare, of this unharmonious torture, of these unintelligible ideas, of this methodical madness – and I must admit: these were not bad men who felt this way.' As a staunch guardian of tradition himself, he recognized how disquieting his music must appear to those for whom the diatonic conventions were absolute. But, as Schoenberg's use of the word 'nightmare' suggests, the objection was as much to what he was expressing as to how he was expressing it. Nor could it be otherwise: atonality had arisen from the need to expose the most extreme and intense emotional states, and, so it seemed for a while, only the most disturbing feelings could be expressed through it. Schoenberg wanted to show that its range was wider, and in 1912 he set about writing a work of 'light, ironic, satirical tone'. That work was *Pierrot lunaire*.

Unlike Schoenberg's other atonal works, *Pierrot* soon received a fair number of performances, enjoyed a measure of popular success and gained the interest of composers outside his immediate circle: Debussy, Stravinsky and Ravel each drew something from it. *Pierrot* appealed partly because Schoenberg had chosen a subject which was in the air, that of the commedia dell'arte figure and his enigmatic existence as a creature whose thoughts and feelings are bigger than his stock character would have one believe. Part dumb puppet, part feeling being, Pierrot presented an image for contemporary doubts about man's power over himself, an image which appealed as much to Stravinsky (in *Petrushka*) and Picasso as to Schoenberg.

Pierrot lunaire is an ambiguous work in many senses. The soloist is required to use Sprechgesang, a mode of vocalization lying between

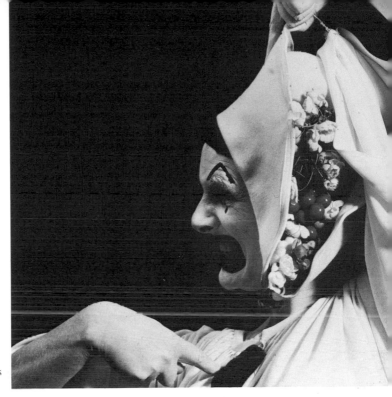

Schoenberg's Pierrot,
as interpreted by the
Welsh mezzo-soprano
Mary Thomas at the
time of the composer's
centenary in 1974.

song and speech. The poems, German translations of verses by Albert
Giraud, repeatedly switch between first-person narration and third.
The piece belongs between the stage and the concert hall: it was writ-
ten not for a singer but for an actress, who gave the first performance
in costume. The manner is part that of 'serious' music, part that of the
cabaret, the vocalist being accompanied by a small band of flute,
clarinet, two strings and piano (in 1901 Schoenberg had written some
songs for a rather literary night club in Berlin). Above all, the 'light,
ironic, satirical tone' is fused with feelings of terrified isolation,
murderous violence, macabre glee and hopeless nostalgia. In 1908–9
Schoenberg had exposed such emotions openly; now he did so
through the shield of irony, and inevitably this demanded a change in
style. Though still freely atonal, *Pierrot* returns towards the contra-
puntal proprieties and so prepares the way for that ordering of atonality
which Schoenberg was to achieve in serialism.

But that was not to come for another eight years, and, lacking the
method, Schoenberg fell almost silent. He at last completed *Die glück-*

liche Hand; he worked for three years on the set of Four Orchestral Songs; and he laboured at the oratorio *Die Jakobsleiter* ('Jacob's ladder', 1917–22) without coming anywhere near finishing it. *Die Jakobsleiter* was his first attempt to give explicit expression to the moral and religious questions which he was to pursue in the works of his last two decades, particularly in the opera *Moses und Aron*. Here, however, the verbal and visual imagery comes more from Swedenborg, through Strindberg and Balzac, than from Judaism. The oratorio concerns the soul's achievement of perfection through struggle and prayer, and it begins with a vehement injunction from the Archangel Gabriel which might almost stand as Schoenberg's motto: 'You must go on, without asking what lies before you.'

At its close *Die Jakobsleiter* was to have called for enormous forces: 'The choir and the soloists join in', Schoenberg noted, 'at first mainly from the platform, then more and more far off – offstage choirs located next to the offstage orchestras – so that, at the close, music is streaming into the great hall from all sides.' Like Skryabin in his final project, Schoenberg must have intended an overwhelming effect on his audience, and the oratorio, even in its unfinished form, serves as a powerful reminder that Expressionist art, Strindberg's as much as Schoenberg's, was concerned with spiritual revelation as much as with erratic psychology. Webern's later atonal songs, those of 1921–4, are all on religious texts, and in 1913 Berg had planned a symphony with a Swedenborgian finale. Deterred from that idea, he instead composed the Three Orchestral Pieces, and these led not to a religious work but to the most complete display of the power of atonality as a means for delving into character: the opera *Wozzeck* (1917–22).

Berg based his opera on the fragmentary play by Georg Büchner, which shows an inadequate central character, a simple soldier, who is the victim of all around him: his flirtatious mistress Marie, whose true affections are reserved for herself and her child; the cruelly mocking Captain; the crazed Doctor, who saps Wozzeck's strength by using him as a dietary guinea-pig; the brutish Drum Major, who boasts scornfully of his conquest of Marie. Each of these figures is drawn by Berg with extraordinary vividness, that vividness depending, as in *Erwartung*, on the extended range of melodic and harmonic possibility opened up by atonality. But Berg's opera differs from Schoenberg's monodrama in its direct references back to tonality, and these allow the events and attitudes, no matter how weird, to be suffused with the composer's sympathy. Berg makes no obvious judgment: he shows the world as it is, and he shows it continuing that way.

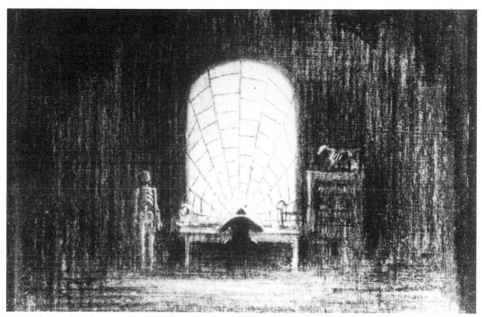

Stage design for the Doctor's laboratory for the first production of Berg's opera *Wozzeck*, given at Berlin in 1925.

Wozzeck achieves coherence not only through this sympathy and its concomitant essential harmonic stability but also through Berg's use of established forms as ground-plans for each scene or act, the forms of symphony, passacaglia, invention on a theme and so on. The old forms had here returned; the old counterpoint had been revived in *Pierrot lunaire*; the way was open for the formalization of atonality in serialism.

In such works as *Wozzeck* and *Pierrot lunaire* atonality had abundantly proved itself the most fruitful new direction to be pursued after the seeming exhaustion of the old diatonic system, but it was not the only one. The possibilities might be extended alternatively by combining more than one key at the same time (polytonality) or by using finer divisions of the octave than the conventional semitone. Polytonality was used by Igor Stravinsky (1882–1971) in his ballet *Petrushka*, where the torn hopelessness of the main character is represented by the simultaneous sounding of C major and its opposite pole, F sharp major, and it became the principal distinguishing mark of the copious output of Darius Milhaud (1892–1974).

Microintervals (intervals smaller than a semitone) have similarly become associated with the name of Alois Hába (1893–1972), who first used quarter-tones in his Suite for string orchestra (1917) and went on to write a variety of works, including complete operas, in quarter-tones and sixth-tones. Hába's work had parallels in the music of others, such as the Mexican composer Julián Carrillo (1875–1965), whose later works include eighth- and even sixteenth-tone compositions. Another independent pioneer was Ivan Vishnegradsky (b. 1893), whose first quarter-tone pieces date from 1918; and quarter-tones were among the eccentric phenomena explored by Ives.

A major problem with microinterval music was that of performance, since musical instruments are built to play in semitones. Ives and Vishnegradsky overcame the difficulty by using two pianos tuned a quarter-tone apart, while Carrillo and Hába had special instruments built. String players and singers might manage to perform in microtones, but still the effect was often of something makeshift, even of ordinary music just out of tune. The flowering of microtone music came only when all barriers had been broken by the arrival of electronic means.

If polytonality and microtones offered limited extensions to musical possibility, atonality opened vast new realms. Indeed, Schoenberg's revolution may be said to have affected all western art music since 1908, for even if a great deal of tonal music has been written since that date (not least by Schoenberg himself), the abjuring of such a fundamental change in music has to be seen as a creative decision of some significance.

New rhythm, new form

In May 1913, seven months after the first performance of *Pierrot lunaire*, the Russian Ballet of Sergey Diaghilev was responsible for the world premières in Paris of Debussy's *Jeux* and Stravinsky's *Rite of Spring*. With these works the foundations of modern music were complete, for the harmonic venturings of Schoenberg's atonal music were equalled in audacity and influence by the new founts of rhythm tapped in *The Rite* and by the formal freedom of *Jeux*. Of course, it is only a crude analysis that would seek to separate the elements of harmony, rhythm and form – of pitch, time and structure – in any piece of music: all are mutually dependent, and inevitably Schoenberg, Stravinsky and Debussy each made innovations on every front. Nonetheless, it is Schoenberg's harmony, Stravinsky's rhythm and Debussy's form which have excited most interest and proved most important to later composers.

The rhythmic newness of *The Rite of Spring* was recognized immediately; it could hardly be mistaken. On the opening night, as Stravinsky recalled, 'the first bars of the prelude . . . at once evoked derisive laughter. I was disgusted. These demonstrations, at first isolated, soon became general, provoking counter-demonstrations and very quickly developing into a terrific uproar.' Probably the audience was reacting as much to Nijinsky's choreography, 'a very laboured and barren effort' in Stravinsky's view, as to the score; but the music itself was soon the object of furious debate. Some condemned it as a barbaric annihilation of all that musical tradition stood for, and, this being Paris, others praised it on the same grounds. The truth was that Stravinsky had found for music a new dynamic force. Like Schoenberg, he had recognized that increasing chromaticism was loosening the power of diatonic harmony to sustain musical movement, but his answer to the problem was very different. *The Rite* demonstrated with almost savage force that rhythm could be a new motivating impetus.

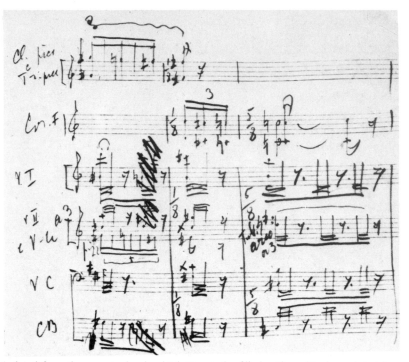

A detail from the exercise book which Stravinsky filled with multicoloured sketches for *The Rite of Spring*.

In the great mass of music from the Renaissance onwards, rhythm had been subservient to melody and harmony, or dictated by a text. This is not to deny its importance, its inescapable importance in such a work as Beethoven's Fifth Symphony, but merely to assert its lesser status: Beethoven's rhythm supports and intensifies a fundamentally harmonic development. In *The Rite of Spring*, by contrast, particularly in the final 'Sacrificial Dance', it is rhythm that drives the music, with harmony a matter of secondary importance. Most of the 'Sacrificial Dance' is constructed from 'cells' of from one to six or so notes, not from phrases in the conventional manner. Often the cells are heavily accented, and the music proceeds by their repetition, interposing and variation, processes which, given that the cells are unequal in length, require frequent changes of time signature. The measurement of time has ceased to be in terms of bars: now it is marked by the individual durations of quaver and crotchet.

The Rite of Spring abounds in new approaches to rhythm. Its very

Part of the 'Sacrificial Dance' from the 1947 revised edition of *The Rite of Spring*. The last three bars of this excerpt correspond with the draft shown opposite.

opening is a bassoon solo which destroys the regulation of the barline in another way, by ignoring it and continuing without perceptible metre; and other passages are syncopated against the metre indicated by the barring. What immediately attracted the notice of Stravinsky's contemporaries, however, was not the subtlety of his rhythm but its primitive force, the pounding energy of the score. After all, *The Rite* had been designed as music to accompany 'scenes of earthly joy and celestial triumph as understood by the Slavs', to quote Nicolas Roerich, the author of the scenario. Stravinsky did not set out to produce a compendium of new rhythmic ideas; they came unbidden, and he found that he was inventing music which he did not at first know how to notate. He was, as he later wrote, 'the vessel through which *The Rite* passed'.

Stravinsky's earlier career had generated little to prepare for the onslaught of *The Rite*, however inevitable that work may seem in retrospect. As a pupil of Rimsky-Korsakov he had gained a mastery of

colourful orchestration, which he had put to use in his first ballet score for Diaghilev, *The Firebird* (1909–10). That had been a brilliant and exotic fairy tale in the manner of Rimsky, though it also shows an awareness of what Skryabin and Debussy were achieving. Much more individual in style is Stravinsky's second Diaghilev ballet, *Petrushka*, where rhythm is becoming the most important structural and expressive element, closely linked as it is with movements on stage: the bustle of a fair, or the awkward gestures of the humanized puppet hero. But *Petrushka* owes its rhythmic life more to ostinatos and irregularities of metre than to the cell technique developed in *The Rite*.

The original idea for the new ballet had been Stravinsky's own and had come to him in a dream: 'I saw in imagination', he wrote, 'a solemn pagan rite: wise elders, seated in a circle, watching a young girl dance herself to death. They were sacrificing her to propitiate the god of spring.' In contemplating that subject he had been able, as he put it, 'to tap some unconscious "folk" memory'. He came up with simple diatonic ideas of folk character and, more importantly, he invented those rhythms of a potency to match both the abandonment and the deliberateness of ritual dance.

For a while Stravinsky pursued the two interests which *The Rite* had opened up: the music and imagery of folk culture, and the new possibilities of rhythm. As far as the latter is concerned, the ballet score found a significant successor in the Symphonies of Wind Instruments (1920), which clearly show the structural implications of the new rhythm. Stravinsky realized that his cell technique could not lead naturally to the freely flowing developmental forms of tradition, and in the Symphonies he abruptly abandoned any attempt to make the music follow a single line of argument. Instead the work is in a severe 'block form', switching repeatedly between quite different kinds of music, coming finally to rest only when the most rhythmically stable of the basic types, a chorale, takes over. The piece is, of course, nothing like a conventional symphony, the plural title indicating the plurality of the music and otherwise no more than a 'sounding together'.

Stravinsky had composed his Symphonies in memory of Debussy, who had died in 1918 after composing a sequence of works that brought his own innovations to a high point of liberty. That was not immediately appreciated, however, for Stravinsky was now the darling of Paris: *Jeux* had passed almost unnoticed when the storm broke on *The Rite*. Debussy seems to have been somewhat piqued by Stravinsky's success, and in 1915 he gave it as his opinion that 'the

Stage design for *The Rite of Spring* by Nicolas Roerich, who was also responsible for devising the work's scenario.

young Russian inclines dangerously towards Schoenberg'. Perhaps he was thinking of Stravinsky's recent Three Lyrics from Japanese Poetry, where the instrumentation and the odd tinge of harmony reflect an admiration for *Pierrot lunaire*. Apart from that the work is not at all Schoenbergian; but for Debussy, at the height of the first world war, any respect for modern Austro-German music was reprehensible. 'Musicien français' he proudly signed himself at the head of each new manuscript, and he set his mind to the renewal of a French tradition of abstract music, something which had not existed since the mid-eighteenth century.

In order to achieve this Debussy eliminated the visual and literary references which his music had previously contained so abundantly. After the Three Mallarmé Poems (1913) he composed no more vocal music of any importance, and he progressed only slowly and fitfully on his various dramatic projects. His creative energies were directed instead into works of pure music: the suite *En blanc et noir* for two pianos, the Twelve Studies for piano and a set of six sonatas, of which he lived to complete only three.

SIX SONATES

POUR DIVERS INSTRUMENTS

Composées par

CLAUDE DEBUSSY

Musicien Français

La Deuxième pour Flûte, Alto et Harpe

A PARIS

Chez { *les Éditeurs* DURAND ET C.ie
Maison sise au N.º4 Place de la Madeleine
proche des grands boulevards.

Title page of the first edition of the Sonata for flute, viola and harp by 'Claude Debussy, musicien français'. The design emphasizes Debussy's intention to restore the French classicism of Rameau.

Debussy and Stravinsky at the time of > their Diaghilev ballets *Jeux* and *The Rite of Spring*. Stravinsky dedicated to the older composer his mystical chorus *The Star-Faced One* (1911–12) and wrote his Symphonies of Wind Instruments (1920) in Debussy's memory.

These works, together with *Jeux*, show how far Debussy had developed what had been foreshadowed in the *Prélude à 'L'après-midi d'un faune'*. *Jeux* upsets the traditional norm of continuous evolution quite as much as do Stravinsky's Symphonies of Wind Instruments, but in another way. In place of a bald juxtaposition of diverse ideas it presents music in continuous change, moving in unpredictable directions as various kinds of material are taken up, developed for a while and then dropped. Occasionally a theme is suddenly interrupted in its progress; more often the impression is of a fluid musical substance in which different subjects rise to the surface of perception at different times. Debussy's emancipation from consecutive development, presaged in the *Prélude*, is complete in this score, as it was also in the central section, 'Jeux de vagues', of *La mer*. There the stimulus had come from the attempt to capture the wave motion of the sea, always different yet always the same, whereas in *Jeux* Debussy achieved his ideal of impalpable form through creating a backcloth for the fleeting emotions and capricious movements of a group of young people at a tennis party. There is now little sign of descriptive 'impressionism'.

In the late sonatas, and even more in the piano studies, Debussy extended the freedom he had gained. Many years earlier, when a

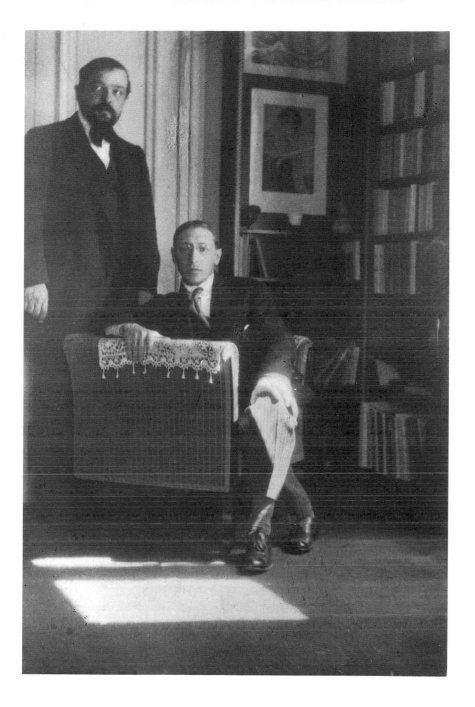

Stage design by Bonnard for a revival of Debussy's *Jeux* at the Paris Opera in 1931.

conservatory professor had asked him what rule of harmony he followed, he had replied: 'My pleasure'. Now it seemed that truly there was no other restriction, and these last works remain elusive to analysis. Often there is a sense of mercurial improvisation, and yet there is also the impression of a close control which was probably itself intuitive. Harmonic linkages are transitory and elastic; tempos and rhythms are rarely stable for more than a few seconds; thematic references are oblique, or else there is no discernible theme at all. Debussy had become entirely himself, though he could still take something from 'the young Russian' in the abrupt rhythm of his last piano study.

The lack of clear formal relation in Debussy's late music may be found also in Schoenberg's atonal works of 1909–11, for in abandoning tonality Schoenberg had lost the primary means he knew for assuring development – and for a composer whose aim was 'continuous development' that loss must have been as disconcerting as the lack of harmonic security. In some of the Five Orchestral Pieces there are the

outlines of established forms, but in others, the third and the last especially, the musical flow is as unbounded as it is in *Jeux*. But there is a difference. *Jeux* maintains the appearance of movement on several planes at once, focusing now on one, now on another, whereas Schoenberg's third piece, his impression of a dawn-lit lake, is almost motionless, and his fifth follows a single line of perpetual change.

A greater resemblance between *Jeux* and the Five Orchestral Pieces exists in their diversity of rhythm and their extraordinarily subtle use of the orchestra. For both composers, orchestration was by this time a fully fledged part of musical invention. Debussy had set out towards that as early as the eighteen-nineties, in the *Prélude à 'L'après-midi d'un faune'* to be sure, but more radically in a projected work, *Trois scènes au crépuscule* ('Three twilight scenes'), where a solo violin was to be accompanied in the first movement by strings, in the second by flutes, brass and harps, and in the third by both groups. He never achieved such a fundamental rethinking of the orchestra, but Schoenberg did. Each of his Four Orchestral Songs of 1913–16 is scored for a different and unusual complement, the first requiring six clarinets, trumpet, three trombones, bass tuba, percussion and strings without violas.

And yet the aesthetic differences between Debussy and Schoenberg are more significant than these similarities. Debussy's music, though it often breaks with the formal expectations of diatonic harmony, is not atonal in detail. His chords usually appertain to some mode or scale, even if they are placed in a structure which is at root atonal: the unacceptable thought is, as in a dream, clothed in acceptable images. Schoenberg, on the other hand, was concerned that his thought, no matter how difficult or disturbing, should be expressed without prevarication or illusion; and it was his atonal music of 1908–11 that exposed most openly what Debussy had called 'the naked flesh of emotion'.

For reasons as much psychological as technical, such a position could not be maintained for long. After the Five Orchestral Pieces Schoenberg found it impossible to compose at length without the guide of a text: his only subsequent atonal instrumental works were miniatures, three posthumously published pieces for chamber orchestra (1910) and the Six Little Piano Pieces (1911). He attributed the difficulty of abstract composition to the lack of means for coherent development in atonality, but it is reasonable to suppose that he also found it arduous to continue baring his inner self so completely. The words of a poet could provide not only a formal foundation but also an expressive distancing.

The last of Schoenberg's Six Little Piano Pieces. This very concise composition was written on 17 June 1911 in memory of Mahler, who had died thirty days earlier.

Webern also at this time experienced the impossibility of composing atonal music of long duration. Never at all a prolix composer (his longest movement, the tonal Passacaglia for orchestra, plays for about eight minutes), he was incapable in 1911–14 of writing pieces lasting for much more than a minute. Of his Six Bagatelles for string quartet (1913) Schoenberg wrote that they express 'a novel in a single gesture, a joy in a breath'. But this brevity was not easily come by. Later Webern was to recall the anguish involved in achieving the one-page Bagatelles: 'I had the feeling that once the twelve notes had run out

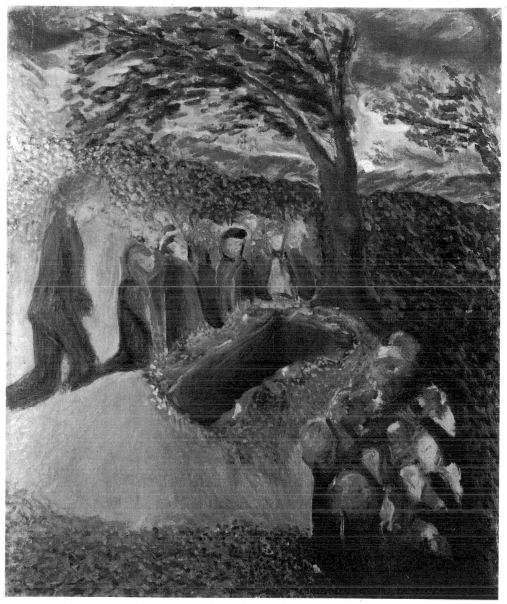

Schoenberg's oil painting of Mahler's funeral, done soon after the event in 1911.

the piece was finished. . . . It sounds grotesque, incomprehensible, and it was immensely difficult.'

These Bagatelles, together with Webern's Five Orchestral Pieces (1911–13) and Three Little Pieces for cello and piano (1914), are as exploratory as they are concise. Their time-scale and their enigmatic stillness – so different from the dynamic movement present in almost all of Schoenberg's atonal works – are those of the haiku. In rhythm, too, Webern's pieces have something of the oriental, for the regular pulse of barred metre has been dissolved, giving place to tenuous breaths of sound or unemphatic ostinatos. The abandonment of a metrical framework suggests the direction in which Debussy was moving at the same time in *Jeux*, and it was a rhythmic revolution as radical as Stravinsky's, though utterly different in kind. Stravinsky was insisting on the individual duration, while Webern removed as far as possible the sense of time-measuring. His little phrases make no promises about the future, and his ostinatos became timeless in immobility.

Thus at the moment when the first world war was about to begin, composers from quite different backgrounds, with Debussy, Schoenberg, Stravinsky and Webern at the head of them, had brought about the most rapid and far-reaching changes ever seen in western music. In the course of a few years the standard principles of tonality, formal direction and equilibrium, thematic continuity, rhythmic stability and orchestral homogeneity had all been questioned, sometimes all at once, as in Webern's Five Orchestral Pieces. It might have seemed that music could never be the same again; and yet the greatest efforts of composers in the next thirty years were to be directed towards showing that it could.

The genius of place

Almost all the great strides in music before 1914 took place in two cities, Paris and Vienna. It would be rash to offer any neat explanation for this: the simultaneous presence in Paris of Picasso and Stravinsky, for instance, is suggestive, yet the two men did not meet until 1917, some years after the revolutions of cubism and *The Rite* which have often been considered analogous. Schoenberg in Vienna was associated with such men as the painter Oskar Kokoschka and the architect Adolf Loos, not to mention his pupils Berg and Webern. But just as important as the support of this sympathetic circle was the stimulus of more general opposition. 'Maybe something has been achieved', Schoenberg said towards the end of his life, 'but it was not I who deserves the credit for that. The credit must be given to my opponents. They were the ones who really helped me.'

In Europe there may have been the need for both the sustaining encouragement of a like-minded artistic community and the provocation of public antipathy, but in America it was possible for a composer to break through the bonds of tradition entirely on his own. It was possible for Charles Ives (1874–1951) to ignore the conventions and go as far as any of his European contemporaries towards fresh musical horizons – indeed, in many ways further. Before he had heard a note of Schoenberg or Stravinsky, before he had heard much music at all later than Brahms, Ives had explored atonality, free rhythm, quarter-tone harmony, superimposing different metres, different tonalities and even different kinds of music, employing unconventional combinations of instruments, placing musicians in different acoustic positions, leaving a large degree of freedom to the performer, and virtually all the other new techniques which have exercised composers in the twentieth century. He did so undisturbed and little known, working in the spare time he could take from the successful insurance business he had established.

But Ives was no amateur. He had been trained at Yale, and in the last years of the old century he had composed symphonies, songs,

chamber pieces and church music in which he had made the effort to abide by the academic good manners most American musicians had learned in Germany. Ives, however, did not make the journey to Leipzig, and soon he was setting out in new directions, following up what he had learned from his most important teacher, his father. George Ives, an ex-Civil War bandmaster, had given his son the conviction that there were no rules in music, that the whole world of sounds was open for experiment and use.

As for traditional music, it seems that Ives junior liked little apart from his own and that of a few similarly independent Americans with whom he came into contact only after he had virtually ceased composing, in 1918: Beethoven he considered 'a great man – but Oh for just one big strong chord not tied to any key'. For Ives, music had been emasculated by the need composers felt to please their audiences; now one must offer stronger meat for the ears and the mind: complex rhythms, involved textures and, above all, dissonant chords. His reaction to sounds of hissing at a performance of a work by his friend Carl Ruggles was characteristic: 'You god damn sissy,' he rose and shouted, 'when you hear strong masculine music like this, get up and use your ears like a man!'

However, Ives's exploratory cast of thought was also part of a deeper philosophy. Music was for him an expression of subjective emotion, but it also had the power of transcendental revelation; and it held the promise of utopia. 'The instinctive and progressive interest of every man in art', he wrote, 'will go on and on, ever fulfilling hopes, ever building new ones, ever opening new horizons, until the day will come when every man while digging his potatoes will breathe his own epics, his own symphonies (operas, if he likes it); and as he sits of an evening in his backyard and shirt sleeves smoking his pipe and watching his children in *their* fun of building *their* themes for *their* sonatas of *their* life, he will look up over the mountains and see his visions in their reality, will hear the transcendental strains of the day's symphony resounding in their many choirs, and in all their perfection, through the west wind and the tree tops!'

Here is expressed Ives's sympathy with the ordinary, hard-working man of the soil, his insistence on the integrity of the individual and his transcendental vision. All these came from his New England heritage, and it was to his experience as a Yankee boy that he returned again and again in his music. His self-dependence and his lack of inhibition may be regarded as generally American characteristics, but his music was most intimately linked with the history, landscape, philosophy and

Front cover, designed by Carl Ruggles in 1932, for the first of Ives's works to appear in Henry Cowell's New Music Edition (see p. 114).

Charles Ives in Battery Park, New York, about 1913.

literature of Massachusetts and Connecticut. In the 'Concord' Sonata for piano (1909–15) he gave his responses to the work of the writers and thinkers associated with that town: Emerson, Hawthorne, the Alcotts and Thoreau. The orchestral *Three Places in New England* (1903–14) evoke personal memories of other parts of his native world, with 'Putnam's Camp', the central 'place', depicting a children's outing and a boy's vision of stirring events in the war of independence.

In this piece Ives needed his taste for experiment in order to represent, for example, the arrival of a marching band while other things are going on. Some of his works appear to have been undertaken in a spirit of pure speculation – the atonal *Tone Roads* for instance – but more often his innovations came about in this way, summoned by a descriptive image or a text. It is not surprising, therefore, that his abundant and eccentric genius is expressed most completely in his many songs, most of them to poems by American writers and the great

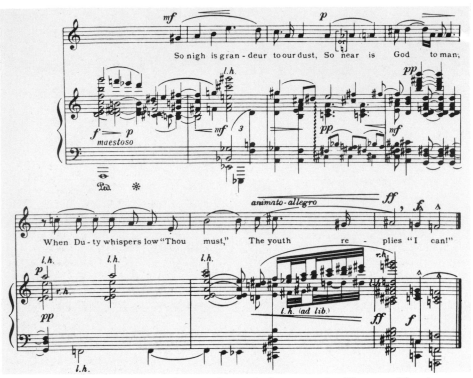

'Duty' (1921), an epigrammatic song by Ives to words of Emerson. The piano part, which includes some physically unplayable chords, must be regarded as an ideal towards which the performer is to strive.

English Romantics. In these he could reveal his sturdy self-reliance and his sentimentality, his imitation of nature and his ability to see beyond, his commitment to a plain man's democracy and his reverence for God.

Like Schoenberg, Ives was concerned less with what he called the 'manner' of music than with its 'substance': Schoenberg would have used the words 'style' and 'idea'. But Ives was willing to go further than Schoenberg in abandoning traditional limitations in order to give proper expression to his substance. He was sometimes careless of what is feasible for performers or instruments: 'Why can't music go out in the same way it comes into a man', he wrote, 'without having to crawl over a fence of sounds, thoraxes, catguts, wire, wood and brass? . . . Is it the composer's fault that man has only ten fingers?' He was careless

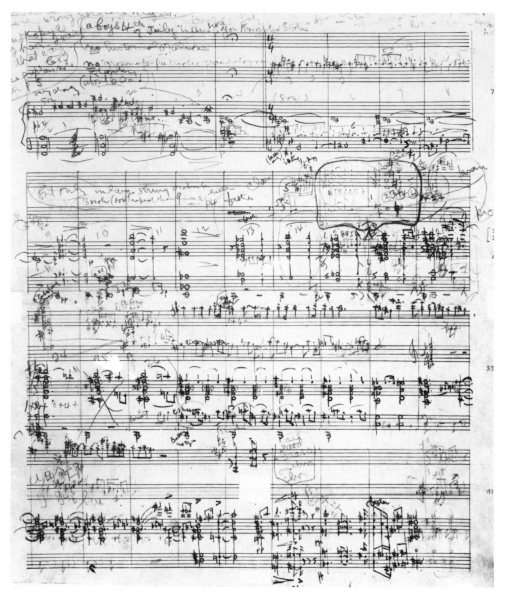

The first page from Ives's autograph score-sketch of *The Fourth of July* for orchestra (1912–13). Among the comments and emendations is a note to the copyist in the top left corner: 'Mr Price: Please don't try to make things nice! All the wrong notes are *right*.'

too of the score as an ultimate statement; he went on revising and rearranging his works long after his period of intense creativity had passed. Eventually, finding only neglect, hostility or disbelief, he became careless of performance. Not until the 1930s did his music begin to excite much interest in the American musical world, and not until the 1960s was it at all widely played or recorded. And by then musical history had at last caught up with him.

Ives's memories of nineteenth-century New England, particularly in such orchestral works as the *Three Places* and the *Holidays Symphony*, depend for their evocative exactness on the quotation of marches, popular songs, dance music and hymns, all frankly interpolated. When Dvořák had been in the United States in the 1890s he had suggested that American composers should look to their native music for stimulus, just as he had drawn on Czech folk song in forming his own melodic style; but he can hardly have expected that his advice would shortly be taken up in such riotous celebrations of America as *The Fourth of July* from Ives's *Holidays Symphony*. As far as Ives was concerned, the music of the American people was too diverse and too rich in reference for it to be used in Dvořák's symphonic manner. Instead of seeking to adjust his country's music and himself to the European mainstream, he showed that a man might forget about tradition and make of music whatever he wanted.

Several European contemporaries, though less radical than Ives in ignoring the conventions, were also determined to base their music in the art of the people, and to do so without Dvořák's accommodation to the Austro-German norms. In this there was a certain political motivation: the Austrian hegemony of eastern Europe was under threat from nationalist movements in the years before the first world war, and it followed that composers should seek similarly to free their music from the yoke of Vienna and turn instead to the national source of folk song.

In Hungary the way was led by Béla Bartók (1881–1945), who devoted as much attention to collecting and classifying folk music as to composition. He became one of the foremost folk-song scholars of his time and by far the greatest nationalist composer of any country, but at the same time his view was wider. 'My real idea', he once wrote, 'is the brotherhood of nations. . . . I try to serve this idea in my music . . . and that is why I do not shut myself from any influence, be the source Slovak, Rumanian, Arab, or any other.'

Bartók made his first notation of a Magyar folk song in 1904, and during the next fifteen years he travelled throughout Hungary and

Béla Bartók; oil portrait by Róbert Berény dating from the spring of 1913. Berény was a leading member of a group of avant-garde artists in Budapest at the time of Bartók's early folk-song researches. Copyright G.D. Hackett, NY.

neighbouring countries, to North Africa and to Turkey, gathering folk music wherever he went; nor was he less assiduous in studying his own and other collections. As a composer he was interested not simply in using folk themes but in penetrating to the roots of folk music and using what he found. 'The study of this peasant music', he wrote, 'was for me of decisive importance, for the reason that it revealed to me the possibility of a total emancipation from the hegemony of the major–minor system. For the largest and, indeed, the most valuable part of this treasure-house of melodies lies in the old church modes, in ancient Greek and still more primitive scales (notably the pentatonic), and also shows the most varied and free rhythms and time-changes.' Bartók thus took part in the general movement away from diatonic harmony and rhythmic stability, taking his lead from the ancient folk music of Hungary. From that source he also learned, as he acknowledged, 'the art of expressing any musical idea with the highest perfection, in the shortest form, and using the simplest and most direct means'. Furthermore, the mass of alterations to be found in folk songs, occurring as a result of repeated aural transmission, contributed to his acquiring an extraordinary skill in musical variation.

At the time when Bartók began his collecting journeys he was most influenced by Richard Strauss and Debussy, but it was not long before his music was showing what he had learned in the villages of Hungary.

His one-act opera *Duke Bluebeard's Castle* (1911) owes its brilliant orchestration in part to Strauss and its manner of word setting to the example of *Pelléas et Mélisande*, but its melodies, its rhythms and its ballad style are all thoroughly Hungarian. After the further experience of *The Rite of Spring*, to whose dynamism he responded in his own ballet *The Miraculous Mandarin* (1918–25), Bartók was ready to base his art completely in folk music, or rather in the ideas, principles and methods he had drawn from it.

The next twelve years saw the composition of his finest works: the First and Second Piano Concertos, the Third, Fourth and Fifth String Quartets, the Music for Strings, Percussion and Celesta, and the Sonata for Two Pianos and Percussion. All of these show how much he had assimilated from folk music in the use of various scales, in enlarging harmonic possibilities (almost to atonality on occasion), in creating ideas of sharp clarity, in finding new rhythms and in handling variation with supreme ingenuity. Folk music had here led him to works of high structural intricacy and emotional force, not the vague pastoralism of other folk-song composers.

In Czechoslovakia the great nationalist composer of the early twentieth century was Leoš Janáček (1854–1928), who was influenced not only by folk music but also by the sounds and rhythms of speech in his native Moravia, as was natural in a musician who produced his greatest work for the operatic stage. Though born before Mahler and Debussy, Janáček was little known before the Prague opening in 1916 of his first important opera, *Jenůfa*, and most of his best works date from after that première. His achievement in creating a distinctively national operatic style may be compared with Bartók's in *Bluebeard*, and his advance beyond the norms of western tradition was almost as radical; certainly his late works bear little relation to the Czech Romantic styles of Smetana and Dvořák. The variety and power of his concise melodic ideas, coupled with an elusive harmony, gave him the means both to intensify dramatic situations and to explore the motivations of his characters.

Outside eastern Europe nationalism was no less a force in the years around the first world war. Spain, often the source of colour for Russian and French composers in the nineteenth century, began to find musicians of her own, the greatest of them being Manuel de Falla (1876–1946). For several years before the war Falla lived in Paris, so that he came into contact with Debussy; and it was the Spanish pictori-alism of his French contemporaries that influenced such works as *Nights in the Gardens of Spain* for piano and orchestra (1909–15).

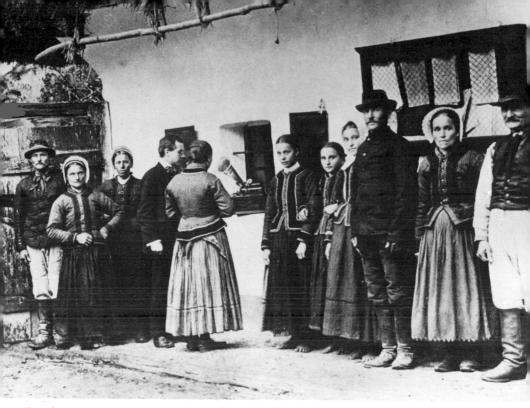

Bartók using a gramophone to collect folk songs in the village of Darázs (now Drazovce, Czechoslovakia) in 1908. Copyright G.D. Hackett, NY.

Folk song notated by Bartók. The arrow on the F in the penultimate bar indicates that its pitch was slightly sharper than that written.

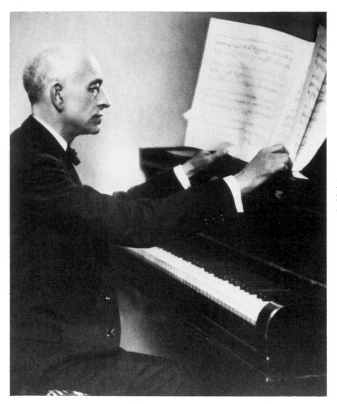

Manuel de Falla, the leading
Spanish nationalist of the
twentieth century.

Costume design by Picasso for
the first production of Falla's
ballet *The Three-Cornered Hat*.

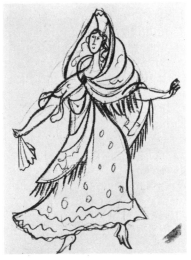

Returning to Spain, however, he discovered his own way of treating local material and his own starker style, starting out in his Diaghilev ballet *The Three-Cornered Hat* (1917–19). Like Bartók, though in a less analytic fashion, he made abstractions from folk music without quoting it directly and went on to pare down his style in pieces like the Harpsichord Concerto (1923–6). But perhaps the main influence on him at this time was that of Stravinsky.

Stravinsky's interest in the folk arts of his native country was greatest during the first years of his self-imposed exile from Russia, that is, from 1914 to 1920, when he was living in Switzerland. He had used the occasional folk melody in *Petrushka* and *The Rite of Spring*, but now he devoted himself much more thoroughly to evoking the spirit of old Russia, its humour as well as its ceremony. In a series of songs and choral pieces he set little folk verses, often with the pungent accompaniment of a small instrumental ensemble, and he used the same peasant literature in the two stage works which followed *The Rite*: *Renard* (1915), a farmyard fable in the form of a 'burlesque in song and dance', and *Les noces* ('The wedding', 1914–23), a set of 'Russian choreographic scenes' on ancient wedding ceremonies.

Renard, scored for four male voices and small orchestra, has the earthy gusto of the songs of the same period, but the choral *Les noces* is altogether more ritualized. Here the rhythm of *The Rite* is developed so that the whole work is set on the carefully engineered workings of tiny, insistent cells, the human participants being caught in the orderings of formal ceremony and so exalted. Even the comedy of drunken wedding guests is subject to this ritual presentation. Perhaps because the music is so strict and stylized, Stravinsky had difficulty in finding the right medium for *Les noces*. At first he scored the accompaniment for the large orchestra of *The Rite*, but eventually he settled on a paring down to the constructivist sound of four pianos and percussion.

Both *Renard* and *Les noces* are ballets with song, but in neither is there a one-to-one relation between the dancing characters and the singing voices. The action is shown in dance while the singers, whom Stravinsky intended should be placed with the instrumentalists on stage, provide an oblique commentary. Again, the sense of ritual enactment is enhanced by having everything on display, the music becoming as much a part of the ceremony as the action on stage.

Stravinsky pursued the idea of having all the forces in evidence in a third stage piece of this 'Russian period', *Histoire du soldat* (1918), which was designed for a travelling theatre in the straitened

Front cover by Picasso for the first edition (1919) of Stravinsky's piano arrangement of his *Rag-time*. The central design of two musicians is drawn in a single line.

circumstances of war. This Faustian tale, again originating in Russian folk stories, is 'to be read, played and danced' by a narrator, two actors, a female dancer and a small band, with short musical numbers fitted into the direct and narrated drama. The music is, typically for the period, tart in harmony and instrumentation, and it includes sharp parodies of popular dance forms, including ragtime and tango, as well as an acerbic chorale. More such quirky interpretations of established styles occur in the contemporary Easy Pieces for piano duet, *Rag-time* for eleven instruments and *Piano-Rag-Music*, and these pointed the direction in which Stravinsky's music was to go.

Neoclassicism

In the years immediately preceding the first world war Romanticism had come to its zenith. The gigantic forces of Mahler's Eighth Symphony and Schoenberg's *Gurrelieder* would never again be assembled, nor would the intense subjective expression of Schoenberg's first atonal works be equalled. Something else was needed for the postwar era; a new spirit was urgently wished for. Romanticism, associated with the old order, now seemed to many irrelevant, even distasteful, its ambition seen as bombast, its emotionalism as sentimentality. The nineteenth century must be forgotten as an aberration. A new start must be made, so many composers decided, on the basis of earlier music: it was the adventure of Neoclassicism.

The lures of a return to the eighteenth century were many. Baroque and Classical music offered models of lucid and concise forms, as opposed as could be to the complexity and length of Mahler or the intangibility of Debussy. Composers also found in the 'old style' a rhythmic alertness and a clarity of idea which they could emulate in writing music appropriate to the rapid pace and uncluttered emotions of their own times. Moreover, the music of Bach in particular could be seen as a pattern of objective construction, and objectivity was now high among the aims of artists.

Stravinsky made the classic statement on this in his *Chroniques de ma vie* of 1935: 'I consider that music is, by its very nature,' he wrote, 'essentially powerless to *express* anything at all, whether a feeling, an attitude of mind, a psychological mood, a phenomenon of nature, etc. . . . The phenomenon of music is given to us with the sole purpose of establishing an order in things, including, and particularly, the coordination between *man* and *time*.' Even if every one of Stravinsky's Neoclassical works belies his thesis that music is 'powerless to express anything at all', it is important to recognize that such anti-Romantic attitudes had a determining place in the genesis of Neoclassicism.

That genesis, as far as Stravinsky was concerned, took place in a rather curious way. In 1917 Diaghilev had won a great success with *Le*

Stage design by Picasso for Stravinsky's ballet
Pulcinella. The setting was based on impressions
Picasso had gained in Naples, which he had
visited with Stravinsky in 1917.

Costume design by Picasso for one of the
commedia dell'arte characters in *Pulcinella*.

Igor Stravinsky; drawing by Picasso dated 24 May 1920, nine days after the première of the ballet *Pulcinella*, on which the two collaborated.

donne di buon umore ('The good-humoured ladies'), a ballet for which Vincenzo Tommasini had orchestrated music by Domenico Scarlatti. He proposed that Stravinsky, the star composer in his stable, should do something similar with pieces by Pergolesi (or rather, as now is known but then was not, attributed to him by contemporary publishers). Stravinsky set about the work with delight and accomplished it in 1919–20; but he did so with scant regard for the proprieties of period style. The balance of the music is upset by his alterations to rhythm and harmony, and by his scoring for a chamber orchestra in which winds are prominent. *Pulcinella*, as the ballet was called, was put on with aptly pseudo-eighteenth-century Neapolitan designs by Picasso and was greeted immediately by protests from those who detected in the score an attitude of ridicule. Stravinsky, however, was unrepentant. 'Respect alone', he rejoindered, 'remains barren, and can never serve as a productive or creative factor. In order to create there must be a dynamic force, and what force is more potent than love?' As in his recent ragtime pieces, he had offered not only satirical wit but also genial affection; and the two were to remain inseparable in his Neoclassical works.

After the resuscitation of existing music in *Pulcinella*, Stravinsky began a gleeful examination of the past for models of form and gesture which might be used in original music. He decided to revive the *opera buffa* of Pergolesi's time, finding in its delimited numbers a mode as opposed as possible to the through-composed music drama of Wagner. This form also gave him the opportunity to announce his new affiliation to the Italianate Russian musical stream of Glinka and Tchaikovsky, his removal from the nationalist school with which, as a pupil of Rimsky-Korsakov and the composer of *The Firebird*, he had been associated. At the same time, the new opera, *Mavra*, demonstrated his departure from his more recent past: his rhythmic subtleties are now contained within conventional barring and his harmony relates to diatonic tonality, if often teasingly. Through reference to the eighteenth century he had discovered rules – rules of form, of metre, of harmony – and it was against those rules that he played.

In the practice of his ludic Neoclassicism Stravinsky turned next to pure instrumental music. He composed quasi-Baroque structures in his Octet for winds (1922–3), and there are reminiscences of Bach in the Concerto for piano and winds (1923–4). His neglect of the strings in these scores, as also in *Mavra* and *Les noces* (then being orchestrated for pianos and percussion), is probably to be explained by a feeling that string instruments were too easily associated with exactly the kind of

Erik Satie; caricature
by Cocteau, his most
enthusiastic promoter
in the years immediately
after the first world war.

nineteenth-century sentimentality he wanted to avoid. Only recently he had used woodwinds and brass alone in the Symphonies of Wind Instruments to create 'an austere ritual which is unfolded in terms of short litanies between groups of homogeneous instruments'. Now he found that the same instruments could be brilliant and witty as well.

The ballet *Apollo* (1927–8), however, was composed entirely for strings, whose 'multi-sonorous euphony', as Stravinsky put it, could embody the classical sobriety of the French Baroque. 'And how', he asked, 'could the unadorned design of the classical dance be better expressed than by the flow of melody as it expands in the sustained psalmody of strings?' As *Apollo* shows, and as other works confirm, Stravinsky's Neoclassicism was not always bitter and satirical: stealing might also be accomplished by seduction.

Other composers of the period took a more consistently irreverent attitude to the past, particularly those in what was now Stravinsky's own city of Paris. By 1920 a group of them, influenced by Jean Cocteau's manifesto *Le coq et l'arlequin* (1918) and largely stage-managed by him, found themselves banded together as 'Les Six', espousing an aesthetic of flippancy and determined anti-Romanticism. Debussy was out; Wagner was most definitely out. Music now must be straightforward, drily witty and up to date. The chosen model was Erik Satie (1866–1925), whose harmonic experiments may have influenced his friend Debussy in the 1890s, but who had since become

something of a Dadaist. He wanted music stripped to the barest essentials; he dealt in poker-faced clowning and parody, offering his music under such titles as *Choses vues à droite et à gauche (sans lunettes)* ('Things seen to right and left (without spectacles)') and *Sonatine bureaucratique*; and he cultivated inconsequence in his 'furniture music', designed to be ignored.

Satie's six young colleagues followed him in mocking all accepted musical conventions, if more with Cocteau's shock tactics than the dapper composer's disarming charm. Five of them collaborated with Cocteau on a crazy skit, *Les mariés de la tour Eiffel* (1921), and they all wrote short instrumental pieces and songs which combined Stravinsky's urbanity with Satie's satirical sense of the ridiculous. But Les Six did not exist as a group for more than a few years, and the three leading members, Arthur Honegger, Darius Milhaud and Francis Poulenc, all went off in more positive and promising directions.

For Stravinsky the main point about Neoclassicism had never been that it enabled the composer to poke fun at the past but rather that it lent a work distance. This he took advantage of with particular effectiveness in his opera-oratorio *Oedipus rex* (1926–7), for which he had a text by Cocteau translated into Latin, 'a language of convention, almost of ritual' as he put it. He also took 'a language of convention'

Les Six; group portrait in oils by Jacques-Emile Blanche. The five members of the group depicted are Germaine Tailleferre (seated left), Darius Milhaud (seated left, facing front), Arthur Honegger (seated left, facing right), Francis Poulenc (standing right, head inclined) and Georges Auric (seated right); Louis Durey is absent. Cocteau presides over the group from the far right, and the picture also shows Marcelle Meyer and Jean Wiener, who were associated with Les Six as pianist and conductor.

Stage design by Ewald Dülberg for the Kroll Opera (Berlin) production of
Stravinsky's opera-oratorio *Oedipus rex*.

in choosing to set *Oedipus* in the form of an abbreviated Baroque ora-
torio. His stated reasons for this are revealing of his Neoclassical atti-
tudes in general, and indeed of his deepest artistic beliefs. 'The need
for restriction,' he wrote, 'for deliberately submitting to a style, has its
source in the very depths of our nature. . . . Now all order demands
restraint. But one would be wrong to regard that as any impediment
to liberty. On the contrary, the style, the restraint, contribute to its
development, and only prevent liberty from degenerating into licence.
At the same time, in borrowing a form already established and
consecrated, the creative artist is not in the least restricting the
manifestation of his personality. On the contrary, it is more detached,
and stands out better when it moves within the definite limits of a
convention. This it was that induced me to use the anodyne and
impersonal formulas of a remote period and to apply them largely in
my opera-oratorio, *Oedipus*, to the austere and solemn character of
which they specially lent themselves.'

Like the *Histoire du soldat*, *Oedipus* has a narrator, but now he stands
quite apart from the action. He wears modern evening dress and,
speaking the vernacular, explains the story to the audience, so con-
firming their dissociation from what is happening on stage. There is

no invitation to identify with the characters, rather to observe; and the quasi-liturgical presentation of the legend is, as Stravinsky implies, emphasized by the square-cut form of the music. But having chosen a stark framework, Stravinsky often allows his principals to sing with a Verdian effusion of feeling, the emotion safely rendered objective by the formal surroundings. *Oedipus* was Stravinsky's first success in using Neoclassicism as the means with which to create that ritual severity which marks his greatest works, earlier examples including *The Rite of Spring* and *Les noces*; and he soon repeated that success, though in quite different ways, in the Symphony of Psalms and the ballet *Perséphone*.

Stravinsky's reference to Verdi in *Oedipus rex* draws attention to the inappropriateness of 'Neoclassicism' as a label. The movement was not always directed towards revamping the 'classical' styles of the seventeenth and eighteenth centuries, though certainly those periods came in for most attention. Nor even was the element of return a distinguishing mark, for Reger had looked to Bach without being at all Neoclassical in the sense of the 1920s. Neoclassicism meant, above all, irony, and the subject of that irony could be taken from any period. In his Piano Sonata, Stravinsky glanced at Beethoven within the context of his pseudo-Baroque contrapuntal style, and in his Capriccio for piano and orchestra he brought Tchaikovsky and early Romantic lyricism into the concerto grosso form. Such eclecticism was typical of the Neoclassicist, but in Stravinsky's music the borrowings are always to some degree hidden: his intention was not to assemble musical *objets trouvés* but to own them.

Francis Poulenc (1899–1963), on the other hand, appears to have delighted in the incongruity of a blatant popular tune appearing within a concerto, or a piece of post-Gounod sentiment in a monumental sacred work after the Baroque mould. His music may seem gay and flippant, and some of it is no more than that; but in many of his larger compositions there is the same disconcerting juxtaposition of banal objects that one finds in much Surrealist painting, and the same academic skill which brings quite unrelated things into a coherent whole. In music the technique had its roots in such works of Satie as his ballet *Parade* (1917), which includes a typewriter and a revolver within the orchestra and which drily places one naïve musical construct after another. Poulenc's works of the 1930s and 1940s, however, have changed Satie's prankishness into something both more seductive and more perturbing.

For a German composer Neoclassicism had of necessity to be a more earnest affair. Across the Rhine, Busoni's 'young classicism' was

Picasso's design for a drop curtain for the first production of Satie's ballet *Parade*.

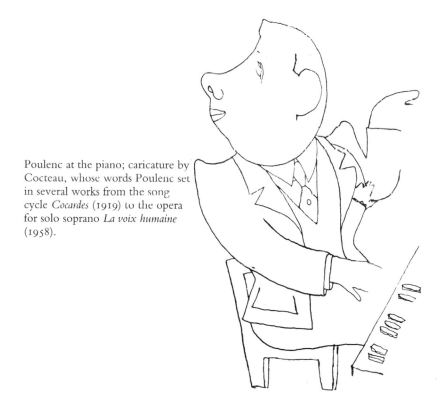

Poulenc at the piano; caricature by Cocteau, whose words Poulenc set in several works from the song cycle *Cocardes* (1919) to the opera for solo soprano *La voix humaine* (1958).

Hindemith at about the time
of his emigration to America
in 1940.

a movement without the satire that spiked Neoclassicism in Paris, one
which sought a more genuine return to Mozart's clarity of execution
and Bach's density of thought. At the same time the young Paul
Hindemith (1895–1963) was basing his first compositions on Reger's
organic adoption of the Baroque. Soon, however, Hindemith's music
was beginning to parallel Stravinsky's in filling the old bottles of estab-
lished form with the new wine of wind-based instrumentation,
expanded tonal harmony and tricky mechanical rhythms.

The new style emerged in Hindemith's *Kammermusik no. 1* for small
orchestra (1921), which was followed by more chamber and orches-
tral works similarly akin in form to the Bachian concerto or suite.
There came also an opera, *Cardillac* (1926), in which Hindemith aimed
to compose musical numbers proceeding under their own vigorously
contrapuntal steam, to a large degree independent of the plot. In this,
as in the devices of his other works, he drew his examples almost
exclusively from the Baroque, and he took what he chose without any
display of the cynical wit current in Paris. Hindemith's Neoclassicism
may therefore be said to have been 'purer' than Stravinsky's, in both
ethical and material terms. Yet the irony of stylistic displacement is still

very much present, arising largely from the astringent harmony, based on fourths rather than thirds, which Hindemith preferred. And the resulting absence of full harmonic relaxation, coupled with rhythms more heavily driving than those of Stravinsky, gives much of Hindemith's early Neoclassical music a rather pugnacious character.

In Germany, as in France, Neoclassicism was at its height between the wars, and young composers who came to maturity during that period, whatever their nationality, took to it as the musical *lingua franca* of the time. Many of them came to Paris to learn the rudiments of the style at the hands of Nadia Boulanger, whose American pupils alone included Elliott Carter (b. 1908), Aaron Copland (1900–90) and Roy Harris (1898–1979). In England the appeal of Hindemith was felt by Michael Tippett (b. 1905) and that of Stravinsky by Benjamin Britten (1913–76). And Stravinsky also provided starting points for his younger Russian colleagues Sergey Prokofiev (1891–1953) and Dmitri Shostakovich (1906–75).

Prokofiev, indeed, had anticipated Stravinsky's Neoclassicism in his Classical Symphony (1916–17), though that charming pastiche has little of the older composer's keen irony. For that quality one must turn to the early operas of both Prokofiev and Shostakovich, the former's

Front cover designed by Hindemith for his piano suite *1922*, in which he caught the mood of the period. The work includes a 'Shimmy' and a 'Ragtime'.

Sergey Prokofiev; drawing
by Matisse dating from the
composer's years in Paris,
1923–33.

The Love for Three Oranges (1919) and the latter's *The Nose* (1927–8),
both of which mock the conventions of the genre, introducing bizarre
turns of plot and disconcerting musical satires. The two composers
may have been alike on such occasions, but their situations were very
different. Prokofiev had established himself as a composer before the
revolution, and after it, like Stravinsky, he spent most of his time as an
exile in Paris until, unlike Stravinsky, he returned to Russia in 1933.
Shostakovich, on the other hand, was a child of the Soviet state and
rarely ventured outside his native country.

Both Prokofiev and Shostakovich had the typical Neoclassical pen-
chant for eclecticism, but Shostakovich was discouraged by official
policy from casting his net too wide. Partly in response to ideological
pressure he abandoned the zestful pickings and iconoclastic outrages
of *The Nose* for the distinctive blend of Tchaikovsky and Mahler he
created in his Fifth Symphony (1937). Similarly, Prokofiev found that
he had to tone down his sarcasm on entering the company of Soviet
composers. The brittle Neoclassicism of his Second Symphony (1924)
was as out of place as the rich colour and weighty post-*Rite* rhythms
of his ballet *Chout* (1920): both had to be replaced by something more

Dmitri Shostakovich; a photograph from his later years, when he was the accepted master of the Soviet symphony, though still finding himself in conflict with authority on occasion.

'optimistic', less 'formalist', wider in appeal. This Prokofiev achieved in his Fifth Symphony (1944) and his full-length post-Tchaikovsky ballet *Romeo and Juliet* (1936), in which Neoclassicism has given place to a full-hearted return to Romanticism.

But it would be wrong to attribute the Soviets' softening of Neoclassicism entirely to political intervention, for the tendency was general. Copland and Harris, for instance, were leading the way towards a Romantic American nationalism, expressed most notably in the former's ballet *Appalachian Spring* (1944) and the latter's Third Symphony (1937). Tippett and Britten, whose understanding of Neoclassicism embraced learning from English music of the past (the Elizabethan madrigalists and Purcell above all), had never participated in the anti-Romantic reaction, and their works exhibit both a positive engagement with tradition and a willingness to deal with social and philosophical issues in the case of Tippett, or with the springs of human personality in the case of Britten. Elliott Carter, later than his contemporaries in coming to a fully individual style, began in the late 1940s to clear his way from Neoclassicism to the elaborately wrought style of such works as his first two string quartets (1951 and 1958–9).

Elliott Carter, master of
Neoclassicism and later of a
greatly more complex style.

Atonal, formally inventive and rich in incident, these pieces are a long
way indeed from the dazzling wit of Neoclassical restoration.

Throughout Europe and America there was an anti-anti-Romantic
reaction in the thirties and forties to the dominating trends of the
previous decade. Olivier Messiaen (1908–92), whose student years
coincided with the heyday of Parisian Neoclassicism, would have
nothing to do with the irony and objective elegance of Poulenc and
the new Stravinsky. He stood for a return to 'human' values, and he
achieved this in music whose opulent modal harmony is as distant as
possible from the bitter 'wrong note' tonality of the Neoclassicists. At
the same time Honegger, once a rather unconvincing member of Les
Six, came into his own as a composer of churning symphonic works
whose harmonic richness comes close to that of Schoenberg, even if
their driving rhythms remain a legacy of Baroque imitation.

Composers of an older generation were also able to show, even in
the twenties, that Neoclassicism could be adapted to quite individual
ends. Falla's development of a sparer style came at this time, and there
was a similar evolution in the music of Maurice Ravel (1875–1937).

Maurice Ravel in dapper pose, looking very much the composer of the urbane
G major Piano Concerto (1931), with its Gershwinesque admixture of jazz to an
exquisitely crafted Neoclassical score.

Ravel had begun his career taking up from Debussy and Rimsky-Korsakov in fashioning bright musical images, images of the orient in his orchestral song cycle *Shéhérazade* (1903), of Spain in his opera *L'heure espagnole* (1907) and other works, of childhood fantasy in his ballet *Ma mère l'oye* ('Mother Goose', 1908–11) or of classical Greece in his Diaghilev ballet *Daphnis et Chloé* (1909–11). In all these works his stance had been objective, his manner artificial and his technical interest in the construction of intricate musical objects to be set in motion. It was unremarkable that he should have taken readily to the disguise of Neoclassicism in *Le tombeau de Couperin* for piano or orchestra (1917–19), where the forms of a French Baroque suite are made to hold self-contained ideas of characteristic finesse. And in his later sonatas and piano concertos he went on to produce music more generally typical of inter-war Parisian Neoclassicism.

Other composers of the older generation found themselves unable either to accept the cool manners of Neoclassicism or to find another way in the brisker postwar times. Elgar achieved very little in the fifteen years remaining to him after his Cello Concerto (1919); Sibelius virtually stopped composing after writing *Tapiola* (1926), though he lived another thirty years; and Paul Dukas (1865–1935) destroyed almost everything he composed after his ballet *La péri* (1912). The silence of a composer offers little evidence from which to infer his attitude, but one may in part attribute such men's near abandonment of composition to a feeling that music had irrevocably changed. And so it had. In the first fifteen years of the century the bounds of musical convention had been pushed back in almost every direction; now the advent of Neoclassicism came as an open acknowledgment that the continuity of tradition had been lost, for the fruits of the past could be used and re-used without concern for their original meanings and functions. Stravinsky regarded his stealings from the past as expressions of love, yet his attitude was that of an outsider, visiting a musical tradition which had become a museum.

This is very evident in his Violin Concerto in D (1931), which he wrote after a study of the great violin concertos of the past and for which he chose the key that had been used by Beethoven, Brahms and Tchaikovsky. Yet there is nothing directly imitative in the work; rather it is composed against its predecessors and, like so many of Stravinsky's Neoclassical compositions, against the Baroque forms in which it is couched. This distancing technique, to which he refers in his statement on the style of *Oedipus rex*, was brought to a culmination in his opera *The Rake's Progress* (1948–51), where the

foil of Mozart's operas, and in particular of *Don Giovanni*, is never absent.

Other works of Stravinsky's later Neoclassical years, such as the quasi-Brandenburgs he produced in the 'Dumbarton Oaks' Concerto (1937–8) and the Concerto in D (1946), show a less cynical delight in adopting past patterns. Such a rapprochement with tradition, also to be seen in the contemporary works of Hindemith, admitted a positive use of diatonic harmony, as opposed to the often crabbed tonality of the twenties, and so opened the way to that renewal of symphonic writing variously displayed in the works of Prokofiev, Shostakovich and Honegger. Stravinsky himself composed a Symphony in C (1938–40) and a Symphony in Three Movements (1942–5) in which he applied the techniques developed in Neoclassicism – textural lucidity, clarity of design and motor rhythm – to large-scale instrumental forms on the old tonal pattern. Even so, diatonic harmony had been irrevocably corrupted by irony: it could now appear only within quotation marks; and Schoenberg's revelation of the atonal universe had made the choice of a key seem an anachronistic gesture. Most of the greatest diatonic compositions written since the 1920s, including the symphonies of Shostakovich and the operas of Britten, have been those which have admitted the corruption.

There remains, however, one composer who was able to take up methods and materials from the past without the dead hand of irony, and that composer was Bartók. His approach to Baroque music, like his approach to folk song, was thorough and analytic. He extracted the essence, whether in the construction of ideas or in the building of forms, and then applied what he had learned without carrying over so much of the original as to make the result a pastiche. In the first movement of his Music for Strings, Percussion and Celesta, for instance, he based his work on the idea of the fugue, but only on the idea: his meandering, chromatic and metrically irregular subject could never have been imagined in the eighteenth century, and the form of the movement, a symmetrical shape about a central climax, is quite unlike that of any earlier fugue.

Bartók had a special liking for forms which, like this movement, are at once palindromic and progressive, the second part both a reversal and a continuation of the first. They appear in most of his chamber and orchestral pieces of 1926–37, and they provided the opportunity for him to show his characteristic use of Baroque practices – the inversion of themes, for example, or the establishment of clear structural demarcations – to utterly new ends. Even where he sounds very much

Bartók near the end of his life. He died in New York in 1945 with his Third Piano Concerto just unfinished. Copyright G.D. Hackett, NY.

like Bach, as he does at certain points in the first movement of his Second Piano Concerto, he can do so without any sense of parody, for the Bachian material is somehow justified within the composition: it does not stand out as a defiant or satirical reference to the past. But for most composers progress seemed possible only against the spring-board of the past, of a past which had been lost.

Serialism

In 1921, the year when Stravinsky and Hindemith were beginning their first Neoclassical works, Schoenberg announced to his pupil Josef Rufer that he had 'discovered something which will assure the supremacy of German music for the next hundred years'. That discovery was serialism; and if Schoenberg's words now have a rather sinister ring, one must remember that the great German tradition was for him the centre of music and its continuation an absolute necessity. Atonality had involved a suspension of most of the fundamental principles of the tradition: Schoenberg had been troubled by the lack of system, the absence of harmonic bearings on which large forms might be directed. Serialism at last offered a new means of achieving order.

It was not that there had been no order in the atonal compositions of Schoenberg and his pupils: many of their pieces from the atonal period can be shown to be based on small groups of notes which are rearranged and transposed in a multitude of ways. But it seems clear that, as far as the composers themselves were concerned, atonal writing came largely intuitively. It had arisen from the felt need to eliminate the guidance of intellect or education, and the very speed at which such works as *Erwartung* were composed would argue against their having been in any way calculated. To be sure, in later atonal works there were conscious attempts to impose order. *Pierrot lunaire* and some of Webern's late atonal songs show their composers using learned contrapuntal devices to bring structural clarity, and Berg's use of established formal models in *Wozzeck* may be understood in the same light. Yet these were only partial solutions, for the problem remained that there was no law governing the construction of melodies and harmonies, no replacement for the hierarchical operations of notes and triads in the major–minor system. The new law was provided in Schoenberg's invention of serialism – or perhaps his own word 'discovery' should be preferred, since serialism was in essence a

formalization and extension of a principle already primitively expressed in Schoenberg's *Die Jakobsleiter* and Berg's *Altenberglieder*.

That basic principle of serialism is simply stated: the twelve notes of the chromatic scale are arranged in a fixed order, the series, which can be used to generate melodies and harmonies, and which remains binding for a whole work. The series is thus a sort of hidden theme: it need not be presented as a theme (though, of course, it may be), but it is a fount of ideas and a basic reference. It may be manipulated in a composition in a variety of ways: the individual notes of the series may be changed in register by one or more octaves; the whole series may be uniformly transposed by any interval; it may be inverted; and it may be reversed. By these means the composer is provided with a whole range of forms of the series, all related by the same sequence of intervals, and he may use these forms in any way he chooses. It is not necessary for themes to consist of twelve notes, nor for the series to be used as melody: it may be used to construct a theme and its accompaniment, for example, or several forms of the series may be combined in a sequence of chords or a stretch of polyphony. The possibilities are vast; but the serial principle can provide a guarantee that a composition has a degree of harmonic coherence, since the fundamental interval pattern is always the same. Such coherence is not necessarily vitiated by the fact that, in most cases, the workings of serialism in a piece of music are not audible, nor meant to be.

The application of serialism in Webern's later music is clearer and more rigorous than any to be found in Schoenberg's works, so an example from one of his pieces may most readily demonstrate the serial principle in action. The plate opposite shows the opening of his Symphony (1928), arranged to display the serial structure. The music is, typically for Webern, constructed as a four-part canon, each part of which begins with a statement of the series in a different form. It is not difficult to follow how each part of the canon continues with successive serial forms, each new form starting on the final two notes of the last.

Works of this kind are apt to stimulate the accusation that serial composition is somehow mathematical or mechanical, and indeed the method was subject to such attacks from the first. Yet many of Webern's earlier, non-serial works show similarly intricate planning, and a great deal of the polyphonic music from Guillaume de Machaut to Johann Sebastian Bach is no less highly organized. Indeed, Webern was creatively influenced by the Netherlandish polyphonic school of the early sixteenth century.

The opening of Webern's Symphony redrawn to show the four-part canonic structure: the second and fourth lines mirror the first and third respectively, in instrumentation as well as in melodic shape. Moreover, all four lines are related, in that they all use forms of the same basic series.

Anton Webern, the most single-
minded of Schoenberg's pupils in
pursuing serial technique.

Serialism is not a style, nor is it a system. It simply provides the
composer with suggestions, suggestions in many ways less restrictive
than the conventions of diatonic harmony or fugal composition. As
Schoenberg insisted, 'one uses the series and then one composes as
before', which for Schoenberg could only mean 'as the great Austro-
German composers always have done'. Once he had established the
method, Schoenberg found it possible to compose serially with free-
dom, and he rejected the notion that serialism was a constructivist's
dream: 'My works are twelve-note *compositions*', he wrote, 'not *twelve-
note* compositions.'

Schoenberg naturally emphasized the continuity of tradition in
serialism, since it was in order to 'compose as before' that he had
introduced the method. Serialism offered the means by which a return
to instrumental composition was possible, for it was 'an organization,
granting logic, coherence and unity'. In the period between the break-
through into atonality and the emergence of serialism Schoenberg had
written only a few works without words, none after the Six Little
Piano Pieces of 1911. Significantly, the development of the serial
method came about in three almost purely instrumental compositions:
the Five Piano Pieces, the Serenade for septet (with a bass voice in one

Self-portrait in pencil by Schoenberg dating from the early twenties,

movement) and the Piano Suite, all composed between 1920 and 1923. Of these the Suite was the first fully twelve-note serial piece, the others including non-serial movements as well as movements based on series of more or fewer than twelve notes.

But, for Schoenberg it was not enough that serialism provided 'an organization' for the composition of substantial instrumental movements: the new rules must be applied to the construction of forms and textures in the old manner. The daring freedom of rhythm, phrasing, form and orchestration Schoenberg had achieved in his atonal works was now constrained as he returned to composing 'as before': on the plane of structure, indeed, his first serial works are clearer and sharper than anything in his earlier output. In his tonal compositions of 1899–1906 he had attempted new weldings of different movement-types into continuous forms, but now he used the established patterns, if with considerable modifications. The Piano Suite is a suite after the Baroque fashion, and it was followed by a Wind Quintet (1923–4) with the four movements of chamber-music tradition: sonata, scherzo and trio, ternary slow movement and rondo finale.

Schoenberg's 'backsliding', which has often been criticized by later composers, may be accounted for in several ways. In the first place,

serialism had been developed precisely so that a traditional style of composition would again be possible: it is hardly surprising that its arrival should have been accompanied by the resurgence of traditional forms. At the same time, Schoenberg may have experienced the need to escape from the deep psychological self-probing of atonal expressionism, a need both personal and public, for such intense self-examination cannot have been less harrowing for the composer to carry out than it was and is for the audience to witness. Furthermore, lucidity and structural clarity were required if Schoenberg was ever to achieve his aim of showing that atonality could encompass expression of a lighter kind: having found the method he worked hard at displays of musical humour in the Serenade, the Piano Suite, the Suite for septet and the comic opera *Von heute auf morgen* ('From today to tomorrow', 1928–9). He may also have taken up the old forms to prove that he was indeed creating 'twelve-note *compositions*' and to give his audience something familiar in an unfamiliar sound world. Finally, of course, Schoenberg's renewed acceptance of established forms corresponds with the Neoclassicism of Stravinsky and Hindemith: the same irony of stylistic displacement is there, however latent it may remain.

Schoenberg appears not to have recognized this. He was intransigent in his opposition to Neoclassicism, since for him it was irresponsible of a composer to use the old forms and the old materials without concern for a traditional harmonic motivation, whether tonally or serially engendered. While he was forging a continuation of the great tradition, Stravinsky and Hindemith were, in his view, merely dipping into the stock of received musical ideas, and again this was morally indefensible. In his Three Satires for chorus (1925) he attacked both Neoclassicism and its leading proponent: 'Look who's beating the drum – it's little Modernsky! He's got a wig of genuine false hair! Makes him look like Papa Bach – he thinks!' However, showing a breadth of sympathy as characteristic as his high moral resolve, Schoenberg admitted in the preface to his Satires that 'it is certainly possible to make fun of everything. . . . May others find themselves able to laugh at it all more than I can, since I know, too, how to take it seriously!'

The irony of reappropriation in Schoenberg's own works of the early twenties must be assumed, then, to have been unconscious, or at any rate less conscious than it had been in *Pierrot lunaire*. And with succeeding years the distancing lessened. The Third String Quartet (1927) and the Orchestral Variations (1926–8) show a more intimate liaison

Schoenberg's autograph of the beginning of his Piano Suite, the first work in which
he used twelve-note serialism throughout. This is freer, more dramatic music than
Webern's, being based on the perpetual development of small motifs.

between form and content, a decreased obedience to models of the past, and this was a developing tendency in Schoenberg's serial works of the thirties and forties: again there is a parallel with Stravinsky and the greater smoothness of most of his later Neoclassical scores.

In the early thirties, however, Schoenberg created two works which, whether he realized it or not, show how far he had travelled from the tradition he held dear. Both are arrangements, the Cello Concerto after a harpsichord concerto by the mid-eighteenth-century composer Georg Matthias Monn and the String Quartet Concerto after a concerto grosso by Handel. But in both Schoenberg goes a long way beyond simple orchestration, 'improving' the originals with elaborate redevelopment, adding contrapuntal detail, updating the harmony to that of Brahms and providing brilliant instrumentation. The spirit of *Pulcinella* is not far away.

These recompositions led Schoenberg back to composing original tonal works again, and for the rest of his life he continued occasionally to write pieces somewhat in the style of his First Chamber Symphony, a style which he regretted having abandoned so swiftly. He also belatedly completed the Second Chamber Symphony which he had begun soon after the first, in 1906. This simultaneous cultivation of different styles was the action of a man more reactionary than radical, a man who perhaps needed to assure both his audience and himself that he could still compose in the old style, a man who, quite simply, sometimes had good diatonic ideas which he wanted to work out. It was not a case of adopting different masks in the manner of Stravinsky, for both his tonal and his serial style belonged completely to him, and the choice of style was dictated solely by the nature of the musical idea.

Schoenberg, perhaps more than any other artist, recognized the weighty problems involved in being true to an idea, of avoiding corrupting the initial conception in its artistic realization. That, though he himself denied it, can be seen as part of the matter of his opera *Moses und Aron* (1930–32). Here Moses is the man gifted with a vision, that of the unfathomable Jewish God, but he lacks the verbal skills to communicate that vision to his people. Aaron can make the vision known and acceptable, but only at the cost of compromise with what the people expect: wonder and spectacle. The metaphor is, however, more deeply religious and philosophical in meaning. Beyond the problem of communication the opera is about finding a way to God through obedience, prayer and steadfast commitment to truth. Schoenberg completed the work's text and the music of the first two

'The Dance around the Golden Calf' from Schoenberg's opera *Moses und Aron* in the Covent Garden production by Peter Hall. This orgiastic sequence of dance, song and mime takes up a large part of the opera's second act.

Moses and Aaron in the Covent Garden production of Schoenberg's opera.

acts, but the third remained unset, despite repeated attempts and statements of intention. Perhaps he felt himself unable to compose adequate music for Moses' final declaration of the ultimate goal, 'unity with God': *Die Jakobsleiter*, which Schoenberg also always hoped to finish, was left incomplete with the argument at a similar stage.

The whole of *Moses und Aron* as it stands, nearly two hours of music, is based on a single series, used with the mastery of variety foreshadowed in the recent Orchestral Variations. In a sense serialism was the most appropriate possible technique for the opera, since the series is an idea which can be represented in music only partially, its possible forms being infinite, just as Jehovah is infinite: the voice in the burning bush, heard at the beginning of the work, is only one representation of him. This Platonic view of the series may not have been in Schoenberg's mind, but it certainly appealed strongly to Webern.

Unlike Schoenberg, Webern had continued to compose atonal works after the crisis years of 1910–14, though his output had been limited to songs, usually with accompaniments for a few instruments. In this form his vulnerable lyricism, his delicate counterpoint and his improvisatory feel for melody, rhythm and instrumentation had come to full development, particularly in the Six Trakl Songs for voice with pairs of clarinets and strings (1917–21). When he took up the serial method, the first composer after Schoenberg to do so, his style changed very little initially, though like Schoenberg he found that he could now return to instrumental composition. His first important instrumental piece for thirteen years was the String Trio (1927), and the great change in his style came after this work, with the Symphony.

Here Webern's music suddenly becomes lucid and closely controlled, its textures canonic, its forms clear and symmetrical. It is as if he had recognized in a belated flash the capacity of the series for assuring a coherence more all-embracing even than that which had been achieved by the sixteenth-century polyphonists he so much admired. Like a plainsong fragment in a Josquin mass, the series could be endlessly reinterpreted; and as a prescription for a work it was still more complete. Webern understood the series as a 'law': in one of his letters he writes of his compositional processes and then notes that the Greek *nomos* means both 'law' and 'melody'. As a law, as an ideal ordering of the chromatic universe of sound, the series could give rise to an abundance of coherently related shapes, just as the laws of ice structure can generate a whole variety of similar but different snow crystals. Webern expressed this in writing of his late Orchestral Variations: 'six notes are given . . . and what follows . . . is nothing

Drawing of Webern by Hildegard Jone, who provided Webern with texts for all his later vocal works. The musical extract is from one of those works, the Second Cantata (1941–3).

other than this shape over and over again!!!' (six notes and not twelve, since the series itself is symmetrical in this work, as in most of Webern's pieces from the Symphony onwards). For Webern the series was an instance of Goethe's 'prime phenomenon', 'ideal as the ultimate recognizable thing, real when recognized, symbolic, since it embraces every case, identical with every case'.

Unlike Schoenberg and Berg, Webern never returned to non-serial composition nor broke the rules. If anything, he made them more restrictive with his symmetries within the series. The resulting limitation of interval content strengthened the harmonic coherence of a work, while the symmetries made his series particularly appropriate for the imitative textures and mirror forms in which he delighted. In the Symphony the canonic first movement is succeeded by a palindromic set of variations, and similarly tight forms exist in most of Webern's late works. They arose in part from his desire to emulate the perfect forms of flowers and mineral crystals; as he wrote, 'between the products of nature and those of art no essential difference prevails'. But his

A detail from Webern's sketches for his Concerto. The work's series is written out at the top; then come two of several attempts to make musical use of the series, the first scored for flute, celesta, harp and glockenspiel, the second for clarinet, trumpet, harp and flute.

The opening of Webern's Concerto > as it finally emerged. The passage sketched opposite is now scored for flute, oboe, clarinet and trumpet.

approximation to nature was not just a matter of form: the cool colour and the limpidity of Webern's late music suggests the ambience of the Austrian Alps he loved, and there is support for the connection in his sketchbooks. Against a projected concerto movement, for example, he writes: '(Dachstein, snow and ice, crystal-clear air, cozy, warm, sphere of the high pastures) – coolness of the first spring (Anninger, first flora, primroses, anemones (hepatica, pulsatilla)).'

From a different perspective, however, Webern's precise forms and textures can be seen as products of Neoclassicism. With Schoenberg he had returned to structural models from the past, even if he often combined them in his own closely knit forms: one movement from his First Cantata he described as 'a *scherzo form* that came about on the basis of *variations*, but still a *fugue!*' His Concerto for nine instruments (1934) is a twentieth-century Brandenburg, and the two cantatas,

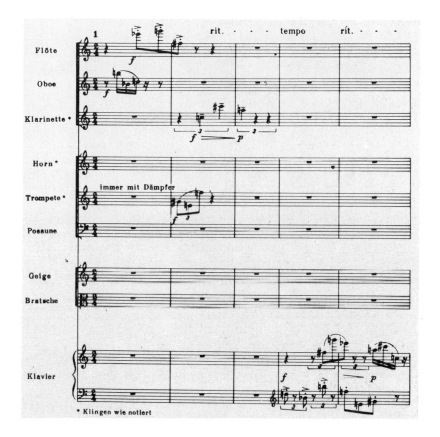

though he likened the second to a Renaissance mass, have much in
common with the church cantatas of Bach, piety included. It is the
radical newness of Webern's style that makes his Neoclassicism unob-
trusive, as unobtrusive as that of Bartók, who was at the same time
adapting Baroque devices in the construction of symmetrical forms.
Very different though their styles were, Webern and Bartók stood
apart from their Neoclassical contemporaries in the integral related-
ness of their music.

Webern's fellow student Berg took to serialism less readily and
never with anything like Webern's strictness. Moreover, his first serial
essay, a song, was on a series containing all the eleven possible inter-
vals, not one with Webern's symmetries and consequent restrictions.
Having proved to himself that he could use the method, Berg went
on to use the same series for his Lyric Suite for string quartet (1925–6)

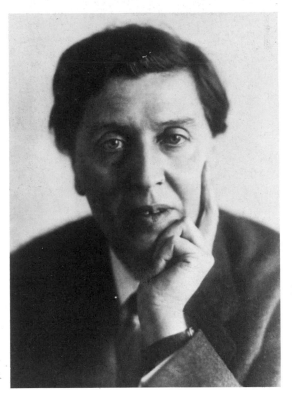

Berg at the time of his
first major serial work,
the Lyric Suite for
string quartet.

Scene from Berg's >
opera *Lulu* (Zurich,
1963).

and then set about writing a second opera. He decided to make his own conflation from the two Lulu plays of Frank Wedekind, in which the central character is a pure animal woman who, without her willing it, leads all she attracts to their doom.

Berg's letters to Schoenberg and to Webern indicate that he found serial composition slow and arduous, but he discovered his own way forward by a complex and unorthodox development of the method, working with several different but related series and combining serial operations with the rich tonal harmony which had never been wholly absent from his music. These techniques were adumbrated in the Lyric Suite, where serial and non-serial movements are united by the pervasive, ominous weight of tonal infiltration. In the opera *Lulu* the effect of Berg's half-tonal serialism is an over-ripe schmalzy quality, to which the sounds of saxophone and vibraphone add a contemporary decadence.

Work on *Lulu* was interrupted while Berg wrote two works to

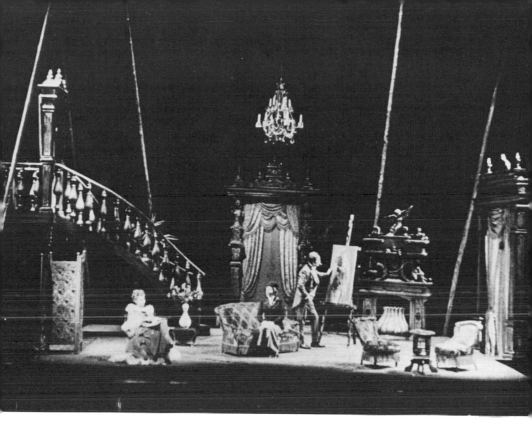

commission: the concert aria *Der Wein* for soprano and orchestra (1929), which surrounds three poems of Baudelaire with cabaret-tinged music in the manner of the opera, and the Violin Concerto (1935). This last work of Berg's, subtitled 'to the memory of an angel', was composed as a sort of requiem for the eighteen-year-old daughter of Mahler's widow, and here again Berg used the series to gather in the potentially sprawling anarchy of his Mahlerian harmony, just as he had used intricate formal schemes and numerology to avoid the structural collapse which threatens all his works. His atonal Chamber Concerto for piano, violin and thirteen winds, for instance, is full of triple formations, intended to pay homage to the trinity of the Second Viennese School. If such musical games supported Berg's form, they cannot be said to have limited his expressiveness; rather they seem to have been essential to it. The traditional forms used in the Lyric Suite act to contain and enhance psychological developments, as in *Wozzeck*: indeed, the piece was described as a 'latent

opera' by Theodor Wiesengrund-Adorno, the philosopher-musician who took a deep interest in the work of Schoenberg and his pupils, and Berg himself said that it expressed 'a submitting to fate'. Like almost all of his music since *Wozzeck*, the Lyric Suite appears to have been a preparation for the second opera, just as his earlier works seem to have laid his path towards the first. At his death, however, the third and final act of *Lulu* remained unfinished.

While Berg was working on his late serial-tonal compositions, Schoenberg was keeping the two styles separate; but later he did try various kinds of combination, if never with Berg's indulgent opulence. In the *Ode to Napoleon Buonaparte* for Sprechgesang vocalist, piano and string quartet (1942) he adjusted the rules of serialism to admit frank references to E flat major, the key of Beethoven's Napoleonic 'Eroica' Symphony, and in the Piano Concerto (also 1942) he chose a series which would allow certain approximations to diatonic harmony. He seems to have recognized that serialism did not after all guarantee what he had hoped for, a harmonic ordering as coherent and as versatile as that provided by the major–minor system. Webern had overcome the problem by a close restriction of harmony, Berg by retaining a hold, however uncertain, on tonal practices. Yet neither of these solutions appealed to Schoenberg: the first was too limiting, the second too abandoned. And so he went on in search of his own answer. In his Violin Concerto and Fourth Quartet, both completed in 1936, he tried to establish serial analogies for diatonic functions, and in his String Trio (1946) he produced an astonishing serial return to the wildly varied style of his expressionist works, where emotional vehemence had rendered less vital the need for harmonic coherence. Yet on his death his call was for what had eluded him: 'Harmony! harmony! . . .'

Schoenberg in later life. He returned in these last years to the moral and religious issues of man's relationship with God which he had tackled in *Die Jakobsleiter* and *Moses und Aron*, both works which he was unable to complete.

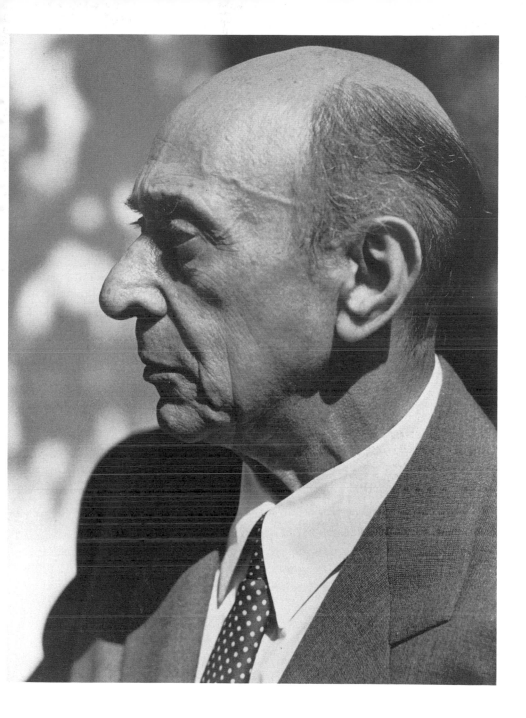

The modern world

'Supposing times were normal', Schoenberg once wrote, ' – normal as they were before 1914 – then the music of our time would be in a different situation.' Of course, the modern movement in music had begun before the first world war, in those few years after 1908 when Schoenberg had begun composing without theme or tonality, when Stravinsky had introduced a new conception of rhythm, and when similarly radical departures had been made by Debussy, Bartók, Berg and Webern. But these revolutions had come about on the basis of tradition, as extrapolations of tendencies already present in western music. After the war things were indeed different. Neoclassicism, in its eclecticism and its irony, demonstrated how severe was the break with the past which the earlier revolutions had made, and even Schoenberg's late tonal works, heavy with nostalgia, looked to an age irrevocably lost.

For some, however, the cut was to be welcomed: a new music was needed to voice the new age. Again, this attitude had surfaced in that period of artistic upheaval immediately before the war, present in the music, but more particularly in the manifestos, of the composers associated with the Italian artistic movement of Futurism. Marinetti's initial statement of 1909 – '. . . a roaring motor car . . . is more beautiful than the Victory of Samothrace . . .' – was followed by equally bold resolutions on musical revolution by the Futurist musicians. By 1913 even Debussy was echoing the sentiment: 'Is it not our duty', he asked, 'to find a symphonic means to express our time, one that evokes the progress, the daring and the victories of modern days? The century of the aeroplane deserves its music.'

Luigi Russolo (1885–1947), the most persistent and influential of the Futurist composers, also called for a music that would relate to the sounds and rhythms of machines and of factories, an 'art of noises' which must be strident, dynamic and eagerly in tune with modern life. To this end he built a number of 'intonarumori' (noise intoners), which were mechanical contraptions designed to produce a variety of

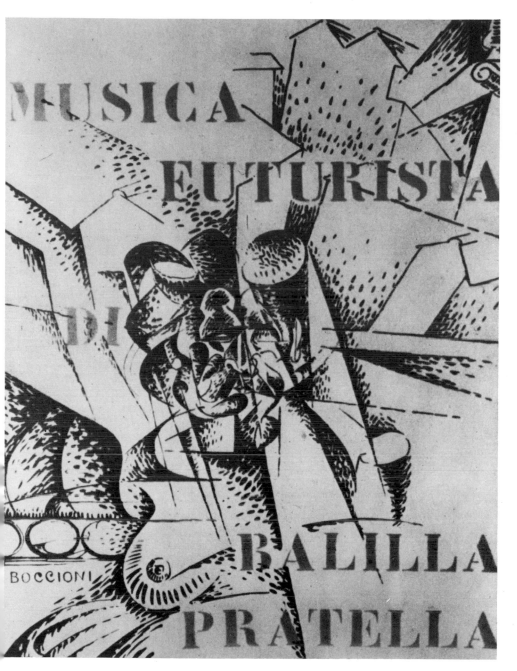

Front cover designed by Boccioni for one of the few published Futurist works, Pratella's orchestral *Musica futurista* (1912).

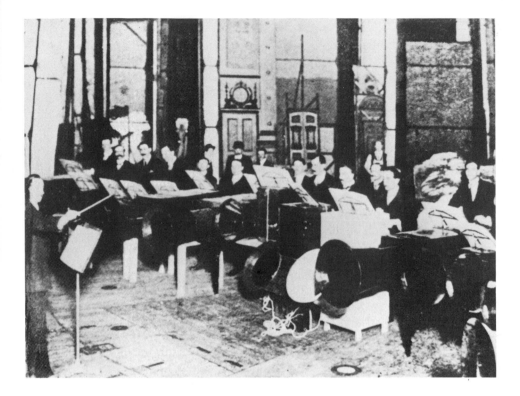

exploding, crackling, rubbing, buzzing noises. They were demonstrated in Italy and in London before the war, but it was not until they had been exhibited in Paris, in 1921, that they began to receive wide and serious attention, not least from Stravinsky, Honegger and Varèse. Russolo was not, however, a trained musician – he had begun his Futurist activities as a painter – and his compositional expertise seems not to have matched his ideas. He continued his experiments until around 1930 but then lost interest and left his machines in Paris, where they were destroyed during the second world war. All that was to remain of his endeavours was a single, scratchy 78 rpm record.

A decisive fresh start had, however, been made, and 'machine age' music was soon all the rage, particularly in Paris. George Antheil (1900–59), an expatriate American, caused a sensation there in 1926 with his *Ballet mécanique*, scored for the bizarre forces of eight pianos, eight xylophones, pianola, two electric doorbells and aeroplane propeller. Honegger's *Pacific 231* of 1923, an orchestral picture of a moving locomotive, was another Parisian offshoot of Futurism,

RUSS
SSOLO
l'Intonaruma

Boccioni

< Russolo conducting his 'intonarumori'
in a concert at the London Coliseum on
15 June 1914.

Luigi Russolo; caricature by Boccioni
dating from 1912.

though in the terms of a symphonic poem for conventional orchestra, and there is perhaps some Futurist influence to be detected in Stravinsky's percussion scoring of the quite un-Futurist *Les noces*.

In the new Soviet state, too, Futurist ideas reached those composers who were allied with the Constructivist movement and who could defend their aesthetic stance as one of allegiance to the urban proletariat. The factory ballet *Steel* by Alexandr Mosolov (b. 1900) was only the most celebrated of many attempts to create appropriate music for a workers' state of new hope and determination. Back in Paris, the vigour of the young Soviet Union was celebrated in Prokofiev's ballet *Le pas d'acier* ('The steel step'), produced by the Diaghilev company in 1927, and it was this work that best proved the power of Parisian-Soviet modernism.

However, the man who most profitably followed up the Futurists' delight in urban sounds was Edgard Varèse (1883–1965). Trained in Paris, he had had his musical horizons broadened by contact with artists in Berlin. He had been able to introduce Schoenberg's music to

Debussy, and he had been closely acquainted with Busoni, whose *Sketch for a New Esthetic of Music* probably had more influence than the Futurists on his revolutionary ideas. In 1915 he emigrated to the USA, leaving behind most of his works, which were subsequently lost or destroyed, but taking with him Busoni's ideas and the recent experience of *The Rite of Spring, Jeux* and Schoenberg's Five Orchestral Pieces. And with him the centre of the most radical new music moved from Europe, which had seen the premières of these three scores in 1912–13, to New York.

Varèse's first American composition, a piece for an orchestra of 142 players, was called *Amériques* to signify its affirmation of 'new worlds on the earth, in the sky, or in the minds of men'. Though bearing traces of Stravinsky, Debussy and Schoenberg, it was a strikingly new contribution, a work of gargantuan cumulative energy yet with gentler echoes, a melt from which Varèse was to extract ideas and possibilities for his later works. Above all, the power and fascination he had discovered in the percussion was to continue to occupy him. In the elaborate percussion writing of *Amériques* he was perhaps following the example of Russolo, but he did not build his own instruments and he was critical of the Italian's reliance on coarse imitations of everyday noises. For him the percussion brought dynamic force, emphatic attacks and the means to create a rhythmic framework beneath the bolder sounds of woodwinds and brass. And in his *Ionisation* (1929–31) he created one of the first western works for percussion alone.

The immediate successor to *Amériques* was, however, a five-minute concentration of his new techniques in *Hyperprism*, scored for a small orchestra of two high woodwinds, seven brass and several percussion players. This instrumentation is characteristic: Varèse disliked string instruments, preferring the urgent penetration of woodwinds in the top register, the splendour of brass and the propulsive power of percussion. Equally characteristic is the streamlined quality of the piece. *Hyperprism* is, like the post-Futurist works of Soviet and Parisian composers, a product of the urban milieu; but though there are references to the sounds of the city, most obviously in the use of a siren, the piece achieves its effect more by reflecting than by representing the speed and brusque vitality that New York in the twenties must have presented to a man brought up in provincial France before the coming of the motor car.

Hyperprism caused an uproar at its first performance, which took place in New York in 1923, but there is no reason to suppose that Varèse was being deliberately provocative in the manner of the

Edgard Varèse; silverpoint drawing by his friend Joseph Stella dating from 1921. In that year Varèse completed his first work written in New York, the orchestral *Amériques*.

Futurists. His startling sounds were meticulously planned and shaped; there is finesse even in his ferocity. As for the pseudo-mathematical title, certainly that was intended as a bald declaration that a new age in music was beginning, an age of scientific impulse to contrast with the pastoral and literary evocations of Romanticism. But Varèse foresaw the new era as one of sophistication, not barbarism, when music might benefit from technological advance and keep pace with scientific thought. Undoubtedly he was seduced by the magic and mystery of science; he had more sympathy with the late-medieval necromancer Paracelsus, from whose writings he took an esoteric inscription for his second large orchestral work, significantly entitled *Arcana*, than he had with Einstein, who only wanted to talk to him about Mozart. Nonetheless, he did recognize that technology had a great deal to offer the creative musician, and he kept pressing for new, versatile sound-generating machinery.

He had been doing so, indeed, ever since his arrival in America, and in 1939, after contacts with acousticians, electronics engineers and instrument builders, he was able to make an astonishingly far-seeing

Front cover of the first edition of Varèse's *Hyperprism*. Its première in New York had provoked outrage, but the London publisher Keith Curwen had been sufficiently impressed to accept it into his catalogue.

prediction of the possibilities: 'And here are the advantages I anticipate from such a machine: liberation from the arbitrary, paralyzing tempered system; the possibility of obtaining any number of cycles or, if still desired, subdivisions of the octave, consequently the formation of any desired scale; unsuspected range in low and high registers, new harmonic splendours obtainable from the use of sub-harmonic combinations now impossible, the possibility of obtaining any differentiation of timbre, of sound-combinations, new dynamics far beyond the present human-power orchestra, a sense of sound-projection in space by means of the emission of sound in any part or in many parts of the hall as may be required by the score, cross rhythms unrelated to each other, treated simultaneously . . . – all these in a given unit of measure or time which is humanly impossible to attain.'

By the time of this statement several electrical sound-producing machines had been constructed, and Varèse followed their

Léon Thérémin (left) giving an early demonstration of the electronic instrument which he developed in 1924. Its sound production was controlled by movements of the hand around the upright pole.

development with interest, though their capacities still fell a long way short of his needs. The pioneer here was Thaddeus Cahill, a Canadian scientist who demonstrated an extraordinarily bulky 'telharmonium' in 1906: it was this machine that stimulated Busoni's hopeful prognosis for electronic music. Not for another two decades, however, did any useful instruments appear, and then there were three rivals: the 'aetherophone' or 'thérémin' developed by the exiled Russian Leon Thérémin, the 'ondes martenot' of the Frenchman Maurice Martenot and the German Friedrich Trautwein's 'trautonium'. Hindemith wrote a concertino for trautonium and orchestra in 1931, and Varèse used two thérémins or ondes martenots in his *Ecuatorial* of 1934, where they add intensity to the imprecatory demands of a Maya incantation set for bass voices, brass, percussion and organ. Both Hindemith and Varèse were at the same time investigating how the gramophone record might become a creative medium, enabling the composer to synthesize electronic music directly, without instruments of limited capacity and dependent on human skills. But advances in that direction would have to wait until the tape recorder had become available after the second world war.

Even if there were more electrical instruments than composers with an active interest in writing for them, Varèse was not alone in making radical departures, certainly in New York. In the twenties and thirties the city was the scene of musical innovation on all fronts. The music of Ives was beginning to be known, and new compositions could be heard at the concerts of Varèse's International Composers' Guild or those of the League of Composers, at Stokowski's evenings with the Philadelphia Orchestra or at the Copland–Sessions Concerts. Young composers could express their ideas in the journal *Modern Music*, receive encouragement from the critic Paul Rosenfeld and have their scores published in the New Music Edition run by Henry Cowell (1897–1965).

Cowell was a central figure in what became known, in approval or castigation, as 'modern' or even 'ultra-modern' music. While still a boy he had shown an unconstrained experimental approach to composition, such piano pieces of his as *The Tides of Manaunaun* (1912) asking the performer for the first time to play clusters, i.e. large groups of adjacent notes depressed with the fist, palm or forearm. He soon went on to explore the inside of the piano, requiring the player to pluck, brush or beat the strings directly in his *Aeolian Harp*, *The Banshee* and other similarly ethereal works. Then, in several compositions of the early thirties, he began to call for free improvisation, to

Henry Cowell towards the end of his life. He was responsible for stimulating experiment in American music and for numerous innovations in his own enormous output.

present scores in which musical segments might be ordered at will by the performers (as in his *Mosaic Quartet* for strings) and to demand extremely complex rhythmic coordination among the musicians of an ensemble. For the combination of unrelated rhythms he invented a keyboard percussion instrument, the rhythmicon, which Thérémin built for him, and all the time he continued to work energetically on behalf of new music as publisher, propagandist and writer, bringing together his compositional discoveries in his book *New Musical Resources* (1930).

Among the composers published in Cowell's New Music Edition were Ives, Schoenberg and Webern, the music of the American pioneer now coming as a confirmation of radical experiment rather than exerting any great influence, while the Europeans could be taken as examples in a manner that would have surprised them. The most Schoenbergian of the New York composers was Carl Ruggles (1876–1971), with his tough exercises in dissonant counterpoint. Yet his heroic statements, such as *Suntreader*, have a pounding energy that

is very American, and even his sinuous polyphonies are not developed at anything like Schoenbergian length. Quasi-serial methods were used by Ruth Crawford Seeger (1901–53), notably in her String Quartet of 1931, but again the results are quite un-European: hers is music of abstract speculation, sometimes contained in rhythmic structures arising from numerical patterns. The New Music Edition published both Crawford Seeger's Quartet and Ruggles's *Suntreader*, and it also had room for energetic Latin American scores, such as *Ritmicas* for percussion ensemble by the Cuban Amadeo Roldán (1900–39).

One of the principal virtues of the New Music Edition was its lack of exclusivity, and in this it stood for Cowell's approach to music. Varèse saw himself as the torchbearer of a new period in music, a new kind of composition which might draw some sustenance from the past (medieval and Baroque music, Berlioz and recent predecessors in his case) but which was essentially new and expressive of his own times – so new, and so scientific, that the term 'organized sound' was to be preferred to 'music'. Cowell was not at all so concerned with progressive polemics. For him music was now an open field where any resource, any experiment, any tradition (including, most definitely, exotic and ethnic traditions) might prove of value. Such an easygoing, open-minded attitude seems to have been a product of the West Coast, for it was shared by Cowell's fellow Californians Harry Partch (1901–74) and John Cage (1912–92).

Partch abandoned traditional composition in 1928 for a hobo existence, building his own instruments, often from found objects, and tuning them to a scale of forty-three notes to the octave in just intonation (as opposed to the conventional acoustic approximation of equal temperament). This made it possible for him to use exact intervals, and the effect is something strange and pure. Partch took issue with almost all European music since the Renaissance, propounding a philosophy of music as a 'corporeal' art, a physically involving experience of sound, word, myth and action. Dance and drama entered into his work, particularly in the larger pieces he went on to compose in the fifties and sixties, and the sight of musicians performing on his weird and beautiful instruments was meant to contribute to the deliriously exciting effect.

Cage's disregard of tradition was as complete as Partch's. He would have received encouragement towards being naïve and open from his lessons with Cowell, perhaps less from those he had with Schoenberg, now, in the mid-thirties, a refugee in Los Angeles. Schoenberg's verdict was plain: 'He's not a composer, he's an inventor – of genius.'

The opening of John Cage's autograph of his *Imaginary Landscape no. 1* for players on electronic frequency recordings (1 and 2), percussion (3) and prepared piano (4). Copyright © 1960 by Henmar Press Inc.

Among the works Cage invented before the second world war were several for a small percussion orchestra he directed himself, among them his *First Construction (in Metal)*. In this medium he could most readily pursue his main interest of the time, which was in rhythmic structuring, in building forms from numerical patterns of sound and silence. The result is something like the music of the gamelan, the Balinese percussion orchestra, and quite unlike the dynamic, asymmetrical percussion music of Varèse, whose ideas on the emancipation of noise and the development of electronic music Cage was echoing.

In 1938 Cage discovered that he could produce a percussion orchestra under the control of two hands by applying foreign objects, generally of rubber, metal, wood or paper, to the strings of a piano. This 'prepared piano' then offered a wide range of percussive sounds instead of the usual tones. Moreover, the instrument allowed the composer to make empirical adjustments to his timbres during the course of composition: for the first time he could experiment at first hand with sounds in a way that was to become commonplace in the electronic studio. In 1939 Cage went further and created the first composed piece for electrical reproduction apparatus, his *Imaginary Landscape no. 1*, in which musicians have to perform with frequency recordings on variable-speed turntables.

While Cage and his American colleagues were thus exploring new musical resources between the wars, composers in Europe were making a generally more tentative response to the challenge of writing music for the modern world. Conscious of tradition, they could not be modern in the manner of Varèse or Cowell, but they could at least be contemporary. They could draw on the brash vitality of popular music, especially jazz; they could take their subject matter from modern life; or they could make their music serve current social and political purposes.

The exciting rhythms and bright clean instrumentation of twenties jazz offered a new freshness and, as some composers thought, an immediately recognizable and accepted set of conventions to replace the outworn rules of diatonic harmony. Stravinsky had led the way with his *Rag-time* of 1918, composed before he had heard any of the music he was imitating. In the next decade, when the jazz vogue reached its height in Europe, there came a stream of derived works from serious composers, and some not so serious. Poulenc seized on the opportunities a vulgar form presented to satirize convention or to cause a jolting double-take, while Milhaud, in his sleazy jazz ballet *La création du monde* (1923), took advantage of the earthy force in Afro-

Stage design by Léger for Milhaud's ballet *La création du monde*.

American music. Ravel wrote a blues movement for his Violin Sonata (1923–7) and welcomed a swing sound in his Piano Concerto in G (1931). Indeed, no Parisian composer could afford to ignore the new wind from the west, and it was not long before the Americans themselves were following suit, though their jazz works were to be more direct, ebullient and unreserved. Copland's 1926 Piano Concerto displays all the exuberance of American art-jazz composition, and Gershwin, in his *Rhapsody in Blue* of 1924, reached a similar style from the other side.

Jazz even entered the opera house, most famously in *Jonny spielt auf* (1925–6) by Ernst Krenek (1900–91). Krenek, like many European composers of his generation, had shown himself able to change his style at will, from post-Mahlerian symphonism to Neoclassicism (and later to a revival of Schubertian lyricism); now, in *Jonny*, he added jazz to his store of Classical and early Romantic artifice. The work caught the public mood, and within a few years it had been played in almost a hundred cities from New York to Leningrad. Its success was owed as much to its up-to-date subject and staging as to its musical style: the

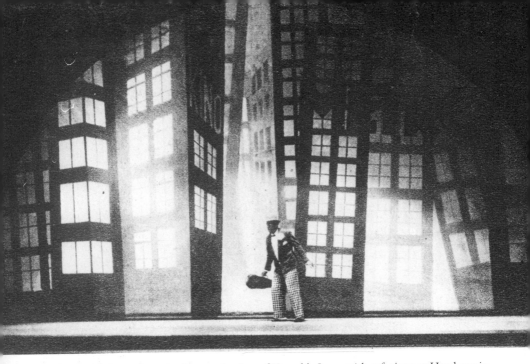

Scene from the first production of Krenek's *Jonny spielt auf*, given at Hamburg in 1927.

last scene, for instance, takes place in a railway station with a train on stage. The story, an invention of the composer's, is significant of the times in showing the European artist's yearning after the untroubled naïvety of the American jazz musician, his easy vitality and his ability to make his way in the modern world. America, which Krenek had never visited, was for him a dream environment where a composer might create unburdened by tradition. The very few concerts of American music in Europe between the wars can only have confirmed that vision.

Jonny was just one example of the Austro-German 'Zeitoper', or opera with an alive, contemporary subject. The assiduous German opera-goer of 1929–30 might have attended the first performances of several such works: Hindemith's *Neues vom Tage* ('Daily News'), a story of newspaper rivalry, Max Brand's *Maschinist Hopkins*, and Schoenberg's *Von heute auf morgen*, which typically sets the genre against itself and so pokes fun at the whole notion of keeping up to date, taking the form of a satirical comedy of contemporary manners.

Another novelty of the 1929–30 season was *Aufstieg und Fall der Stadt Mahagonny* ('Rise and fall of the city of Mahagonny'), with words by Bertolt Brecht and music by Kurt Weill (1900–50). For them, engagement with modern life was a more serious matter, one of political importance. 'Opera', Weill wrote, 'will be one of the essential factors in that universally apparent development which is heralding the coming liquidation of all the bourgeois arts. . . . It must . . . turn to the areas of interest of that wider audience toward which the opera of the immediate future must be directed if it is to have any kind of *raison d'être*. . . . The absence of inner and outer complications (in the material and in the means of expression) is in keeping with the more naïve disposition of the modern listener.' *Mahagonny* is thus a parable of modern society, a work in which the bitter, commercialized sounds of jazz hold no freedom but instead stand as a metaphor for the corrupt condition of the capitalist state.

Weill was not the only musician with whom Brecht worked: he also had dealings with Hindemith, though the collaboration was brief, since Hindemith's concerns were more social than political. He placed

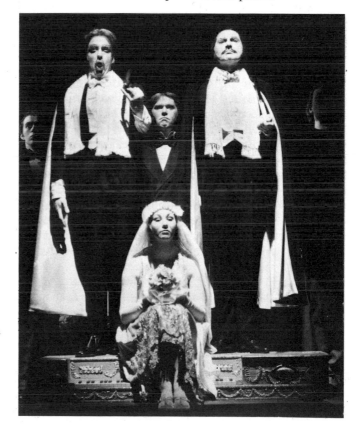

Scene from *Die Dreigroschenoper* ('The threepenny opera', 1928), which was the first stage work on which Weill worked with Brecht. The text was adapted from Gay's *Beggar's Opera*.

Bartók aboard the S.S. *Escalibur* on his way to settle in America, October 1940. Copyright G.D. Hackett, NY.

his art at the service not of a political party but of the musical amateur, composing a great deal of 'Gebrauchsmusik' (music for use) in the form of simple chamber works; didactic pieces, school music and so on. The most politically committed musician in Weimar Germany was Hanns Eisler (1898–1952), and he became the closest, most long-standing of Brecht's collaborators. His party affiliation was deplored by his teacher Schoenberg, but he went on producing an enormous output of songs, choruses, theatre music and film scores, most of them declaredly political in intent and militant in feeling. In the last years before Hitler's accession to power, and again after the war in the new German Democratic Republic, he established agit-prop music as a forceful demonstration of the composer's involvement in contemporary life.

The shape that involvement should take was a matter of controversy in the USSR. Lenin's requirement that art 'must unite the feeling, thought and will of the masses, inspire them' was difficult to interpret, and there existed no precedent, at the time when the Soviet state was in its youth, for music of an expressly political motivation. In the twenties there were two rival views on what should be the music for the Russian masses, views represented by the Association for Contemporary Music and the Russian Association of Proletarian Musicians. The ACM stood for the independence of the artist, his freedom to explore the newest techniques, and its members included such men as the serialist pioneer Roslavets and the sub-Futurist Mosolov. The RAPM was opposed to anything which might not appeal directly to the worker or peasant, and so they placed the emphasis on lusty songs for massed chorus.

Shostakovich, the brightest young composer in the new republic, belonged to the ACM camp, and his works of the mid-twenties, such as his First Symphony and his opera *The Nose*, show a lively awareness of what was being achieved in the west by Prokofiev, Hindemith, Bartók, Krenek and others. In 1931, however, the RAPM came out on top, and though its dominance lasted only a year, the establishment of its successor, the Composers' Union, brought official endorsement of the anti-ACM aesthetic of 'socialist realism'. Composers were obliged to be 'optimistic'; they were to shun 'formalism', by which was meant the use of almost any technique originating in the twentieth century; and their work was to be instructive or inspiring in a social or political sense. The official removal from the stage of Shostakovich's taut psychological opera *The Lady Macbeth of the Mtsensk District* in 1936 came as a sign and a warning that modernism, even of a mild kind, was not to be tolerated.

It is ironic that at the same time in Nazi Germany any adventurous contemporary music was being banned as 'bolshevist'. The new phenomenon of state interference soon resulted in the more or less permanent exile of many composers from the Soviet Union and from Nazi-dominated Europe, so that by the early forties the USA, which had seen the furthest developments of musical modernism between the wars, had gained almost all the leaders of contemporary music in Europe: Stravinsky, Schoenberg, Bartók, Hindemith, Eisler, Krenek, Weill. Under the conditions of war and enforced removal, however, the effect could not be the release that Krenek had hoped for.

To the east

If there were to be a new release in music, it would come not from the west but from the east. Musical orientalism has a long history – most of the standard western orchestral instruments can be traced back to Arab sources – but as far as modern music is concerned the trend has its origins, again, in Debussy's *Prélude à 'L'après-midi d'un faune'*. In 1889, three years before he began work on that composition, Debussy had been greatly impressed by the eastern music he heard at the Paris Exhibition. It is possible that the melodic arabesque of the *Prélude* owes something to that experience; certainly Debussy used quasi-oriental scales and rhythms in the piano piece 'Pagodes' (1903) and later works. At the same time the east became the object of longing regard for many other composers, particularly in France. Ravel, in his orchestral song cycle *Shéhérazade* (also 1903), expressed this feeling to the words of Tristan Klingsor: 'Asia, Asia, Asia! Old and marvellous land of nurses' tales where fantasy sleeps as an empress in her forest full of mystery!'

The tide of exoticism in the arts was encouraged, from 1909 onwards, by the annual appearance of Diaghilev's Russian Ballet in Paris, for the company's first great successes were tales of eastern splendour (such as *Shéhérazade*, danced to Rimsky-Korsakov's symphonic poem) or Russian fairy-tale magic, like Stravinsky's *Firebird*. Albert Roussel (1869–1937) created in his opera-ballet *Padmâvatî* (1914–18) a spectacle of music, drama and dance set in ancient India, and Puccini responded to the public mood, by now international, in his last opera *Turandot* (1924). As yet, however, no composer had made a serious study of eastern music, nor done much more than apply oriental features to works of western form and style.

Things began to change in the thirties, when the music of the east started to become more widely and thoroughly known through recordings and the reports of musical ethnologists. Perhaps, too, a certain lack of confidence in the continuing strength of the western tradition – a lack of confidence notably expressed in Neoclassicism – had

Costume design by Bakst (1910) for Fokine's ballet to Rimsky-Korsakov's *Schéhérazade*.

a part in encouraging a more whole-hearted and searching investigation of alternatives. The American composer and musicologist Colin McPhee (1901–64) spent several years in Bali studying the music of the gamelan and using what he learned in his own compositions; and the same music, with its incessant rhythmic patterning and metal percussion orchestration, had a strong influence on Cage in his pieces of the late thirties and forties for percussion ensemble or prepared piano.

Cage's work with unpitched sounds in these pieces led him naturally to use rhythmic rather than harmonic means of construction, for there could be no harmony where there was no pitch. He came to the conclusion that rhythmic structuring was even to be preferred as a method, since duration is the most fundamental musical characteristic, shared by both sound and silence. 'It took', he wrote, 'a Webern and a Satie to rediscover this musical truth, which, by means of musicology, we learn was evident to some musicians in our Middle Ages, and to all musicians at all times (except those whom we are currently in the process of spoiling) in the Orient.' Satie had used number schemes to prearrange durations in composing some of his pieces, and Webern had exposed the significant possibilities of silence; but only in the east could Cage find fully developed musical traditions in which rhythmic pattern was the prime structural feature.

Other American composers were also turning their attention to oriental music. Partch could find there models of integrated musical-dramatic creation, and Cowell was beginning a musical exploration that would lead him to use instruments and musical principles from as far afield as Japan, India and Persia. For Cage, however, the interest soon became more than aesthetic. In his most ambitious work for prepared piano, the Sonatas and Interludes (1946–8), he 'decided to attempt the expression in music of the "permanent emotions" of Indian tradition: the heroic, the erotic, the wondrous, the mirthful, sorrow, fear, anger, the odious, and their common tendency toward tranquility.' Later he began studying Zen with Dr Daisetz T. Suzuki at Columbia University, and this led to more than the musical expression of oriental thought: in his *Music of Changes* for piano (1951) he brought eastern philosophy into the very process of composition. Creative decisions were taken by reference to what he termed 'chance operations', in this case coin-tossing procedures derived from the *I ching*, or Chinese 'book of changes'.

Cage's *Music of Changes* is fully composed; in other words, though the sounds and their successions were to some extent dictated by chance, the notation is complete and must be observed by the

An example of Balinese gamelan music as transcribed by Colin McPhee. The *gangsa gantung* and the *jejogan* are rather like small vibraphones, the *kajar*, the *kemong* and the *kempur* are gongs of different types, and the *réong* is an instrument with several gongs attached to a frame.

Balinese gamelan players, with a *réong* in the foreground.

performer. But it was only a small step to make the outcome of a piece entirely a matter of chance, by liberalizing the notation, and Cage took that step in his *4′33″* (1952). In this work, originally given by a solo pianist but not unadaptable to other forces, there is no notated sound at all: the musicians remain silent, the piece 'consisting' of the sounds of the environment, and, like as not, those of the audience. Inevitably, *4′33″* was received as a joke, but there was a serious intention to it, or rather, in Cage's terms, a 'non-intention'. His work with chance had been very much influenced by Zen thought, and he now saw it as his aim to make compositions 'free of individual taste and memory in their order of events', so that the composer might 'let sounds be themselves in a space of time'.

Only an American composer could have made such a drastic revision of the notion of what music is about, substituting Zen 'non-intention' for the achievement of a product of the individual will, the goal of European art since the Renaissance. An anecdote related by Cage has some pertinence here. 'Once in Amsterdam', he recalled, 'a Dutch musician said to me, "It must be very difficult for you in America to write music, for you are so far away from the centers of tradition." I had to say, "It must be very difficult for you in Europe to write music, for you are so close to the centers of tradition."'

Cage's French contemporary Messiaen, who also began to interest himself in oriental music in the thirties, took a quite different path. Above all, he was concerned with musical ideas from outside Europe, and not with matters of religion and philosophy, for in those spheres his allegiance was consistently to Roman Catholic Christianity. His attention to eastern music was wide-ranging and penetrating, but all his works have the western qualities of finish and uniqueness, though they may still contain undisguised adoptions of oriental modes, of the rhythmic formulae codified in a medieval Hindu treatise, or of the sounds of the Balinese gamelan.

Hindu rhythms first appeared in Messiaen's music in his *L'Ascension* for organ or orchestra (1933–4), and they returned, often in complex combinations and developments, in most of his subsequent work. Like Cage, Messiaen acknowledged rhythm as the most important aspect of music: 'Let us not forget', he once wrote, 'that the first, the essential element in music is Rhythm, and that Rhythm is first and foremost the change of number and duration' (this sub-clause reveals his debt to the cellular techniques of *The Rite of Spring*). Messiaen's rhythmic repertory was accordingly extensive, including not only Hindu rhythms but also the metrical patterns of classical Greek

MUSIC OF CHANGES

John Cage

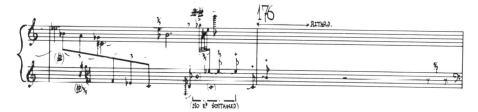

poetry, both used very much as formulae, shorn of their original functions and associations. Thus the use of Hindu rhythms does not make Messiaen's music sound particularly Indian, nor is there much concern with the symbolic meanings of the rhythms. It is the same with his quasi-gamelan orchestration for the percussion in such a work as his *Turangalîla-symphonie* (1946–8), which calls for celesta, vibraphone, glockenspiel and other struck metal instruments: the colour may be that of Bali, but it is combined with rhythmic and harmonic material from elsewhere, and the total effect is pure Messiaen.

Messiaen's ability to weld musical ideas from different sources into instantly recognizable music depended most of all on his modal harmony, and this he developed principally from western examples: Debussy, Liszt, the Russian nationalists and plainsong. Modality appeared in his music right from the first, arising perhaps from a wish to avoid the corrupt tonality of Neoclassicism. Having grown up in the Paris of Les Six, he felt the need to express his faith in music as a serious art, able to deal with the marvellous and the profound, and he found in modality an innocent musical universe. It provided the possibility of advance without irony, and its references were all to cultures in which music had been intimately connected with religion – medieval Europe, classical Greece and the Orient.

At the same time, Messiaen was fascinated by 'the charm of impossibilities' presented by what he termed 'modes of limited transposition' (i.e. symmetrical selections from the twelve notes of the chromatic scale, such as the whole-tone mode). The modes of limited transposition enabled him, in his works of the thirties and forties, to create a sweet and succulent harmony, far removed both from the soured sounds of Stravinsky's Neoclassicism and from the dark confusions of Schoenberg's serial atonality. This was a style ideally suited to serving his expressive aims of celebrating sexual love and marital fondness, and, above all, declaring the greater love and the mystery of God. As he said, 'the first idea that I wished to express, the most important because it is placed above all else, is the existence of the truths of the Catholic faith. . . . This is the main aspect of my work, the most noble, without doubt the most useful, the most valid.'

In his song cycle *Poèmes pour Mi* (1936–7) the main themes of Messiaen's work are combined, in that the attachment between man and wife is seen as mirroring that between Christ and the Church, God and man. The surrealist style of Messiaen's own verse, which he used in several of his works, is matched in richness of imagery by the harmony and colour of his music, by its opulence and abandoned

energy. There is something here of the guiltless erotic force of Hindu sculpture, as there is again, even more so, in the *Turangalîla-symphonie*. Here Messiaen looked to the east not only for rhythm and colour but also for his title, a Sanskrit word whose meanings include 'song of love, hymn to joy, time, movement, rhythm, life and death', according to the composer. The underlying subject of *Turangalîla*, however, is not any oriental myth but the legend of Tristram and Yseult, and in some ways it is among the least oriental of Messiaen's works: several of its ten movements have a harmonic dynamism which separates them far from the clear-cut, distinctly eastern 'block forms' to which his interests in rhythm, symmetry and number more usually and naturally give rise.

Turangalîla is also exceptional in not being an explicitly theological work. Most of Messiaen's larger compositions are exegeses of Catholic doctrine: the resurrection of the body in *Les corps glorieux* for organ and *Et exspecto resurrectionem mortuorum* for winds and percussion, the

Olivier Messiaen, whose vast *Turangalîla-symphonie* finds room for gamelan sounds and Indian rhythmic formulae.

mysteries of Christ's divinity in *L'Ascension* and the oratorio *La Transfiguration de Notre Seigneur Jésus-Christ*, the pattern of holy living and dying in the opera *Saint François d'Assise*. Messiaen's insistence was that such works are not mystical, but undeniably they are elaborate constructions of image and symbol, the symbolism of number playing a central part. And here, in number, Messiaen's main musical interest joined his principal concern as an artist, for a number, or a numerical sequence, may be represented by a rhythmic idea, and may at the same time symbolize a theological quality. Nor was there any contradiction in his use of exotic elements in music intended to set forth the Catholic faith, for in his view the hand of God is shown in all, and all may be used to return glory to Him.

It is noteworthy that Messiaen's first works were composed at a time, around 1930, when other composers too were turning their attention to the divine. Schoenberg's formal return to the Jewish faith came in 1933, immediately upon his exile from Nazi Germany, though he had already completed all he was to finish of *Moses und Aron* as well as several choruses to his own religious-philosophical texts. In America he composed his *Kol nidre*, and his last project was another sequence of choruses, the *Modern Psalms*, of which he lived to compose only the opening of the first, the music trailing off, not inappropriately, at the words 'and yet I pray'. Stravinsky's output of religious works, which had begun in 1926 with a setting of the Lord's Prayer in Church Slavonic, continued during this period with the Symphony of Psalms and the Mass for chorus and winds. And this was also a time that saw a revival of composition for the liturgy in several European countries: Stravinsky's Mass, indeed, was intended for church use.

Messiaen did not take part in this movement. He served the Church as organist of La Trinité in Paris for most of his adult life, but he published only one short motet for use in the liturgy. However, several of his concert works carry a suggestion of ritual order and ceremony. In his *Trois petites liturgies de la présence divine* for women's chorus and orchestra (1943–4) he attempted 'to accomplish a liturgical act; that is, to carry a sort of office, a sort of organized praise to the concert hall', and *La Transfiguration* (1965–9) is another, much larger work for the sacred concert, while *Saint François* (1975–83) is a piece of sacred theatre, showing 'the progress of grace in the saint's soul' in a sequence of eight immense tableaux.

These last two works are in many ways Messiaen's theological and musical *summae*. The subject of the Transfiguration, in particular,

provided him with the opportunity to treat those themes which had always been most important to him: the mystery of the Trinity, the divinity of Christ, the affiliation of man to God, the grandeur of nature as a revelation of God's majesty. In musical terms, the work draws on Messiaen's whole repertory of ideas and techniques, from Hindu rhythms to gamelan percussion writing, from Greek metres to modal harmony, from plainchant melody to bird song.

This last, a principal source of material in most of Messiaen's music since the early 1950s, represented for him 'the true, lost face of music', a music, as it were, in a 'state of grace', unsullied by human civilization. In his transcriptions, based on notation in the field, he tried to convey the melodies, rhythms and timbres of many different bird songs, and some of his later works were created very largely from this natural material. The *Catalogue d'oiseaux* for piano (1956–8), for example, is a collection of pieces, each painting a sound picture of a bird in its habitat, together with its companions, often at a particular time of day, and the drama of St Francis – all of it, not just his celebrated sermon – takes place in an orchestral context imitating the shouts, cries, shrieks and songs of birds from around the world. Such descriptive writing may have had its origins in Debussy, but Messiaen's approach was a great deal more 'scientific': the representations of bird songs are closely observed, and the colours of sky, plumage and environment are rendered by harmonies which are intended to create a correspondence with the appropriate visual impression. What he called 'the second mode of limited transposition', for instance, 'turns through certain violets, certain blues and violet-purple – while mode no. 3 corresponds to an orange with tints of red and black, touches of gold and a milky white with iridescent reflections, like opals.'

Messiaen's sound-colour correspondences are among the many personal, even private symbolisms in his music. Together with his supreme ambition to declare the mysteries of Catholic theology, they make his output something quite separate in the music of the twentieth century. Indeed, Messiaen saw himself as having more in common with much earlier artists of splendour and divine symbolism – the Gothic cathedral builders or the temple architects of the ancient Near East – than with those of his own time. Perhaps Giacinto Scelsi (1905–88), the reclusive Italian composer whose works attain qualities of stillness and presence by means of slow change and stretched, strained sonority, was his closest contemporary. Yet as a teacher, he had an influence on modern music second only to that of Schoenberg, his pupils including three members of that gifted generation which

Page from Messiaen's autograph score of the 'Epode' from his orchestral *Chronochromic* ('Time-colouring', 1960). This movement consists throughout of birdsong imitations on solo strings.

< Messiaen at work in the field notating birdsong by ear.

emerged in Europe soon after the second world war: Pierre Boulez (b. 1925), Jean Barraqué (1928–73) and Karlheinz Stockhausen (b. 1928).

As was the case with Schoenberg, what Messiaen's pupils learned from him was not so much the technical basis of his own style as the means to go further in their own ways, particularly in the rhythmic field. But perhaps the principal lesson of Messiaen's music was that anything might be used in the creation of a composition, above all, any exotic music. As Boulez has written, 'he has taught us to look around us and to understand that *all* can become music.'

The lesson, especially as it relates to alien traditions, is apparent in Boulez's *Le marteau sans maître* ('The hammer unmastered', 1952–4), scored for contralto voice and a small ensemble in which the vibraphone is used as a substitute for the gamelan while xylorimba and percussion suggest the influence of black African music. In Boulez, however, all references to other music are as far as possible expunged. Messiaen, in his *Sept haïkaï* for piano and small orchestra (1962), went so far as to recreate the gagaku music of the Japanese Imperial court, but for Boulez such imitative exoticism held little interest. Certainly he learned much from non-European music, particularly when touring as music director of Jean-Louis Barrault's theatre company: as he admitted, 'the discoveries that I made through that were very

An extract from Boulez's *Le marteau sans maître*, whose percussion sonorities and rhythmic dynamism owe something to the influence of Balinese and black African music.

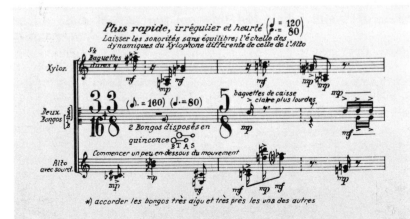

Karlheinz Stockhausen meeting Japanese nō-play musicians during his visit to Japan in 1966

important for me as a composer, since they allowed me to free myself from European conventions of instrumental usage.' Nevertheless, though his use of the harp in his *Improvisations sur Mallarmé* for soprano and percussion ensemble (1957) may owe something to the experience of hearing a Peruvian Indian play the instrument, there is no question of mimicry in terms of material.

Stockhausen's music of the later sixties and seventies shows a greater willingness to admit open exotic influence, a willingness stimulated by what he felt when working in Tokyo in 1966. There he tried to accommodate himself to an alien culture, to 'discover the Japanese in myself', as he put it; and in the electronic *Telemusik*, composed in Tokyo, he endeavoured to 'write not "my" music but rather the music of the whole earth, all lands and races'. The piece includes recordings of indigenous music from Spain and from Vietnam, from Bali and from the southern Sahara, from Japan and from Hungary, all appearing fleetingly and caused by electronic means to interact with each other, as if music from all over the globe were being heard from some super shortwave radio. In several subsequent compositions Stockhausen has been influenced, as Cage was twenty years earlier, by

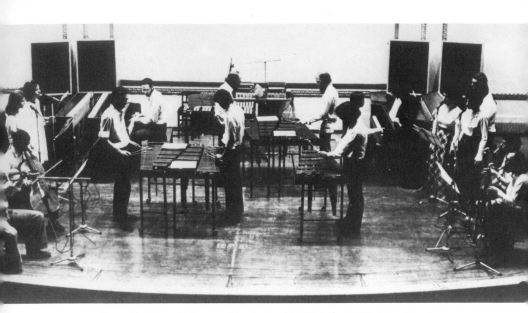

Steve Reich and his ensemble playing his *Music for 18 Musicians* (1976).

eastern thought, but in his case this has led to a view of music as a means of communicating with the divine and as an integral part of human life. His *Mantra* for two pianos and electronics (1970), for example, is an attempt to create that 'mantric music' which can, in the words he quotes from Satprem's *Sri Aurobindo, or The Adventure of Consciousness*, 'bring the gods into our life'.

By the time of *Mantra* the effects of oriental music and philosophy in the west had become widespread, from the use of sitars in rock bands to Stockhausen's music of spiritual awakening. Several American composers, following the example of McPhee, made a close study of exotic traditions and even learned to play the music of Japan, Bali, India or black Africa. One such was Steve Reich (b. 1936), who, in 'Some Optimistic Predictions (1970) about the Future of Music' expressed what he hoped might come out of this interest: 'Non-Western music in general and African, Indonesian and Indian music in particular will serve as new structural models for Western musicians. Not as new models of sound. (That's the old exoticism trip.) Those of us who love the sounds will hopefully just go and learn how to play these musics.'

Serialism continued

The alternative, or the counterpoise, to a 'music of the whole earth' has, since the late forties, appeared to lie in the development of the purely western technique of serialism. This renewed interest in Schoenberg's method was in the first place surprising, for when Webern died in 1945 the impetus of serialism might have seemed spent. Berg had died ten years previously, and Schoenberg had only a few years to live. The method had been taken up by some of Schoenberg's later pupils, men less gifted than Webern and Berg but still in some cases able to use serialism to distinctive ends: Roberto Gerhard (1896–1970) used the principle with a Spanish feeling for energy and colour, and Nikos Skalkottas (1904–49) took serialism back to Athens, worked quietly as a back-desk violinist and produced a large quantity of dense serial music. There were also a few others who adopted serialism independently. Krenek turned from his jazz-classical style to serial composition in his opera *Karl V* (1930–33), and Frank Martin (1890–1974) began in the mid-thirties to employ serial techniques within an individual style of French harmonic finesse. Luigi Dallapiccola (1904–75), impressed above all by the grace of Webern's music and the dramatic potency of Berg's, started to develop his own serial style in 1942. More generally, however, serialism was castigated as 'mathematical', even anti-human.

Change came, and the wider dissemination of serialism began, in the very year after Webern's death. Then Boulez composed his first acknowledged works, and in the following year, 1947, Milton Babbitt (b. 1916) produced his first serial essay, the Three Compositions for piano. Nor were these isolated cases. Boulez had soon become the leader and chief polemicist of a close-knit band of Parisian serialists, and Babbitt was only the most inventive and methodical of many American composers who were interesting themselves in serialism at this time.

There were good reasons why, strange though it first appeared, a method associated with Vienna should have sprouted outgrowths in

Paris (the centre of the opposition, as it were, in being the home of Stravinskyan Neoclassicism) and the USA. The Nazi domination of Europe had driven Schoenberg and his pupils out of Germany and Austria, and it was in Paris and America that they settled. Boulez and his colleagues were all pupils of Messiaen, whose knowledge of serialism was inevitably limited by the general lack of published scores, recordings and performances, but they also received instruction in serial technique from the Webern pupil René Leibowitz. In America, Schoenberg himself taught at the Los Angeles campus of the University of California from 1936, and his presence served as an encouragement even to those musicians who, like Babbitt, did not study with him personally.

The revival of interest in serialism after the second world war may also have been stimulated by the wish to start afresh and construct anew. Nowhere was this more keenly felt than in Germany, and it was there, at the Kranichstein Institute in Darmstadt, that the new European serial movement had its headquarters from the early fifties onwards, at least during the summer months when composers and students would gather to discuss the state of the art. Stockhausen attended

< Milton Babbitt, the most rigorous of serial composers, and the RCA Synthesizer which he has used in the creation of all his electronic works.

Pierre Boulez at the time of the composition of his *Structures* for two pianos, in which he tried and rejected total serial determination.

the Darmstadt courses for the first time in 1951 and there heard a recording of Messiaen's *Mode de valeurs et d'intensités* ('Mode of durations and intensities', 1949), a piano piece which established 'scales' not only of pitch but also of duration, loudness and attack. It seems that in 1944 Messiaen had speculated on the possibility of a serial organization to these other musical aspects. He did not put this into practice in the *Mode de valeurs*, and then in a modal rather than a serial way (modality starts from scales, serialism from orderings of points on scales). But the piece did open the way for what became known as 'total serialism'.

Boulez, perhaps taking up Messiaen's suggestion of 1944, had begun to investigate the possibility of rhythmic and dynamic serialism in his Second Piano Sonata (1948) and *Livre pour quatuor* ('Book for string quartet', 1949), and in 1951 he made the breakthrough into total serialism in the first section of his *Structures* for two pianos. Here he began with twelve-piece scales of durations, dynamics and attacks as well as pitches: each aspect is strictly controlled according to serial principles, and the result is perpetual change at every level. Also in 1951, Stockhausen created his first mature work, *Kreuzspiel*

('Crossplay') for oboe, bass clarinet, piano and percussion, where again serialism is applied to rhythm and dynamics.

Stockhausen and Boulez saw a precedent for their generalized serialism in the later works of Webern, who had become for them 'THE threshold' (Boulez), untainted by the Romantic decadence of Schoenberg and Berg, striving alone to make coherent sense of the serial method. It is in fact unlikely that Webern ever had any thought of applying serialism to other aspects than pitch, but his concentration on minutiae could be seen as presaging music in which each note was

Luigi Nono and Stockhausen at Darmstadt in 1956.

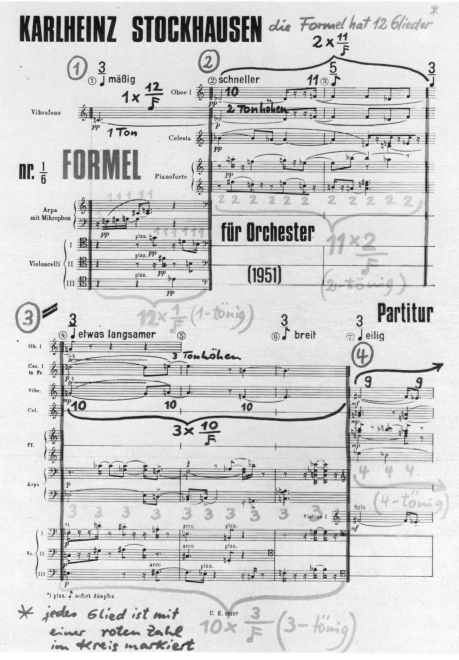

Front cover of Stockhausen's *Formel* for small orchestra, reproducing the first page of the music with the composer's annotation of its rhythmic structure based on the number 12.

separately composed, as it was when total serialism was being applied. Moreover, the clarity of Webern's structures was something to be admired. For Boulez, 'structure' was 'the key word of our time', and the composers of total serialism saw themselves as concerned primarily with structure and organization, as architects or engineers in sound. They pursued their ideas with quasi-scientific rigour; there was much talk of 'research', and much mathematics in their technical writings. In total serialism the desire for an objective art of sound, expressed by Stravinsky two decades earlier, might have seemed fulfilled; yet it was not so. Personality was not to be effaced by constructive rigour, any more than it was to be cast aside by Cage's 'non-intention': despite all the controls, Boulez's *Structures* have a delirious frenzy typical of his earlier works and far removed from the streamlined, jazz-tinged manner of Stockhausen's *Kreuzspiel*.

Unknown to the composers of Darmstadt, Babbitt had achieved his own serial control of rhythm in his Three Compositions for piano

The opening of Stockhausen's *Kreuzspiel* for oboe, bass clarinet, piano and percussion. The tumbas softly announce a rhythmic series: 2—8—7—4—11—1—12—3—9—6—5—(10).

An extract from Boulez's *Structures Ia* for two pianos, showing serial structures of pitch and rhythm.

(1947), but his understanding of serialism was crucially different from that of Boulez and Stockhausen. Applying his mind to the mathematical properties of serialism as a system – and, for all Schoenberg's protestations, his method had now become a system for the younger generation – Babbitt invented rhythmic serial procedures having the closest possible analogy with the manipulative techniques conventionally used in pitch serialism. Boulez and Stockhausen had simply used an arithmetical scale of durations from, say, one demisemiquaver to twelve (a dotted crotchet), choosing that range because there are twelve notes in the chromatic scale. Babbitt, on the other hand, invented subtle and ingenious ways of dealing with something at first ignored by the European serialists, namely that pitch has a regular repeating unit, the octave, for which some rhythmic equivalent must be found. His success in this, and his methodical approach, have brought to his music an impressive coherence, a polish strikingly opposed to the bewildering instability of such a work as Boulez's *Structures*.

Boulez himself soon moved on from the close control of that work, which represented for him a *ne plus ultra*. He had at first thought of giving it a title after Klee, *Monument at the End of Fertile Lands*, and his thinking in creating it can be related to a note in Klee's diary: 'I want

to be as though new-born, knowing nothing, absolutely nothing, about Europe; ignoring poets and fashions, to be almost primitive. Then I want to do something very modest, to work out by myself a tiny formal motive.' Submission to an almost automatic system of control, such as occurs in *Structures Ia*, offered Boulez the means to eradicate all that had been learned from the past, all traces of others' styles. As he later explained, 'our first effort was – perhaps naïvely, but not unhappily so – to research a grammatical expression which would establish the language in precise ways, and do so for a long time to come. That is to say, it was not a question simply of finding a certain fashion for a certain season, as a couturier might have done, but of discovering solutions of long range. These solutions obliged us to pass through strict disciplines, in which we felt ourselves ill at ease, but through which we were nevertheless forced to go. . . . If you do not deny, if you do not make a *tabula rasa* of everything you have received in inheritance, if you do not voice fundamental doubts as to the validity of everything which has gone before, you will never make progress. For us, these doubts developed to the point of absolute control.'

In this light it is possible to understand the comradeship which existed between Boulez and Cage at this time, and which otherwise appears rather odd, since Cage was working towards the benign anarchy of the *Music of Changes* at the very time when Boulez was taking the path of total predetermination. They could believe themselves working in parallel because both used charts of numbers in setting up rhythmic structures, and, more significantly, because they were both equally concerned with objective creation. But where Cage was trying to eliminate the filtering of his own personality, Boulez was attempting to obliterate the past so that a new musical 'language' might be evolved.

What Boulez in *Structures Ia* seems to have been most anxious to obliterate was the heritage of Schoenberg and Messiaen, which had been so important in his earlier music (though he paid homage to his teacher by founding the work on part of the pitch mode from the *Mode de valeurs*). His compositions of 1946–9 had shown his assimilation and development of Schoenbergian serialism and of Messiaen's exotic orchestration, his voluptuous contour. Even more striking, however, is Boulez's own expressive vehemence, whether he is responding to the Surrealist imagery of René Char in the cantatas *Le visage nuptial* ('The nuptial face') and *Le soleil des eaux* ('The sun of the waters'), or taking on Beethoven's 'Hammerklavier' in his Second

Piano Sonata. There is an Artaudesque character to these works, a mixture of hard anger and flamboyance which exists also in Boulez's polemics from the period of total serialism: 'Schönberg est mort' was the title of the barely respectful or even tasteful obituary he wrote for one of his musical fathers, while the other's *Turangalîla* he dismissed as 'brothel music'. His own stance was adamant: 'every musician who has not felt – we do not say understood, but indeed felt – the necessity of the serial language is USELESS'.

The ramified complexity of the 'serial language' in such works as *Structures* and *Kreuzspiel* does not admit of ready understanding, but this is not necessarily a criticism, for musical comprehension does not have to entail the aural analysis of form and function. Babbitt's music does seem to suppose a listener capable of the fine discriminations of metre and duration on which his rhythmic serialism depends, but for the European serialists the rational utopia was hardly more than a point of argument: there may have been much talk of musical 'logic', but in the works it is less easy to find. Moreover, the phase of total serialism was, in Europe at least, brief. While Babbitt was writing such works of sophisticated composure as his Second String Quartet (1954), his European contemporaries were advancing to vaster and more convoluted planes.

From this period onwards, the development of serialism in Europe may be charted largely in the works of Stockhausen. The closest he came to an essay in doctrinaire total serialism appears to have been the orchestral piece *Punkte* ('Points', 1952), which has been published only in radically revised versions. Its title draws attention to the texture most typical of total serialism, which, by treating each note as a separate unit, had given rise to 'pointillist' music, music made up of isolated flecks of sound. Stockhausen saw the limitation of this, and in his *Kontra-Punkte* ('Counter-Points', 1952–3), an explicit denial of the earlier work, he introduced the alternative of 'groups', which are more or less homogeneous bursts of notes. In a 'group' the individual sounds are subsidiary in importance to the character of the whole; it was an idea that came in part from the orchestral flourishes of Debussy's *Jeux*, though in *Kontra-Punkte* it is applied on the smaller scale of a chamber piece for ten instruments, where both 'points' and 'groups' are 'counter-pointed' against themselves and each other.

As far as Stockhausen was concerned, the positive lesson of total serialism was that any aspect of sound could be subjected to serial transformations. In *Gruppen* ('Groups', 1955–7), his most ambitious adventure in 'group' composition, he used a scale of tempos in a serial

Babbitt's autograph of the opening of his Second String Quartet. The first three bars are occupied entirely with the minor third and related intervals, the next two bars with the major third family.

manner, but the most openly new feature of the piece is its use of space, scored as it is for three orchestras in different parts of an auditorium. The spatial separation arose from the need to have complex 'groups' played simultaneously in different tempos, for this could be achieved only if the instrumentalists were divided into distinct ensembles, each under its own conductor, with the conductors taking care of coordination. But having arrived at this situation, Stockhausen proceeded to exploit it, notably at the climax to the work, where a brass chord is swung around the hall from one orchestra to another.

This kind of splendid dramatic gesture was to remain characteristic of Stockhausen, and in this case it opened the way to a use of acoustic

space in a manner that had been neglected since Berlioz. Offstage instruments had appeared in such works as Mahler's Second Symphony, and Bartók had used the antiphonal effects possible with two string groups in his Music for Strings, Percussion and Celesta, but these examples had been no more than adjustments to the normal placing of the musicians on the platform. The orchestras of *Gruppen*, by contrast, are to be placed around the audience, so that the experience is not one of observation but envelopment (one may recall Schoenberg's unrealized plans for the ending of *Die Jakobsleiter*). At the same time Stockhausen tried out the spatial idea in the electronic field with *Gesang der Jünglinge* ('Song of the youths'), designed for several banks of loudspeakers, and he soon had imitators in both tape and orchestral music. Boulez combined the two in his *Poésie pour pouvoir* ('Poetry for power', 1958) for electronic sounds and spirally disposed orchestra.

A rehearsal for the first performance of Stockhausen's *Gruppen*, directed by the composer (orchestra 1, left), Bruno Maderna (orchestra 2, centre) and Pierre Boulez (orchestra 3, right).

Stockhausen himself went on from the three orchestras of *Gruppen* to the four of *Carré* ('Square', 1959–60); but with a difference: the pressing urge felt by European serial composers in the fifties and six-ties was towards the new and untried, and it would have been unthinkable for Stockhausen, especially, to have repeated himself. In place of the intricate interlockings of serial rhythm and tempo in *Gruppen*, its busy textures and its dynamism, *Carré* presents a calm soundscape of subtle chords, drifting among the orchestras and slowly changing, broken only by passages in which sounds appear to be wound up in the whirlpool of the orchestras. There is here a new expanded time-scale, suggested to Stockhausen by the experience of long flights across America. Constellations of 'points' and multifarious 'groups' were being succeeded by 'moments', or relatively stable stretches of music which might last for several seconds or even min-utes. 'You can confidently stop listening for a moment', Stockhausen wrote of *Carré*, 'if you cannot or do not want to go on listening; for each moment can stand on its own and at the same time is related to all the other moments.'

The exploration of 'moment form' was continued in *Momente*, which Stockhausen began in 1963 and scored for solo soprano, chorus, two electronic organs, brass and percussion. This is the most dramatic and abundant expression of the change which had come about in Stockhausen's music since the works of the first half of the fifties, those from *Kreuzspiel* to *Gruppen*. There he had expanded and developed the serial principle, finding that he could work with scales of duration, tempo, instrumentation and even, in *Gesang*, a scale between vocal and synthetic electronic sound. What now emerged was the idea of smooth mediation between extremes in place of the quantum jumps of serialism. *Momente*, though richly varied in detail, describes a continuous modulating arc, the 'moments' arranged to effect transitions of emphasis among the prime factors of melody, rhythm and timbre. Yet Stockhausen insists on the individuality of the 'moments'. 'This is no self-contained work,' he writes, 'with unequivocally fixed beginning, formal structure and ending, but a polyvalent composition containing independent events. Unity and continuity are less the outcome of obvious similarities than of an immanent concentration on the present, as uninterrupted as possible.' The audience is to be carried with the tide of musical invention: 'Hear the moments!', calls the soprano, 'Music of love!'

The path that Stockhausen had taken away from the confines of serial convention was followed, even directly imitated, by many. Each

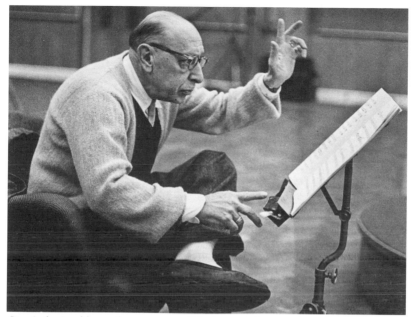

Stravinsky in old age, the composer of the late serial masterpieces.

summer he taught at Darmstadt, and each year would see a crop of works by composers anxious to keep up with him. Despite Boulez's wishes, musical innovation had indeed become a matter of fashion, and it had its effect not only on the young but also on established composers, even including Stravinsky.

Stravinsky's 'conversion' to serialism, which came about gradually in the mid-fifties, struck his admirers as a *volte face*, since between the wars he had been regarded as something of a rival pope to the serialist Schoenberg. But the development was not unprepared. In his Mass (1944–8) and Cantata (1951–2), the works which straddled his apotheosis of Neoclassicism in *The Rake's Progress*, he had looked back to the fourteenth and fifteenth centuries; his music had become less concerned with diatonic harmony, more with contrapuntal artifice. From this point an absorption of serial practices could begin, though Stravinsky was certainly also stimulated by the music of his young European colleagues, not least by their veneration of Webern. The open scoring and extreme rhythmic intricacy of his *Movements* for

Jean Barraqué, who died at the age of forty-four, leaving unfinished his immense cycle *La mort de Virgile*.

piano and orchestra (1958–9), for instance, suggests an awareness of Stockhausen, though he was able to assimilate such influences, as he had assimilated all influences, without making his music any the less characteristic. What he had at last found, in the new serialism, was a style to which he could respond without irony, one within which he could compose the sacred masterpieces and epitaphs of his last years.

While Stravinsky was moving towards his late serial style, Boulez was liberating himself from the total serial rigour of *Structures Ia*. 'We clearly saw', he has recalled, 'that we had to seek beyond a codification of the language and involve ourselves again with aesthetic problems. . . . Once the constitution of the language had been realized, everyone rediscovered his personal concerns, which led him hither and thither.' As far as Boulez himself was concerned, this entailed a return to the imaginative fantasy of his earlier works, now controlled by the elaborate serial extensions he had developed. Unlike Stockhausen, for whom the technical challenge of new structural ideas appears to have been a major motivating force in all his works up to and including *Momente*, Boulez now began with questions of aesthetics.

He turned, as he had turned in the late forties, to the verse of René Char, and took three compact poems for *Le marteau sans maître*

(1952–4). The exotic features of this work, the sound of Bali and black Africa, helped in the liberation from the hermeticism of *Structures Ia*, but more significant was the new suppleness with which Boulez handled the serial method. Formal shape and melodic contour were reintroduced, though *Le marteau* is still unsettling in its rapid rate of change, propelled by the polarities which henceforth were to underlie most of Boulez's music. Sound is contrasted with word, pulsed rhythm with free, 'active' sound with reverberation, sound with silence, sustaining instruments (here voice, alto flute and viola) with percussive ones (guitar, vibraphone, xylorimba, percussion), solo with ensemble, calculation with choice.

Another work for similar forces, Jean Barraqué's *Séquence* (1950–5), indicates a different way out from the impasse of total serialism. Barraqué maintains a quasi-dramatic continuity which is very different from the nervy sectional movement of *Le marteau*, and his melodic expansiveness contrasts markedly with the acute and often fractured phrases that give Boulez's piece its edge. Indeed, Barraqué was the Romantic of the postwar serial movement, which is not to deny that he was a fastidious composer, intensely conscious of the problems of artistic creation. After completing *Séquence* and his grandly yet agonizingly eloquent Piano Sonata, he set about composing a vast series of glosses on Hermann Broch's novel *The Death of Virgil*, which is itself a long poetic and philosophical meditation on the springs of creativity, concerning itself particularly with the artist's impulse to destroy his work because he knows that any creative endeavour can be only partially successful in reaching his ideals, that it will be misrepresented, and that it will never be perfectly comprehended. It was Barraqué's view, put into practice in *La mort de Virgile*, that the natural consequence of serialism was a work long and unfinished – and perhaps also unfinishable.

Electronics

Serialism was not the only force in music in the late forties and early fifties: there was also the new medium of electronic music, which had at last become a possibility with the introduction of the tape recorder. Electric musical instruments, such as the ondes martenot and the trautonium, had never offered more than a few new timbres, though Messiaen had shown in *Turangalîla* how effective the unearthly sound of the ondes could be. The manipulations of sound on disc, too, had proved a dead end, for the possibilities were limited and the procedures laborious. Tape, on the other hand, presented the composer with a flexible, versatile means of recording and storing sounds, of changing them in pitch and rhythm by altering the play-back speed, of superimposing them, and of rearranging them in any order. These few techniques made possible the true birth of electronic music.

Varèse, who had been pressing for electronic means for the last three decades, received a tape recorder in the later forties. Immediately he began collecting material for the new 'organized sound' he had dreamed of. His experiments with disc recordings had already suggested what a world of sound would be revealed; lacking creative facilities, he had begun to explore that world in instrumental works, imitating in his orchestral *Intégrales* (1924–5) the effect of playing recorded sounds backwards. Now, for his first essay with electronics, *Déserts* (1949–54), he chose to use both recorded and instrumental sounds, alternating tape with orchestra in such a way that the unfamiliar takes off from and leads back to the familiar. But it is not only the tape music that is new. Varèse had composed very little since the mid-thirties, and his return to orchestral writing brought an unprecedented finesse in the composition of timbres from an ensemble of winds and percussion. Moreover, the work's bleak features contrast strikingly with the forceful outlines of his earlier music. After the 'new worlds' of *Amériques* had come 'physical deserts, those of the earth, the sea and the sky, of sand, of snow, of interstellar space or of

great cities, but also those of the spirit, of that distant interior space which no telescope can reach, where man is alone.'

It is possible that Varèse was disappointed by what could be achieved with the primitive apparatus available to him, or that, now in his seventies, he found it difficult to adapt to the new mode of composition. In his last years he returned again to conventional resources; but not before he had created one of the few great works of music on tape, his *Poème électronique*. This was commissioned for the Philips pavilion at the 1958 Brussels Exhibition, where it was relayed through a large number of loudspeakers all over the interior walls of a building which had been designed by Le Corbusier. That building was demolished after the exhibition, so that the *Poème électronique* can now be heard only in a stereo version. Even so, Varèse's conception remains astounding in its ambition. His piece combines the instantly recognizable sounds of a solo soprano and a chorus, of bells and organ, with other sounds that are totally new, all creating the impression of a ranging imagination at work.

If Varèse perhaps became disenchanted with electronic means, the mood of younger colleagues was one of buoyant excitement. The composer could now work directly with his material in the manner of a painter or sculptor; he could compose the very sounds of his piece, and he could hear the result immediately, which had been possible before only with the prepared piano. There was thus a close involvement with the material of music, and this seemed particularly appropriate at a time when the development of serialism was being seen as an objective voyage of scientific discovery. Nor, in that light, could the banishment of the performer fail to be viewed as an advantage.

Studios of electronic music sprang up quickly, particularly at broadcasting stations, where the equipment would already be available. Among the first authorities in the field were Radiodiffusion Française in Paris and Nordwestdeutscher Rundfunk in Cologne, and it was not long before their studios had become the centres for opposed factions of electronic composers. In Paris the interest was in *musique concrète*, which was composed from altered and rearranged natural sounds, often metallic and aqueous ones. The head of the Radiodiffusion studio, Pierre Schaeffer (b. 1910), composed a number of works of *musique concrète*, frequently in collaboration with his eventual successor Pierre Henry (b. 1927). Their first major effort, created with disc techniques, was the *Symphonie pour un homme seul* ('Symphony for a man alone', 1949–50), which was also one of the first electronic works

Pierre Schaeffer, composer and theorist of electronic music, who established a studio for *musique concrète* in Paris soon after the second world war.

to be heard in public performance. The development of *musique concrète* was thus exactly contemporary with that of Parisian serialism, but there was little contact between the two groups. Boulez and Barraqué did both work with Schaeffer, but only briefly, and only to produce short studies. Both emerged dissatisfied: Boulez returned to electronic composition only fitfully thereafter, Barraqué never.

In Cologne the situation was very different. Stockhausen spent as much time in the studio as he did working on instrumental compositions, and his concern was not with transforming natural sounds but with 'pure' electronic music created solely by the new means. He and his Cologne colleagues looked forward to the synthesis of any sound from pure frequencies, and this he attempted in his *Studie I* (1953). But the experiment failed. The pure tones did not jell as expected, and the idea had to be abandoned until more sophisticated methods and equipment had been developed. In another sense, however, the project was a success, for *Studie I*, like Stockhausen's other early electronic

Stockhausen in the electronic music studio of West German Radio in 1956, the year in which he there completed his *Gesang der Jünglinge*.

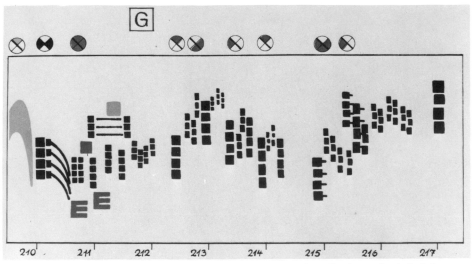

An extract from the 'listening score' for György Ligeti's electronic *Artikulation* (1958). The shapes and symbols, in various colours, represent what is heard.

pieces, sounds totally accomplished for all that the machinery then available was crude and the techniques primitive.

The mediation between Paris and Cologne came in Stockhausen's *Gesang der Jünglinge* (1955–6), for which he used both natural sounds (from a recording of a boy's voice) and electronically generated material. His goal here may have been a technical one, characteristically to effect a fusion between opposed extremes, but the composition emerged also as a work of potent sound imagery, a picture of the three youths in the fiery furnace of the Book of Daniel, praising God to the words of Psalm 150.

Stockhausen's next aim was a return to 'pure' electronic composition, but this time with regular pulses of sound instead of simple frequency tones. Work in the studio had brought him to an appreciation of what he called the 'unity' of electronic music. A pitched note would, when slowed down to below about 16 Hz (i.e. 16 cycles of vibration per second), begin to be perceived not as a tone but as a regular rhythmic beat, with subsidiary rhythms contributed by the frequency components which had given it its timbre. If slowed down still further, a single note could become a whole musical form. Thus the four basic constituents of music – pitch, timbre, rhythm and form – could all be seen as facets of the same phenomenon, that of vibration. A Beethoven symphony would theoretically, if speeded up ten

thousand times, become a single sound, if one of quite inaudibly high register; and a single sound might be extended to the duration of a symphony. It followed also that regular pulses contained all that was required for the composition of new timbres, new rhythms, new sounds; and this Stockhausen put into practice in *Kontakte* ('Contacts', 1959–60).

Electronic music was often criticized in the fifties on the grounds that its sounds were dead, as indeed in some respects they were. Machines could not produce the rapid variations which take place in an instrumental attack, nor could they mimic the subtle changes which are always taking place in a performer's tone; and the rhythms and tempos of electronic music were fixed for all time. Some of these problems did not arise with natural sounds on tape, and they might all evaporate in works of such inventive power as those of Varèse and Stockhausen. But they were taken seriously by composers, and it became increasingly common for electronic music to be combined with some live element.

A passage from the autograph score of Stockhausen's *Kontakte* for piano, percussion and tape.

This Stockhausen tried out in an alternative version of *Kontakte* where a pianist and a percussionist play with the tape. 'These known sounds', he wrote, 'give orientation, a perspective to the aural experience; they function as traffic signs in the unbounded space of the newly discovered electronic sound world. Also, the electronic sounds sometimes come close to being confused with the known sounds.' Here *Kontakte* took up from the mediation of *Gesang*, establishing 'contacts' between the sounds of live performers and the flow of music on tape, yet without spoiling the marvel of new sounds. Discovering new sonorities, or 'timbre composition' as Stockhausen calls it, is important in all his work, whether for electronic, live or mixed media, which is why he has usually taken a quite different set of resources for each work (his orchestra, for example, is always differently formed).

For Babbitt, by contrast, the electronic medium was valuable not for its new sounds but for the fine control of rhythm which it made feasible. In his *Ensembles for Synthesizer* (1962–4) he took advantage of this to aid the engineering of rhythmic serialism. He chose his timbres with exquisite care, avoiding Stockhausen's introduction of the strange and grand, and he restricted himself to pitches from the normal equal-tempered scale, so that his piece sounds rather like the product of an exceptionally versatile and accurate electronic organ. In his *Philomel* (1963–4), however, he did exploit the drama of electronic sound. Here he created a scena for soprano with a tape of recorded soprano and synthesized sounds, a work which dwells on the moment of the mythical heroine's transformation into a nightingale, and which, within Babbitt's more controlled style, rivals the electronic sound poetry of Stockhausen's *Gesang*.

The synthesizer used by Babbitt in *Ensembles* and *Philomel* was a unique instrument constructed for RCA and given to the Columbia–Princeton Electronic Music Center in New York, not a machine of the kind later associated with the name of Robert Moog. When the Moog synthesizer and other similar instruments came on to the market, in 1964, the techniques of electronic music were revolutionized. No longer was it necessary for the composer to spend long hours in the studio preparing and editing his material (it had taken Stockhausen eighteen months to produce the thirteen minutes of music in *Gesang*). The new synthesizers offered an abundance of sounds ready to hand. One had only to set the controls and then play the instrument, on a keyboard or some other device.

By this time, however, much of the enthusiasm and the sense of adventure had gone out of recorded electronic music. There was

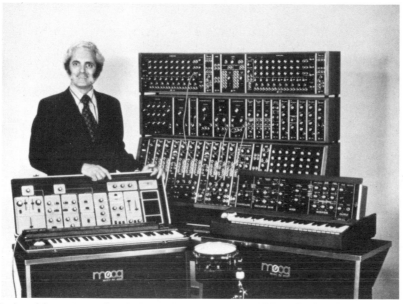

Robert Moog pictured with three of his synthesizers. All have keyboards as well as other means for specifying and altering sounds.

more interest in music to be played on electronic equipment in live performance, in what has come to be known as 'live electronic music'. This had been pioneered by Cage in his *Imaginary Landscape no. 1* of 1939, but little had been done in the interim. Now, in the mid-sixties, live electronic ensembles appeared in quick succession, among them the Sonic Arts Union in America, Stockhausen's ensemble and Musica Elettronica Viva of Rome. Such groups took to using both conventional and electronic instruments (sometimes including synthesizers), together with electronic means of amplifying and altering sounds.

Stockhausen's first live electronic piece was *Mikrophonie I* (1964-5), in which a large tam tam (a kind of gong) is activated by two performers with various objects while two others pick up the vibrations with microphones and another two control the electronic transformation of the sounds. It is a work which, perhaps more than any other, shows how much Stockhausen's work with electronics had led him to concern himself with new sounds, for an important feature of the piece is its display of strange and subtle noises coming from an instrument which might have appeared limited. At the same time Stockhausen

A section from the piano part of Stockhausen's *Prozession*, showing his plus–minus notation. 'Per' indicates that the rhythm must be periodic.

applied electronics to a more obviously versatile medium in his *Mixtur*, a kind of improvisation with the possibilities of modulated orchestral sound. After this he could be confident of the future of live electronic music: 'The way now seems to me completely open', he wrote, 'for a further development of instrumental music, since its irreplaceable qualities – above all its constant versatility, its "living" quality – can now be combined with the acquisitions of electronic music to make up a new unity.'

That 'new unity' was pursued in *Prozession*, written in 1967 for what had become his regular live electronic performing group. Here the players are directed to perform extracts from his earlier works, and to vary those extracts according to simple signs in the score: a plus sign, for instance, might mean 'higher or louder or longer or more components'. The musicians must also react to each other, each sometimes offering a variation of what he has heard from another. In these various ways Stockhausen composes not so much the material as how it must be altered, and he developed the idea of 'process' composition

Two members of Stockhausen's ensemble in a performance of his *Kurzwellen* for instrumentalists and shortwave radios.

in his *Kurzwellen* ('Shortwaves', 1968), where the initial material is received from shortwave radios.

The use of radios as performing instruments had begun with Cage's *Imaginary Landscape no. 4* for twelve receiving sets (1951): the arbitrary nature of broadcast material must have appealed to the composer of the *Music of Changes* and *4' 33"*. Stockhausen, however, used the radio sounds merely as a point of departure. He was more interested in creating a situation for close interaction within his performing ensemble and in opening himself, as he had in *Telemusik*, to a 'music of the whole earth', and perhaps beyond. 'What can be more world-wide,' he wrote, 'more ego-transcending, more all-embracing, more universal and more momentous than the broadcasts which in *Kurzwellen* take on the guise of musical material? . . . What happens consists only of what the world is broadcasting *now*; it issues from the human spirit, is further moulded and continually transformed by the mutual interference to which all emissions are subject; and finally it is brought to a higher unity by our musicians in their performance. . . . We have come to the edge of a world which offers us the limits of the accessible, of the unpredictable; it must be possible for something not of this world to find a way through, something that hitherto could not be found by any radio station on this earth. Let us set out to look for it!'

By this time electronics had become so important in 'serious' music that it was natural there should be some accommodation with pop, and that it should come from both sides. Instruments developed in the pop field began to be used in art music (Stockhausen had some years back included an electric guitar in the forces for *Gruppen*) and some pop groups started to interest themselves in the 'avant garde'. It even became possible for a live electronic ensemble to share a concert with a pop group; and that without any sense of incongruity, for the distinction was now largely a matter of training, background, audience and record label.

In C, a piece composed by Terry Riley (b. 1935) in 1964, is an example of a work on the borders. Riley provides only a number of modal fragments which the performers may introduce freely within a steady pulse, generating obsessive repetitions and spontaneous pattern-making. Both have had their imitators in pop as well as art music. Moreover, the audience for Riley's music, and increasingly that for Stockhausen's, was coming from young people with a closer interest in pop than in the western art tradition.

One electronic technique not normally available to pop musicians in the sixties was the use of computers, then beginning, particularly in

the USA, where many composers have served as university teachers and so had relatively easy access to the machinery. However, the initial work in computer sound synthesis was carried out at the Bell Telephone Laboratories by Max Matthews. His program Music IV has been adapted and developed by several composers in order that they might generate and vary sounds with the assistance of a computer, which might be asked, for example, to calculate the changes needed to give the impression of a sound travelling in the space between two loudspeakers. Sound production by these means can be complete if the computer is made to operate a synthesizer or other apparatus for creating, storing and reproducing sounds, and since the mid-seventies most electronic music has been computer-assisted, whether that music was created on tape or intended for live performance with digitally controlled transformation. An example of the latter is Boulez's *Répons* (1980) for six percussion soloists with computer transformation and small orchestra, one of the first products of the Institut de Recherche et de Coordination Acoustique/Musique he directed in Paris. That institute was, with Stanford University in California, one of the principal centres of computer-electronic music in the seventies and early eighties, until the computer explosion made such facilities much more widely available.

But there are other uses for computers in composition apart from sound synthesis. One can feed in compositional rules and direct the computer to create a 'composition' according to them, as was first done by Lejaren Hiller (b. 1924) in the case of his (or the computer's) *Illiac Suite* for string quartet of 1957. Iannis Xenakis (b. 1922) has also used computers as calculating aids in the composition of his 'stochastic' music, where the musical form is made analogous to a stochastic process (i.e. one ruled by laws of probability, such as a sequence of dice throws). He gives the computer mathematical laws and other data to set the limits for the process, and then converts the printout either into a score for conventional instruments, as in his *Eonta* for piano and brass quintet (1963–4), or into an electronic work. Here the computer is being used merely to facilitate calculation, not to take the creative initiative, whereas in Hiller's work it has been required to make compositional decisions, whether randomly in the *Illiac Suite* or under guidance in later experiments.

In all these various ways the use of computers, tape recorders, synthesizers and other electronic apparatus has been of great and increasing importance in music since 1950. Yet there is an older invention whose effects have been no less radical: the gramophone. As

Babbitt has pointed out, a recording of a Tchaikovsky symphony is a work of electronic music; and if one accepts this enlarged definition, then electronic music is by far the most popular kind of music in technologically advanced countries. Naturally the change in listening habits has influenced composers. It is possible that the breakdown of formal norms – which began in Debussy at the very time when the gramophone was being developed – owed something to the availability of recordings: there was now an easy means of rehearing a work, and so it was less necessary to include conventional structural landmarks as an aid in familiarization. Also, many composers have seized on the new opportunity to present their works in definitive aural versions. Perhaps it is unlikely that Elgar or Richard Strauss regarded their recordings in this light, but certainly Stockhausen views those supervised by him as essential adjuncts to the published scores.

Gramophone listening is a private experience, but amplification can also of course be used on a public scale. Early concerts of electronic music were often unsuccessful because the absence of visual stimuli

Iannis Xenakis, a pioneer in the use of computers as aids to composition.

The auditorium built for performances of Stockhausen's music at Expo '70, Osaka, with the composer seated at the controls.

caused boredom, but this problem vanishes with live electronic music, and it may also be overcome if multichannel techniques are used to give the quasi-visual impression of sounds moving in space. Stockhausen, the composer of many live electronic and multichannel works, has pressed repeatedly for the construction of public halls for electronic music. Perhaps the spherical auditorium built for him at the 1970 Osaka Exhibition was only the first in a new generation of concert halls adaptable to the electronic music of both Stockhausen and Tchaikovsky.

Chance

The electronic music and total serialism of the late forties and early
fifties had come as a postwar recall to order, reaching its apogee in
1951, the year of Boulez's *Structures* and Stockhausen's *Kreuzspiel*. But
1951 also saw the entrance of chance as a powerful force in Cage's
music, in the *Music of Changes* and *Imaginary Landscape no. 4*, and it was
through acceptance of this force that new fields were to be opened to
composers in Europe.

In part this came about through Cage's direct influence (he visited
Europe for concert tours in 1954 and again in 1958), but it was largely
an independent development. As Boulez realized, chance had never
been abolished in the ramified organization of total serialism; rather
the reverse. When so much was given over to numerical manipula-
tion the composer lost control of the details of his work. The prob-
lem was to find a middle way between, on the one hand, a serial
organization so fully predetermined that the composer's choice was
gone, and on the other, the free play of imagination which so easily
could lead to incoherence. This Boulez achieved in *Le marteau sans
maître*, but for him that could be only a one-off solution before a new
aesthetic programme was devised.

Composers of electronic music had also found that their control
could never be as complete as they had hoped: Stockhausen's experi-
ence in composing *Studie I* had been enough to demonstrate that.
Complex sounds could never be precisely defined in terms of their
constituents; there would always remain areas of vagueness, areas
where the characteristics of the sound could be stated only in proba-
bilities. And so both total serialism and electronic composition, of
which so much had been hoped, were proving susceptible to chance.
There would have to be some accommodation with disorder, perhaps
through taming chance as choice.

Cage felt no such obligation to bring order to chaos, and he had
soon, in *4′33″* (1952), opened his music almost completely to chance
occurrence. By this time he had attracted a group of like-minded

colleagues in New York, among them the pianist David Tudor, and the composers Morton Feldman (1926–87), Earle Brown (b. 1926) and Christian Wolff (b. 1934). The group also had associations with the visual artists working in the city, including Jackson Pollock and Alexander Calder, in whom Feldman admired 'that complete independence from other art, that complete inner security to work with what was unknown to them'. With this same security, and with what he has described as the 'permission' granted by Cage's work, Feldman set about composing unassuming pieces made up of simple, delicate, fragile sounds. Here the introduction of chance came about as a result of his wish 'to do something very modest', in Klee's words. His *Projections* (1950–51) and other pieces are written on squared paper, each square representing a unit of time to be filled either by silence or by a sound defined in quite loose terms: it might be a pizzicato note in the middle register of the cello, the player being free to choose the pitch within that range.

Brown, who also took note of what he called 'the creative function of "non-control"' in the art of Pollock and Calder, introduced indeterminacy at the level of form. The player or players of his *Twenty-Five Pages* for from one to twenty-five pianos (1953) may arrange the sheets of musical material in any order they wish. Still more open is his

Feldman's autograph of the opening of his *Projection II* (1951), whose notation is not specific. The string parts, for instance, begin with a violin harmonic in the upper register and a two-note pizzicato chord in the middle range of the cello. Copyright © 1962 by C.F. Peters Corporation, New York.

December 1952, the first example of a 'graphic' score, which is simply a design to be interpreted by any sound sources.

Wolff's first important chance music appeared later in the decade, when it became his aim to encourage invention, communication and interaction among the performers of an ensemble. Music 'must make possible', he wrote, 'the freedom and dignity of the performers. It should have in it a persistent capacity to surprise (even the performers themselves and the composer).' In order to allow opportunities for 'surprise' he sometimes gave only very general instructions, including directions that the musicians should at certain points react to each other, so anticipating such works of Stockhausen as *Prozession* and *Kurzwellen*. The essential difference was that Wolff demanded no control over the finished product.

Some of the music created by Cage and his New York colleagues in the early fifties may give the impression of iconoclastic revolt or nonchalant humour, but this was no exaggerated repetition of events in the Paris of Satie and Les Six. Satie was indeed taken as an example, but what Cage admired in Satie was more his lack of ambition than his wit. The other composer most respected by the New York composers was Webern, who was at the same time being revered as 'St Anton', to quote Stravinsky, by the European serialists. The Americans, however, were less interested in the rigour of his serial thought than in the unpredictability and textural openness of his atonal works, in his significant use of silence and his attention to individual events. Feldman's music, in particular, sounds like an extension of this early Webern into tranquillity.

In Europe, chance composition made its bold entry with two works heard at Darmstadt in 1957, Stockhausen's *Klavierstück XI* ('Piano piece XI') and Boulez's Third Piano Sonata. The Stockhausen piece presented the player with a single sheet bearing nineteen fragments of music to be performed in any order. After playing one the pianist must glance over the page for another and then play that according to markings of tempo, loudness and touch given at the end of the last. A fragment might be performed twice, in which case it would probably appear quite different when repeated, and the piece was to end as soon as one had been played three times.

Boulez's Third Sonata is, characteristically, more measured in its approach to chance. The performer has various options in making his way through material which is all fully notated, except for some flexibility of tempo. There are also different possible orderings for the five movements of the sonata (only two and a portion of a third have been

The opening of the movement 'Constellation-Miroir' from Boulez's Third Piano Sonata, with arrows to indicate different possible routes through the material. Boulez uses precise indications of pedalling and silently depressed keys (marked in small type) to obtain a wealth of piano sounds.

Two fragments from Stockhausen's *Klavierstück XI*.

published), and each of these movements offers choices of a different kind. In the largest, 'Constellation-Miroir', there are many alternative ways of linking together a host of fragments, rather as in the Stockhausen piece. But here the available routes are stipulated, and they all preserve the alternation of 'blocs' (heavy chords) with 'points' (isolated notes and lines) which gives the music a typically Boulezian formal movement through opposition. The movement is printed in a way that indicates its nature, with the sound 'constellations' widely disposed and differently coloured, red for 'blocs' and green for 'points'. For this the model would appear to have been Mallarmé's *Un coup de dès*, where different typefaces are used for the words and phrases which straggle across the pages.

Mallarmé's status as the ancestor of 'aleatory' art (from the Latin *alea*, meaning 'dice') became strikingly apparent in 1957, the very year when these pioneering aleatory compositions of Boulez and Stockhausen were first performed. Then there appeared in print Mallarmé's sketches for the *Livre* which was to have been the sacred book of aestheticism, intended to provide multiple, open-ended possibilities for reciters in their performance. Boulez now embarked on a 'portrait of Mallarmé', his *Pli selon pli* ('Fold by fold') for soprano and orchestra, which gradually developed during the five years of

its composition as a progressive disclosure of the poet's expressive personality and aesthetic belief. There are again five sections, each based on a Mallarmé poem which may be more or less 'submerged' in the music, but now the operation of choice is limited to small-scale decisions. The conductor may, for example, assemble given passages of music in different ways; the soprano may (in the original version) choose from alternative vocal lines; and much of the music is given a floating suppleness by the freedom permitted in tempo, dynamics and the measurement of pauses.

At this level, of course, aleatory composition is no more than a limited extension of freedoms which had always been available in composed music, for no score, not even one so filled with markings as Boulez's *Structures*, can prescribe every detail of a sound with exactitude. Nor is the idea of 'mobile form' totally new, for multi-movement works have commonly been subjected to part omission or rearrangement. Even Cage's chance operations had their precedents in

The score of Cage's *Fontana Mix* (1958), which leaves a good deal to performers' ingenuity. Copyright © 1960 by Henmar Press Inc.

those late-eighteenth-century publications which provided musical material to be formed into 'compositions' according to the results of dice throws. But the introduction of chance in the mid-twentieth century was generally different in both scale and importance. In the extreme case of Cage it led to a complete undermining of the western notion of a piece of music as a fixed work of art, and even to a denial of the need for composition. 'The music I prefer', Cage has said, 'even to my own or anybody else's, is what we are hearing if we are just quiet.'

Boulez would never accept such a view. For him chance offers the only means 'to fix the Infinite' and is also perhaps the logical outcome of the serial method: permutational forms for a permutational technique. Aleatory structures can, indeed, be seen as peculiarly appropriate to atonal music in general. The creation of musical forms without tonal harmony had been a problem for half a century, ever since the first atonal works of Schoenberg, for with the loss of tonality had come the loss of the means for creating goal-directed forms, these means depending on the tonal phenomena of preparation, modulation and resolution. Schoenberg, Webern, Stockhausen and Boulez had all tried various ways of getting around this problem; aleatory composition now allowed it to be ignored. As Boulez wrote of his second book of *Structures* for two pianos (1961): 'Does a musical work have to be considered as a formal construction with a firmly fixed direction? Could one not try to regard it as a fantastic succession in which the "stories" have no rigid relationship, no fixed order?'

The remaining difficulty was that, as far as the naïve listener is concerned, an aleatory work does have a fixed order: he cannot receive the impression of formal mobility from a single performance, still less from a gramophone record. This is where any analogy with, for instance, the mobiles of Calder breaks down, for music is a temporal art. Limited freedom may be evident in the flexibility and spontaneity of a performance, but not formal mobility.

Composers and performers have sought various ways of avoiding this difficulty, whether by having an aleatory piece played twice in a concert, by including theatrical elements which draw attention to its haphazard nature, or by instructing a record listener to alter volume and channel balance while he hears a work. Alternatively, the listening experience itself can become aleatory in music subject to 'aural illusions', such as that of György Ligeti (b. 1923). In many of his works, including the orchestral *Atmosphères* (1961) and the large-scale Requiem (1963–5), the textures are so complex and so active that they

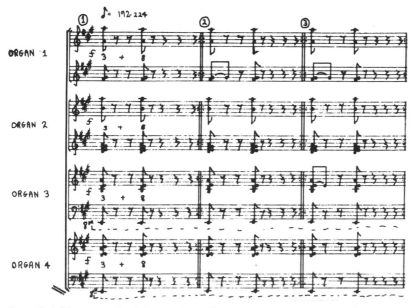

Steve Reich's autograph of the opening of his *Four Organs* (1970). A gradual process of change, within a repetitive context, is here begun.

cannot be perceived in the whole: instead the ear selects, makes its own combinations, even hears things that are not there. This has been further exploited in Reich's music, whose polished, patterned surfaces stimulate 'false' perceptions analogous to those produced by the paintings of Bridget Riley. The mind is mesmerized by repetition, put into such a state that small motifs can leap out of the music with a distinctness quite unrelated to their acoustic dominance.

Stockhausen's *Stimmung* ('Tuning', 1968), a piece for six vocalists using almost exclusively the overtones of a low B flat in quasi-oriental incantations, has something of the same effect, though here within a composition which is itself aleatory. In *Stimmung*, as in other works, Stockhausen used aleatory principles in order to encourage the capacities of his performers for 'intuitive' music making. From *Klavierstück XI* he went on, in *Zyklus* ('Cycle', 1959), to provide a solo percussionist with opportunities for limited invention, much of the score consisting of shapes which may be more or less freely interpreted. However, Stockhausen's graphics always contain a measure of determinism, unlike Brown's *December 1952* and a great many other works: often they are as prescriptive as conventional symbols, if in

other ways. *Zyklus* was also an attempt to enclose formal mobility in a circular design, for a performance may begin on any of the sixteen pages and continue in cyclical order from there.

Stockhausen's next aleatory innovation was the plus–minus notation of such 'process' compositions as *Prozession* and *Kurzwellen*, where the performers' intuitive responses are brought much more fully into play. However, these works were intended in the first place for his own performing ensemble, and so the results (including the definitive recordings of these works) are at least to some extent defined by the composer in his role as director of the group. This is still the case in a set of pieces he composed during a week in May 1968, *Aus den sieben Tagen* ('From the seven days'), where each 'score' is a prose poem conveying general instructions and little more. There could be no further step in the direction of 'intuitive music', a term which Stockhausen prefers to 'improvisation' because the latter 'invariably conjures up an image of underlying structures, formulae and peculiarities of style. . . . By *intuitive music* I mean to stress that it comes virtually unhindered from the intuition. . . . The "orientation" of the musicians, which I call "accord", is not, I would emphasize, random or merely negative

An extract from the published score of Stockhausen's *Zyklus* for solo percussion, which may be read either way up. Graphic signs are used in conjunction with conventional notation.

168

– in the sense of exclusive – musical thought, but joint concentration on a written text of mine which provokes the intuitive faculty in a clearly defined manner.'

Other composers and performers had concerned themselves with improvisation proper, usually in order to allow a display of virtuosity or, as in Wolff's pieces, to encourage an intimate spontaneity of performance. The effect of Stockhausen's 'intuitive' texts included both brilliance and inventiveness, at least in the performances directed by him, but his overriding purpose was spiritual, to make possible a 'musical meditation' (this was 1968, the age of 'flower power', the hippies and the Maharishi), and that required the utmost in concentration and dedication. 'Goldstaub' ('Gold dust'), one of the last pieces from *Aus den sieben Tagen*, makes demands on far more than the performers' musical resources: 'Live completely alone for four days / without food / in complete silence, without much movement. / Sleep as little as necessary, / think as little as possible. / After four days, late at night, / without conversation beforehand / play single sounds / WITHOUT THINKING what you are playing / close your eyes, / just listen.'

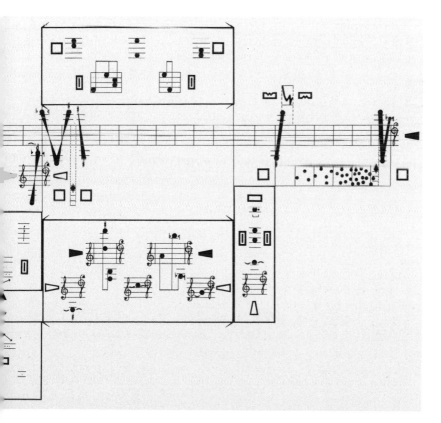

The theatre and politics

In the fifties the efforts of composers had been concentrated in three principal directions: the extension of serialism, the development of the electronic medium and the introduction of chance. The emphasis had been on exploring the materials of music, on evolving a musical 'language', on compositional system and philosophy. Given such objective interests, it was natural that composers should have been little inclined to involve themselves with the bastard genres of opera and ballet, where purely musical problems must of necessity be subsumed. Those who did write for the musical theatre, Britten, Tippett and Hans Werner Henze (b. 1926) for instance, were not among the pioneers of the 'avant garde'.

The next decade, however, saw a reversal of this situation, to the extent that by 1970 there were few vanguard composers who were not bringing theatrical elements into their music. To some it may have seemed that the musical theatre offered scope for a closer rapport with the public than had been achieved in the 1950s, when the statements and theoretical writings of many composers, if not their works, seem almost to have been planned to discourage an audience. Many composers also felt the need to enter directly into public debate on matters of philosophy and politics, and these could be discussed most readily and persuasively in the theatre. Furthermore, the fact that there had been a slough in stage composition since Berg's *Lulu* meant that there was much to be done. In particular, the new forms of music drama suggested by Stravinsky's *Histoire du soldat* and Schoenberg's *Pierrot* remained to be investigated.

One of the first young postwar composers to create an opera was Luigi Nono (1924–90), who had been associated with Boulez and Stockhausen in the total serial endeavours of the early fifties. Even at that time, however, he had written works giving forceful expression to his ideals as a humane, feeling man and a committed communist. Yet his violence was always offset by a very Italianate lyricism, nowhere more so than in the cantata *Il canto sospeso* ('The suspended

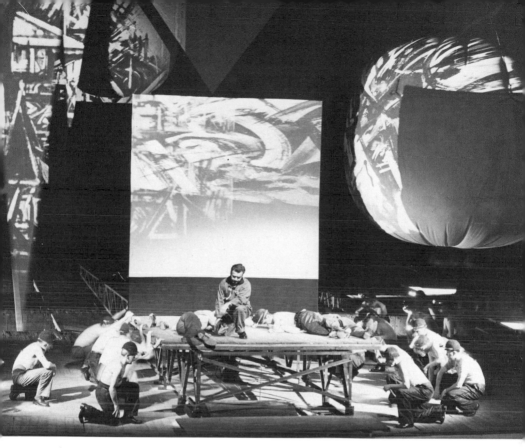

Scene from the first production of the revised version of Nono's opera *Intolleranza*, given at Venice in 1961.

song', 1956), which engages itself with current issues in a dynamic response to the words of political prisoners. When he came to write his first opera, it was to the style of *Il canto sospeso* that he turned: *Intolleranza 1960* is very much a choral opera, the music often being applied with the broad strokes of a poster brush. But Nono extends his lyrical sympathy to the central character, an immigrant who is the victim of hostility from all around him.

Nono's compatriot Luciano Berio (b. 1925) has followed a somewhat parallel path, though his political allegiance has never been so outspoken or unequivocal. In the mid-fifties he also linked himself with the advances of Boulez and Stockhausen, responding to the latter's *Gruppen*, for instance, with his *Allelujah II* for five orchestral

groups (1955–7). However, he differed from his colleagues in the special interest he took in the voice, which he could use with a typically Italian fluency while calling on a wide range of unconventional vocal techniques. He differed, too, in the physical sensuousness of his instrumental writing and in the dream-like ambience of his music. All these characteristics are to be found in two works he wrote around 1960 for Cathy Berberian, then his wife: *Epifanie* for singer and orchestra, and *Circles* for singer, harpist and two percussion players. Both show also the typically close connection in Berio's work between music and word. In *Epifanie* he uses quite different styles for settings of Joyce, Proust, Brecht and other writers, while in *Circles* he demonstrates how sung tone can merge into and imitate the sounds of instruments, producing musical equivalents for the word music and the syntactic disintegration in E.E. Cummings's poetry.

Circles may be considered Berio's first important theatrical work, since the circular character of its form is made plain by the singer's

< Cathy Berberian performing the theatre piece *Recital* (1971), written for her by Luciano Berio. The work is a study of the mental breakdown of a concert singer.

Luciano Berio, many of whose works float between music and theatre.

movement about the stage. It prepared the way for a fully fledged dramatic piece, *Passaggio* (1961–2), in which, as in Nono's *Intolleranza*, the central figure is hounded by the chorus, though here the protagonist is a woman and the subject is the degradation of the individual wrought by society's materialism. Berio followed this with a scenic oratorio on the race question (*Traces*, 1964) and another theatre piece attacking capitalism in a textual-musical collage around words from Dante (*Laborintus II*, 1965).

The latter is an example of the new kind of musical-dramatic composition which began to appear in the mid-sixties, often under the name of 'music theatre', in which sound, text and gesture may be integrated in a manner that has its precedents in Stravinsky's small-scale theatre works and in *Pierrot lunaire*. These were the main influences on the music theatre of such composers as Peter Maxwell Davies (b. 1934) and Harrison Birtwistle (b. 1934). Davies's *Eight Songs for a Mad King* (1969), for example, extrapolates from *Pierrot* in its treatment

of a single character in an extreme mental state (the demented King George III), supported, or perhaps rather antagonized, by the musicians of a small ensemble. Birtwistle's *Down by the Greenwood Side* (1969), on the other hand, has more in common with the ritual theatre of Stravinsky, being an interpretation of the passing of the seasons in terms of a folk mummers' play and an old ballad.

Birtwistle's first opera, *Punch and Judy* (1966–7), could also be considered a piece of music theatre, in that it uses small forces and lends itself to presentation in the rough. It was written for the English Opera Group, an ensemble with a repertory centred on Britten, who had ventured into music theatre himself with the three 'church parables' created for the group between 1964 and 1968. Like the Britten examples, but in a much harsher key, *Punch* is ritual theatre, an enactment of the children's puppet entertainment, but with music to make the protagonist's murderous aggressiveness and urgent sexuality intensely immediate.

All these works of Berio, Davies, Birtwistle and Britten came, however, from a brief phase, and in the seventies all four composers, along with many others, returned to the opera house, though carrying with them the fluidity and novelty of approach that music theatre had made possible. No doubt this was part of a larger return to more conventional forms and practices – Davies wrote his First Symphony during the decade – but there was also a greater willingness to accommodate new work on the part of opera companies.

The principal subject of Berio's operas is – characteristically for an artist so concerned with languages, actions and modes of discourse – opera itself, and his first such work has the simple title *Opera* (1969–70). The work goes back to the origins of its genre in re-using a song text from Monteverdi's *Orfeo* and it contains numerous references to other music, including Berio's own (though without the dazzling rush of direct quotation to be found in his *Sinfonia* for eight voices and orchestra of 1968–9). The work is partly a critical history of western music, but it also tells the story of the sinking of the *Titanic*, and alongside both these catastrophes (as both seem to be) there is a third, the stagnation of western capitalism. This sense of the theatre as political metaphor, itself an inheritance from Verdi and even Monteverdi, also marks Berio's later operas: *La vera storia* ('The true story', 1982) which is a deconstruction of *Il trovatore*, and *Un re in ascolto* ('A king listening', 1984), where the central character is at once an impresario, Prospero in a version of *The Tempest*, and the ruler of a disintegrating kingdom.

A scene from Harrison Birtwistle's first opera *Punch and Judy*, performed in 1968.

Gerald English in a scene from the first production of the revised version of Berio's *Opera*, given at Florence in 1977.

The first page of Concertato I from Luciano Berio's autograph score of his *Un re in ascolto* (1984).

Birtwistle's two large-scale operas, *The Mask of Orpheus* (1973–83) and *Gawain* (1989–91), are both, like his *Punch*, treatments of myths of journeying which have to do with self-discovery. In his *Orpheus* it is as if the myth itself were journeying towards a definitive realization: the elaborate scenario brings in elements from different tellings of the Orpheus story, and others (set to electronic music as windows in the score) from parallel fables of lost love and metamorphosis. *Gawain* is a dramatically more straightforward use of the medieval epic of Sir Gawain and the Green Knight, though again the massive, dense and elemental character of the music suggests at once modern uncertainty

176

and primitive force – the force here being that of ancient society and of the natural world with which Gawain is in combat.

Berio's musical style – caressing, opalescent and rich in reference – is some way distant from Birtwistle's, but the two are linked in that so much of their music has a dramatic feeling for pace and gesture even when it is destined for the concert hall. For Birtwistle the concert hall is essentially a theatre, in which soloists and choruses make statements, challenge one another and join together. This may sometimes give rise to formalized action, as in *Verses for Ensembles* (1969), where players take up different stations on the platform depending on their roles, like celebrants and acolytes in a liturgy, or the aptly named *Secret Theatre* (1984), where one position is reserved for the player or players who at any time are holding the endless melody against the machinery of accompaniment.

In Berio's case the theatrical element in musical performance is often the dramatic potency of the solo musician, which he has

Berio's autograph of the opening of his *Sequenza III* for female voice (1965), using diverse kinds of vocal technique.

Mauricio Kagel, with pin-ups of Bartók and Berg.

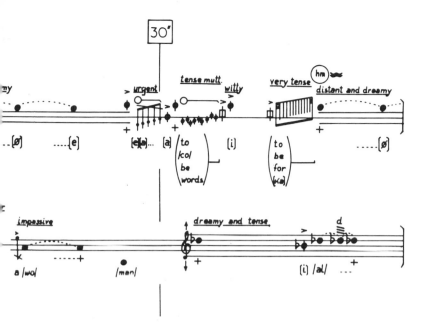

explored in his series of *Sequenze*, each written for a particular virtuoso and each seizing on what is peculiar to performance on a particular instrument. *Sequenza VI*, for instance, requires frenetic bowing on the viola, while *Sequenza IV* demands a pianist of extreme dexterity in both fingers and feet. At the same time, such works, like a great many compositions of the sixties and seventies, set out to extend the limits of performance possibility, introducing new notations for a whole variety of new effects.

Berio's *Sequenze*, and his works for larger forces, all play on the physical, gestural power of superb performance. By contrast, Mauricio Kagel (b. 1932) has concerned himself with a music of poverty and error. His works require unusual techniques, gross deformations of performance skill, the use of extraordinary instruments and so on, all undertaken as much for visual and dramatic as for musical effect. *Sur scène* is a crazy charade of speech, singing, mime and music; *Pas de cinq* notates the movements of five actors about a stage, requiring no other sound; *Match* is a musical tennis game for cellists, with a percussionist umpire; and *Unter Strom* ('Under stress') has three players making music on household equipment.

Works of this kind suggest an irreverent and provocative sense of the comic, and undoubtedly it is part of Kagel's intention to create

Kagel on the set for his film *Ludwig van* (1969), a comic-critical homage to Beethoven.

effects of bizarre humour. Beyond that, however, lie the questions posed by a critical intelligence, questions about the point of virtuosity, about the ethics of a culture based on producing waste, about whether or not there is a need and a function for music, about the overloading of western civilization with masterpieces from the past. Kagel suggested that the bicentenary of Beethoven's birth in 1970 should be marked by an abstention from performance, and his own 'tribute', *Ludwig van*, took the form of a film questioning the use to which Beethoven's music is put.

Kagel's critical sense sets him apart from Cage, who is not prepared to criticize anything, and yet the anarchy of the result often brings a resemblance. Cage's involvement with new forms of theatre began with the 'happenings' he helped to bring about in the summer of 1952 and continued with a sequence of works 'indeterminate with respect to performance'. Instead of composing according to chance operations he was now trying to leave as much as possible unfixed until the moment of performance. 'I try to keep my curiosity and awareness

with regard to what's happening open', he has said, 'and I try to arrange my composing means so that I won't have any knowledge of what might happen.' His *Variations* series (1958–68) shows the result of this attitude: notation is extremely enigmatic or else nonexistent, the instructions for *Variations V* consisting only of descriptions of past performances. One of those included dance, film, television images, lighting effects and scenery as well as sound, and such 'mixed media' shows became common in the late sixties and early seventies, particularly in the USA and Germany. Cage himself moved on in his *Musicircus* (1967) to make a work which was simply an opportunity for artists in different media and from different traditions to take part together in a totally unstructured event.

It is instructive to compare Cage's *Musicircus* with superficially similar conceptions by Stockhausen, such as his *Ensemble*, a four-hour event held at Darmstadt in 1967 and made up of specially written pieces by composers present, or his *Musik für die Beethovenhalle* (1969), a plan for music of his own to be played during an evening throughout the auditoria and corridors of a concert-hall building. The difference here is that Stockhausen orchestrated his events: the 'form scheme' was laid down, and everything was subservient to his creative will. Cage, on the other hand, simply invited his participants and allowed them to get on with it.

Stockhausen's *Ensemble* and *Musik für die Beethovenhalle* could be seen as expansions of the spatial music of *Gruppen*, but now, partly under the influence of exotic traditions, he was becoming more aware of the contributions that location might make to a ritual music. In *Sternklang* ('Star sound', 1971) he composed music to be given in a public park at night, several widely distributed electronic ensembles taking part in an astrological ceremony of sound and incantation, co-ordinated by musical signalling and by torch-bearing runners. This was soon followed by a work for an adaptable indoor space, *Alphabet für Liège*, which is a kind of exhibition of the properties of sound vibrations, both physical and metaphysical. And in two orchestral works of the same period Stockhausen brought ceremonial action to the concert hall: *Trans* is a dream transcription, with orchestral strings seen on stage in a reddish violet light, playing still harmonies which curtain the irruptive sounds emanating from winds and percussion behind them, and *Inori* ('Adorations' in Japanese, 1973–4) has an elevated mime who leads the orchestra in gestures of prayer.

Nearly all of Stockhausen's works since *Inori* carry some theatrical narrative; most of them belong to the seven-day cycle of operas, *Licht*,

which he began in 1977. This is a cosmic drama played out by three central characters: Michael, the hero, knight and saviour, who has elements of the archangel, of Christ and of the composer, Eve, the eternal-feminine, wife and consort, and Lucifer, the spirit of negation. Each of the characters may be embodied by any number of singers, dancers or instrumentalists (the instrumentalist as a costumed character on stage is one of Stockhausen's great inventions), the characterization being achieved musically by constant reference to a distinguishing 'formula' or melody. The presence of these melodies confers a strong musical consistency, even a sense of mantric repetition, but Stockhausen applies to them techniques of transformation that came out of serialism, and the separate scenes of *Licht* continue the exploration of live and electronic resources typical of his work in the fifties. Admirers of *Kontra-Punkte* or *Kontakte* may be bemused by Stockhausen as creator of epic drama, but this does seem to be where he was heading all along – his early purity of design, for instance, was stimulated more by a search for divine perfection than by rigorous materialism.

While Stockhausen has continued to explore the spiritual powers of music, other composers have directed their attention to its use as an instrument not only of political comment but also of propaganda and education. The view that music should take responsibility in the cause

An extract from Cornelius Cardew's autograph of his *The Great Learning* (1971), which was done as a Maoist statement in August 1972.

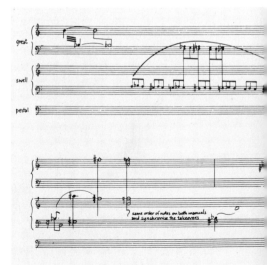

of revolution, already espoused by Nono in the fifties, gained ground in the late sixties, when the new left gained an explosion of support from young people in America, Amsterdam, Germany, Paris, England and around the globe. Suddenly musicians of quite different artistic persuasions responded to the need they saw for music which would serve socialism, whether by demonstrating personal sympathy, by encouraging political activism, or by appealing to the mass public.

Ironically, this was happening at a time when composers in ostensibly communist states were beginning to escape from political constraint and take up the western avant-garde techniques which they saw as a liberation. In Hungary, where Bartók provided a model, there were underground efforts to see beyond Soviet-directed musical Stalinism in the works of Ligeti and of György Kurtág (b. 1926), but Ligeti's career effectively began after his escape to the west in 1956 and Kurtág's music was little known until the seventies. During the sixties the way was led by Poland, whose two most prominent composers, Witold Lutosławski (1913–94) and Krzysztof Penderecki (b. 1933), were influenced by developments in orchestral sonority introduced by Xenakis, Stockhausen, Boulez and Cage. As for Russia, the cultural thaw of the last Khrushchev years made it possible for Shostakovich to take a more overtly critical line, especially in his 'Babiy Yar' symphony (1962), though again it was not until the seventies that

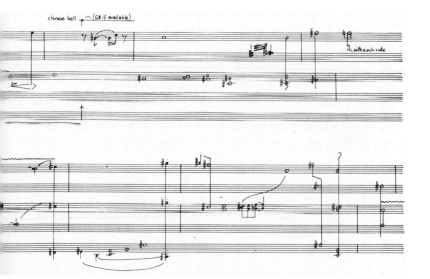

composers of the next generation, notably Alfred Schnittke (b. 1934), began to be known in the west.

So in the late sixties and early seventies, when political engagement was a live issue for composers in western Europe and the USA, the ideal of 'socialist music' that could be observed behind the Iron Curtain was tightly constrained. Cantatas in praise of the Soviet leaders, symphonies expressive of love for the fatherland and operas on tales of peasant heroism were the approved forms, as they had been since the thirties, and composers who went against the grain, like Kurtág and Lutosławski, were also going against the system. Composers of the new left in the west therefore had to search elsewhere for models. Weill's music, particularly that written for words by Brecht, might have offered a pattern for imitation, but by this time 'Mack the Knife' and 'Surabaya Johnny' had become standards in the world of bourgeois entertainment. As for communist China, there was little evidence from there of anything but a denial of native traditions in such farragos of late Romanticism as the *Yellow River Concerto*.

However, some western musicians were attracted by the Chinese practice of composition, involving collective creative work and the submission of works to public criticism so that they might be made more appropriate to the general need. Collective composition was cultivated by the Italian ensemble Musica Elettronica Viva, whose *Sound Pool* (1968) was a freely conceived work in which both 'musicians' and 'audience' might take part, and in London at about the same time the Scratch Orchestra was formed by Cornelius Cardew (b. 1936) and others to play improvisations, collective compositions and pieces by members, most of them amateurs of no great skill. Cage's work had suggested that everyone might be a musician, everyone a composer; now that notion was taking on a more general, social significance.

Within a short time Cardew and Frederic Rzewski (b. 1938), the leading member of Musica Elettronica Viva, had engaged themselves more directly in political struggle, as had Christian Wolff. His *Accompaniments I* for singing pianist (1972) takes a Chinese text in which a veterinary surgeon and a midwife speak of the application of Maoist thought to the problems of everyday life. Rzewski's *Attica* and *Coming Together*, both also composed in 1972, look at events nearer home. They use the words of inmates involved in an American prison riot and, as Rzewski notes, 'attempt to heighten them by underscoring them with music. There is therefore a certain ambiguity between the personal, emotional, and meditative aspects of the texts, which is enhanced by cumulative repetition, and their wider political

Hans Werner Henze, opera composer and, latterly, committed left-wing socialist.

A scene from the first production of Henze's 'actions for music' *We Come to the River*, given at Covent Garden in 1976.

implications. I believe this ambiguity can be either a strength or a weakness in performance, depending on the degree to which the performer identifies personally with the revolutionary struggle taking place in America's prisons and the world at large.'

Like these pieces of Wolff and Rzewski, the great majority of explicitly socialist works have depended for their effect on a text, music alone seeming incapable of carrying a political message. Henri Pousseur (b. 1929), however, has responded to the challenge of writing non-vocal music which might embody his utopian ideals for a society of all-embracing equality and plurality. The background to his ideals was at once political and purely musical, for, as one of the Darmstadt group of the fifties, he had applied himself to the continuing problem of harmony. His particular extensions of serialism had eventually allowed him to integrate a wide variety of harmonic styles in his music, and in his orchestral piece *Couleurs croisées* ('Crossed colours', 1968) he gave this integration a social significance. The song 'We shall overcome' serves, so Pousseur writes, 'as a matrix from which the whole composition is strictly derived. . . . In particular, it is projected through a whole system of melodic-harmonic fields, beginning with a disjunct, chromatic, expressionist musical reality and ending . . . in a diatonic state which is relatively, hypothetically at peace. . . . The whole "large form" thus acts to "recount a story – musically", a story more hoped for than yet effective, at least in full (Martin Luther King: "I have a dream").'

Political music in the theatre has been the chief concern of Henze since his adoption of a militant socialist stance in the late sixties. His *El cimarrón* for vocalist and three players (1969) is a dramatic recital based on the reminiscences of a runaway Cuban slave and expressing sympathy with the abused and under-privileged; and his *Das langwierige Weg in die Wohnung der Natascha Ungeheuer* ('The wearisome path to Natascha Ungeheuer's place', 1971) is another work of music theatre, this time illustrating the ethical and aesthetic problems of a politically committed artist. These and other pieces had their culmination in an operatic work, *We Come to the River*, which Henze composed in collaboration with Edward Bond. 'In our age', the two men wrote in their note for the Covent Garden première of 1976, 'the artist must help to create the image and consciousness of the working class. There *is* nothing else art can do now, that *is* the definition of art in our time.'

Minimalism and multiplicity

For some composers of political music, such as Louis Andriessen (b. 1939) in the Netherlands, contact with a broad public and with an emphatic message has entailed styles of composition and concert-giving more familiar in the rock world – heavy amplification, irregular venues, and strongly pulsed, repetitive pieces. Other musicians, like the Estonian exile Arvo Pärt (b. 1935), have been drawn to repetition, simplicity and stasis as a means of contact not with the political world but on the contrary with the divine. This just exemplifies how the musical characteristics of 'minimalism' have been taken in quite different directions since such works from around 1970 as Riley's *In C*, Reich's *Four Organs* and Stockhausen's *Stimmung*.

The origins of minimalism can be traced only partly to rock and pop. Another significant source, in New York in the mid-sixties, was the music of La Monte Young (b. 1935), who had been writing pieces with unusually few and long notes since the fifties, and who was now giving his slow, static world a grounding in modality and just intonation (having every note in the scale tuned to an overtone of some imaginary fundamental). Repetitive figuration had featured on a smaller scale in some of the music of Cage and Satie, but Young's concern was with protracted states and processes, producing not definable works but musical environments – harmonious conditions for meditation. The music would be performed by a soloist or a small group attuned to the occasion; much was learned from Asian musical practice, and in particular from Indian singing.

Whatever the pathways of influence (Young was a student at Darmstadt in 1959), such works of Stockhausen as *Stimmung*, *Mantra* and *Inori* similarly used minimal material and an extended time-scale in order to induce meditative receptiveness, while the performances of his own live-electronic group, responding so much to the intuition of the moment, were similarly modelled more on Asian than on European musicianship. But Stockhausen never immersed himself so wholeheartedly into the bliss of reiteration, regular beat and pure

harmony as did his American colleagues in the late sixties and early seventies.

That first phase of minimalism was marked by a spirit of discovery: the discovery of models in extra-European music (while Young was taking lessons in Indian singing, Reich was studying drumming in West Africa), and the discovery of how extended musical structures could be created out of rudimentary ideas. Reich and Philip Glass (b. 1937) interested themselves in gradual processes of change, such as the progressive filling-in of rests by sustained sound in the former's *Four Organs* (1969) or the 'phasing' process, by which two or more lines repeating the same simple pattern were shifted against each other, moving in and out of phase. Both composers worked with their own ensembles, Glass preferring the rock-style amplification that had its effect on Andriessen and other European composers, while Reich's sound world was always more delicate and natural. By the early seventies, with increasing public recognition, both composers had quickly moved from pieces created with frugal resources to evening-length works for considerable arrays of instruments and players, for instance, Reich's *Drumming* (1971) and Glass's *Music in 12 Parts* (1971–4).

Glass's subsequent move, coincident with Stockhausen's, was into opera. In 1976 he collaborated with Robert Wilson on *Einstein on the Beach*, a work in panels of musical and scenic imagery with virtually no narrative. Subsequently, he produced a series of pieces in which there are much more conventional characters and stories, though still with the same elementally simple and repetitive musical support (*Satyagraha*, 1980, *Akhnaten*, 1984 and *Voyage*, 1992). His example was followed by John Adams (b. 1947), though with qualities of humour, nostalgia and finesse that Glass's amnesiac music had abandoned. His *Nixon in China* (1987) is a spectacular display of the grand rhythmic and harmonic energy that minimalism can bring into play; it is also a witty and intimate portrait of the privacies and vulnerabilities of those whose supposed role it is to rule the world, the action taking place during President Richard Nixon's visit to Mao Tse-Dong in Beijing.

Reich's music of the seventies and eighties suggests a process as gradual and logical as that of any of his compositions – a consolidation of the rhythmic, harmonic and structural methods that were developed as he worked towards *Drumming*, and an extension from ensembles based on keyboards and tuned percussion to voices in *Tehilim* (1981) and symphony orchestra in *The Four Sections* (1987). Generally the play of pattern gives his music a geometrical abstractness, but there was also a move towards more explicit subject matter, whether of

Richard Nixon arrives at Beijing Airport: a scene from John Adams's *Nixon in China* in the Houston Grand Opera production, Texas, 1987.

global relevance in *The Desert Music* for chorus and orchestra (1984) or more personally voiced in *Different Trains* for string quartet and tape (1988), where the repetitions and interlocking processes of the instrumental music are aligned with a similar network of recorded reminiscences having to do with railway journeys.

Alongside the exuberant progress of Reich and Adams in the seventies and eighties, an older minimalist, Feldman, was moving towards flat musical landscapes of great extent (his Second String Quartet of 1983 plays for four hours), where his cherished quiet, single sounds could unfold with something of the newer music's pattern-making but none of its dynamism. And there were other composers of Feldman's generation whose music was becoming more spacious, less eventful and less propelled. The later works of Nono, for instance, withdraw

György Kurtág, composer
of miniatures having great
expressive power.

from hot engagement in revolutionary struggle to a position of intense
contemplation, of attention to sustained sounds and resonances.

Kurtág is another example. His minimalism is of a different kind, a
matter of inscribing tiny musical spaces with the maximum of expres-
sion and imagination, following on from the atonal miniatures of
Webern. Kurtág's minimalism is a minimalism of daring, of doing
without the upholstery of scale and the comfort of familiarity. Most of
his pieces are very short and for small ensembles (often with a solo
voice). This is music where every note counts and where the perplex-
ities of musical communication are vaulted over by a tense immediacy
of expression. The brevity has something to do with the directness, as
does the freely rethought instrumentation (Kurtág often writes for
unusual combinations, and latterly for unusual spacings of groups
within the concert hall), but the directness itself makes it hard to

explain completely the music's febrile quality. In the concert-length *Kafka-Fragmente* for soprano and violin (1985–6), for instance, just two performers prove capable of conveying the range and intensity of feeling and thought to be found in Kafka's diaries and letters – that is his humour, his despair, his severity with himself and his understanding.

The music of the later Nono and of Kurtág, and also that of Wolfgang Rihm (b. 1952), whose orchestral music like Kurtág's is often for splintered resources, seems to take up the challenge from the position reached by the Second Viennese School around the time of the first world war, the challenge of an aesthetic nakedness, of taking nothing for granted, of constant reinvention. Theirs is minimalism of a sort, even if it has little to do with the bright activity of much of Reich's music or the luminous repetitive chant of Pärt.

The outstanding feature of music since 1970 is probably divergence. Up to that point it had been broadly possible to see contemporary music as divided into two or three streams. In the twenties and thirties, for instance, there was the antagonism between the school of Schoenberg and the school of Stravinsky, with a third stream of unregenerated Romantics such as Strauss or Rakhmaninov. In the fifties and sixties the choice seemed to be that between the avant-garde (Boulez, Stockhausen and Babbitt) and the experimentalists, less encumbered with theory (Cage, Feldman and Wolff), with again a third stream of 'traditionalists' (Britten, Shostakovich and Barber), so that the development of Stravinsky's music in the fifties, for example, could be seen as a move from one party to another.

Looking back over the last hundred years since Debussy's *Prélude*, however, the whole history of modern music begins to seem less a jostling of rival alliances than an increasing turmoil of separate voices. Correspondingly the notion of musical progress, essential to the idea of modernism, begins to appear quaint. The fact that, for instance, while Boulez was writing *Le marteau sans maître* (1953–5) Shostakovich was composing his Tenth Symphony no longer seems very shocking – in the nineties such vast disparities could be found in the output of a single composer, perhaps even in a single work. *Le marteau sans maître* owed its existence partly to Boulez's desire for progress, which is why it may now look more distant than the Shostakovich. Boulez's own virtual silence since the mid-sixties may be understood as the reaction of a leader without a cause.

Another effect of the new viewpoint has been a revaluation of composers who had previously been excluded from consideration, either because they seemed merely reactionary or because their work

was marginal to the main thrusts that had been identified. Alexander Zemlinsky (1871–1942) was disregarded because his music was in the tradition of early Schoenberg and Strauss. He was the former's brother-in-law and admired by him as well as by Berg despite the fact that he did not follow his colleagues into atonality. The wider dissemination of his music, including such particular achievements as his Second String Quartet (1913–14) and opera *Der Zwerg* (1921), did not take place until after the centenary of his birth.

Simultaneously the mavericks of twentieth-century music have come to be recognized as part of its rich fabric: examples would include Busoni, Scelsi and Conlon Nancarrow (b. 1912). Nancarrow's music consists almost entirely of studies for player piano, executing formidably complex rhythmic engineerings inspired partly by jazz and partly by a joy in the mechanical instrument's capabilities. Other independents include Charles Koechlin (1867–1950), whose enormous output touched on virtually all contemporary kinds of music, or Lou Harrison (b. 1917), a pupil of Cowell and another composer whose work assigns no particular value to the western tradition over others from, especially, Pacific Asia.

The western hegemony has, of course, also been questioned, more or less explicitly, by the arrival of composers from outside Europe and North America. Toru Takemitsu (b. 1930), for example, has not only used Japanese instruments alongside a standard symphony orchestra but also, and more fundamentally, allowed a Japanese feeling for time, colour and silence into his much larger body of works for western instruments alone, complementing, and in many ways confirming, what had been achieved in the other direction by Messiaen, Cage and Boulez. For other composers the sense of 'tradition' is in contemporary rock music, or in pre-Renaissance chant and polyphony (for instance, Pärt); few would now want to accept, as Schoenberg and Boulez did in their times, that the essential obligation was to a chain of European masterpieces stretching back through Wagner, Beethoven, Mozart and Bach to a point of origin somewhere in the later Middle Ages.

One signal of the new multiplicity – though it is unlikely to be a cause, since this is much more than an exclusively musical phenomenon – is the constant availability of such a large body of recorded music of all kinds, especially since the introduction of the compact disc in the early eighties. Moreover, recorded music is no longer channelled through a handful of international companies: there are hundreds of small firms, many of them issuing new music, and that in itself has

helped to break down the uniformity of the fifties and sixties. As Elliott Carter has remarked, composition has followed the way of the cinema: there are no longer vast movie houses serving entire populations, but instead a wide variety of small theatres catering for specialist tastes and interests.

The age of the 'great composer', whose music is judged to have a universal validity, may therefore be over, though Carter's own music may be an exception. His escape from the Stravinskian-American Neoclassicism of his Boulanger training was by way of his First String Quartet (1950–51), where strongly independent contrapuntal lines carry themselves through atonal regions with an urgency that welds the usual four movements into one sweep. During the next twenty-five years he proceeded through a sequence of instrumental works, similarly monumental in size and substance, driving in energy, and powerfully characterized as to details and kinds of musical movement, these works including the Double Concerto for harpsichord and piano each with its own chamber orchestra (1961) and the Concerto for Orchestra (1969). Then in the mid-seventies he began writing songs, and in the mid-eighties embarked on a sequence of chamber-instrumental lyrics, while continuing to write concertos and quartets of large dimensions.

There are other composers whose music of the seventies and after conveys a belief in the continuing possibility of musical creation on a large scale without conspicuous reference to the symphonic past. Birtwistle's early reference points in Stravinsky, Varèse and Messiaen were rapidly overtaken, to a point where his music seems – in this respect alone like Carter's – to refer to nothing outside itself, unless to a primeval world of signals and drum beats. This has come about partly because of Birtwistle's concern to create within his music processes of birth and regeneration, beginning from the new and going on, for instance, his big orchestral pieces *The Triumph of Time* (1972) and *Earth Dances* (1986). The former is a procession of events, some of which recur unchanged while others advance through transformation and some just make one startling appearance.

Xenakis is another composer whose music does not relate to any history between the distant past and the present. His later works, such as the orchestral *Jonchaies* (1977), continue the rude eruption of sound that had asserted itself in his very first scores. There is also Brian Ferneyhough (b. 1943), whose fearsomely complex notation takes performers and listeners up to the edge of what is feasible. Ferneyhough, unusual among composers of his generation, has

The opening page of Brian Ferneyhough's *Etudes transcendantales* (1984) for voice and four instruments.

presumed that the modernist quest can be carried forward, and his *Etudes transcendantales* for voice and four instruments (1984) exceeds *Le marteau sans maître* rather as that work exceeded *Pierrot lunaire*.

Much more characteristic of the musical present is its intermingling with so many musical pasts – the musical pasts freely available in recordings and still so dominant in concert halls. The recordings made of Cage's *Variations IV* (1964) include scraps of music and speech of many different kinds, all willingly admitted in a free-for-all image of what Cage has in another context referred to as 'McLuhan's point that nowadays everything happens at once'. Stockhausen's *Hymnen* (1966–7), is a rather thoroughly composed montage which provides ample room for quotations of national anthems from around the world. The third movement of Berio's *Sinfonia* (1968–9) has the orchestra ranging extracts from many composers in an exuberant welter of cross-references around the scherzo from Mahler's Second Symphony, while

at the same time eight vocalists produce a further stream of allusions focused on Beckett's *The Unnamable*. And Pousseur's opera *Votre Faust* (1961–7) is a game of quotation and suggestion in which, as Berio has commented, 'the main personage . . . is the history of music, not out of the old Faustian urge to use the past but out of the desire and the need to deal with realities wherever they may be'.

Dealing with 'realities wherever they may be' has meant for Berio producing a highly diverse output which by itself would demonstrate the range of options currently available, the only common feature being his suavity of execution. In some works, such as the orchestral *Formazioni* (1987), he has gone as far as Carter, Birtwistle or Xenakis in their different ways in finding new possibilities of sound and form. He has also, however, made orchestral transcriptions of Brahms and Mahler and developed pieces out of Sicilian folksongs (*Voci* for viola and orchestra, 1984) or Schubert sketches (*Rendering* for orchestra, 1990). Berio's explorations of solo instrumental gesture have continued in his *Sequenza* series and have brought about a dramatic use of electronic resources with live voices and instruments, as in *Ofanim* (1988), and have generally opened up a creative space in which he can refer to anything in musical history, including his own past works.

The evidence of Berio's generosity and fecundity suggests an optimistic view of the multifarious culture in which he works, but other composers have been less sanguine. Bernd Alois Zimmermann (1918–70) began writing music in the late forties from a position of Stravinsky-Schoenberg-jazz fusion close to that of Henze, but while working on his opera *Die Soldaten* (1958–64) he came to feel that quotation impressed itself on his music and that all times are contemporary – a view dramatically enacted by the simultaneous presentation of diverse scenes. *Die Soldaten* is a work of great boldness and certainty, but Zimmermann's awareness of the omnipresence of the past seems to have led him to despair, and the works he composed shortly before his suicide are inward and bleak.

Others have seen in the same phenomenon a cause of liberation. George Rochberg (b. 1918), who went through a common history of post-Schoenbergian and post-Webernian serialism in the fifties and early sixties, arrived at stylistic synthesis in his *Contra mortem et tempus* for four instruments (1965). Here, however, the quotations are all from twentieth-century works, with the implication that the development of modern music has been stalled. In Rochberg's later works his doubts have become explicit. He came to realize, as he has written, 'that the music of the "old masters" was a living presence, that its

spiritual values had not been displaced or destroyed by the new music'. And so he was led, in his Third Quartet (1972–3) and other works, to write what amount to recompositions of the past, of Mahler and late Beethoven in particular. The retrieval of past possibilities is also a feature of the later music of Ligeti, such as his orchestral *Melodien* (1971) or Horn Trio (1982), but Ligeti's works are like computer representations – fantastical, wild and above all artificial – whereas Rochberg suggests the possibility and need for a direct return to the old certainties, and his lead has been followed by a great many composers, particularly in the USA.

This new Romanticism, necessarily ironized because it is deliberate and recuperative, was also a powerful feature of Soviet music, but for different reasons. The posthumous publication of Shostakovich's memoirs, although disputed, at least allowed scope for discussion about how his apparent acquiescence in state dictates – his Fifth Symphony (1937), named the 'Soviet artist's reply to just criticism' – might have concealed a loud refutation and refusal as its subtext. In that case some of the most apparently reactionary music of the mid-

An extract from the autograph score of Alfred Schnittke's First Symphony (1969–72).

century might indeed be, on a different level, its most forward-looking – music in which, as in the highly sophisticated world of Berio, compositional language itself is subject to the artist's will, to be pushed and pulled and acted against. Mahler, whose symphonies operate in just this world of false appearances, began in the sixties and seventies to seem a central figure in the century's music.

Shostakovich's last symphony, his Fifteenth (1971), took irony a stage further by introducing outright quotations (from Rossini's *William Tell* overture and from Wagner) in a mood seemingly closer to Zimmermann's hopelessness than to Berio's effervescence. Schnittke, in so many ways Shostakovich's successor, has gone on from this, and though the comparison is rather with Berio in the variety of his encounters with the past – Ivesian collage in his First Symphony (1969–72), Baroque pastiche in his several concerti grossi, a distinctly contemporary cadenza for Beethoven's Violin Concerto and identification with sacred chant in several works – the sense of responding to pressure, to political pressure and to the pressure of ill health, is a Russian and Soviet inheritance.

For such composers as Schnittke history may be a burden; for others, like Berio, it is an endless source of fascination and discovery. Some, like Rochberg, would seek to stop the clock; some, like Ferneyhough, would have it race onward. Many more have chosen their own particular histories, so that the history of modern music becomes a history of histories, and there are composers working at the end of the century whose music could be fitted into almost any of the preceding chapters – some writing symphonies that would have been recognized by Mahler and Sibelius, some composing as if at the court of Nadia Boulanger, some continuing the endeavour of early electronic music and some going on with the search for a politically active art. The only certainty about the future must be that the pathways will continue to fork and join and fork again.

Bibliography

This is a select list of books published in English

GENERAL

Martin Cooper, ed.: *The Modern Age
1890–1960*. The New Oxford History of
Music vol. 10 (London, New York and
Toronto, 1974)
Peter Franklin: *The Idea of Music: Schoenberg
and Others* (London, 1985)
Paul Griffiths: *Modern Music: The Avant
Garde Since 1945* (London, 1981)
André Hodeir: *Since Debussy: A View of
Contemporary Music* (New York, 1961)
Paul Henry Lang and Nathan Broder, ed.:
Contemporary Music in Europe (New York,
1965)
David Nicholls: *American Experimental Music
1890–1940* (Cambridge, 1990)
Eric Salzman: *Twentieth-Century Music: An
Introduction* (Englewood Cliffs, NJ, 1967)
Jim Samson: *Music in Transition: A Study of
Tonal Expansion and Atonality 1900–1920*
(London, 1977)
Arnold Whittall: *Music Since the First World
War* (London, 1977)

ANTHEIL

George Antheil: *Bad Boy of Music* (Garden
City, NJ, 1945)
Ezra Pound: *Antheil and the Treatise on
Harmony* (Chicago, 1927)

BABBITT

Milton Babbitt: *Words about Music* (Madison,
Wis., 1987)

BARTÓK

Béla Bartók: *Essays*, ed. Benjamin Suchoff

(London, 1977)
Todd Crow, ed.: *Bartók Studies* (Detroit,
1976)
Ernö Lendvai: *Béla Bartók: An Analysis of his
Music* (London, 1971)
Halsey Stevens: *The Life and Music of Béla
Bartók* (New York, 1953, 2nd ed. 1964)

BERG

Mosco Carner: *Alban Berg: The Man and the
Work* (London, 1975)
Douglas Jarman: *Wozzeck* (Cambridge, 1989)
—: *Lulu* (Cambridge, 1991)
George Perle: *The Operas of Alban Berg*
(Berkeley and Los Angeles, 1980–4)
Anthony Pople: *Berg: Violin Concerto*
(Cambridge, 1991)
Hans Ferdinand Redlich: *Alban Berg: The
Man and his Music* (New York, 1957)
Willi Reich: *The Life and Works of Alban Berg*
(London, 1965; New York, 1965)

BERIO

David Osmond-Smith, ed: *Luciano Berio:
Two Interviews* (London, 1985)
—: *Berio* (Oxford, 1991)

BIRTWISTLE

Michael Hall: *Harrison Birtwistle* (London,
1984)

BOULEZ

Pierre Boulez: *Notes of an Apprenticeship*
(New York, 1968)
—: *Boulez on Music Today* (London, 1971)

—: *Conversations with Célestin Deliège*
(London, 1977)
—: *Orientations* (London, 1986)
—: *Stocktakings from an Apprenticeship*
(Oxford, 1991)
William Glock, ed.: *Pierre Boulez: A
Symposium* (London, 1986)
Paul Griffiths: *Boulez* (London, 1978)
Dominique Jameux: *Pierre Boulez* (London,
1991)

BRITTEN

Peter Evans: *The Music of Benjamin Britten*
(London, 1979)
Eric Walter White: *Benjamin Britten: His Life
and Operas* (London, 1970; Berkeley and
Los Angeles, 1970)
Arnold Whittall: *Britten and Tippett* (London,
1982, 2nd ed. 1990)

BUSONI

Antony Beaumont: *Busoni the Composer*
(London, 1985)
Ferruccio Busoni: *Sketch for a New Esthetic of
Music* (New York, 1911, many subsequent
eds.)
Edward J. Dent: *Ferruccio Busoni* (London,
1933, reprinted 1974)

CAGE

John Cage: *Silence* (Middletown, Conn.,
1961)
—: *A Year from Monday* (Middletown,
Conn., 1967)
—: *M: Writings '67–'72* (London, 1973)
—: *Empty Words: Writings '73–'78* (London,
1980)
—: *For the Birds* (London, 1981)
—: *X: Writings '79–'82* (London, 1987)
—: *I–VI* (Cambridge, Mass. and London,
1990)
Paul Griffiths: *Cage* (London, 1981)
Richard Kostelanetz, ed.: *John Cage* (New
York, 1970)
James Pritchett: *The Music of John Cage*
(London, 1993)

CARDEW

Cornelius Cardew: *Scratch Music* (London,
1972)

CARTER

Elliott Carter: *Collected Writings* (New York,
1977)
David Schiff: *The Music of Elliott Carter*
(London, 1983)

COPLAND

Aaron Copland: *Our New Music* (New York,
1941, 2nd ed. 1968)

COWELL

Henry Cowell: *New Musical Resources* (New
York, 1930, reprinted 1969)

DAVIES

Paul Griffiths: *Peter Maxwell Davies* (London,
1982)

DEBUSSY

Claude Debussy: *Monsieur Croche, the
Dilettante Hater* (New York, 1928, many
subsequent eds.)
François Lesure and Roger Nichols, ed.:
Debussy Letters (London, 1987)
Edward Lockspeiser: *Debussy: His Life and
Mind*, 2 vols. (London, 1962–5)
Roger Nichols: *Debussy* (London, 1973)
— and Richard Langham Smith: *Pelléas et
Mélisande* (Cambridge, 1989)

EISLER

Albrecht Betz: *Hanns Eisler Political Musician*
(Cambridge, 1982)

ELGAR

Edward Elgar: *A Future for English Music and
Other Essays*, ed. Percy Young (London,
1968)
Michael Kennedy: *Portrait of Elgar* (London,
1968)

—: *Elgar: Orchestral Works* (London, 1970)
Jerrold Northrop Moore: *Edward Elgar: A Creative Life* (London, 1984)

FALLA

Ronald Crichton: *Manuel de Falla: Descriptive Catalogue of his Works* (London, 1976)
Jaime Pahissa: *Manuel de Falla: His Life and Works* (London, 1954)

GLASS

Philip Glass: *Opera on the Beach* (London, 1988)

HILLER

Lejaren Hiller and Leonard Isaacson: *Experimental Music* (New York, 1959)

HINDEMITH

Paul Hindemith: *A Composer's World* (Cambridge, Mass., 1952)
Geoffrey Skelton: *Paul Hindemith: The Man behind the Music* (London, 1976)

HONEGGER

Arthur Honegger: *I am a Composer* (New York, 1966)

IVES

Henry and Sidney Cowell: *Charles Ives and his Music* (New York, 1955, 2nd ed. 1969)
H. Wiley Hitchcock: *Ives* (London, 1977)
Charles Ives: *Essays before a Sonata, The Majority and Other Writings*, ed. Howard Boatwright (London, 1969; New York, 1969)
—: *Memos*, ed. John Kirkpatrick (New York, 1971; London, 1973)

JANÁČEK

Hans Hollander: *Janáček: His Life and Works* (London, 1963)
John Tyrrell: *Káťa Kabanová* (Cambridge, 1982)
—: *Janáček's Operas: A Documentary Account*
(London, 1992)
Jaroslav Vogel: *Leoš Janáček: His Life and Works* (London, 1963)
Paul Wingfield: *Janáček: Glagolitic Mass* (Cambridge, 1992)

KRENEK

Ernst Krenek: *Horizons Circled: Reflections on my Music* (Berkeley, Los Angeles and London, 1974)

LIGETI

Paul Griffiths: *György Ligeti* (London, 1983)

MAHLER

Henry-Louis de la Grange: *Mahler: A Biography*, vol. 1 (London, 1974)
Alma Maria Mahler: *Gustav Mahler: Memories and Letters* (New York, 1946, London, 1968)
Donald Mitchell: *Gustav Mahler: The Early Years* (London, 1958)
—: *Gustav Mahler: The Wunderhorn Years* (London, 1976)
—: *Gustav Mahler: Songs and Symphonies of Life and Death* (London, 1985)

MESSIAEN

Paul Griffiths: *Olivier Messiaen and the Music of Time* (London, 1985)
Robert Sherlaw Johnson: *Messiaen* (London, 1975)
Roger Nichols: *Messiaen* (London, 1975)

MILHAUD

Darius Milhaud: *Notes without Music* (London, 1952)

NIELSEN

Robert Simpson: *Carl Nielsen, Symphonist 1865–1931* (London, 1952)

PARTCH

Harry Partch: *Genesis of a Music* (Madison, Wis., 1949, 2nd ed. New York, 1974)

POULENC

Henri Hell: *Francis Poulenc* (London, 1959)

PROKOFIEV

Israel Nestyev: *Prokofyev* (Stanford, Calif., 1961)
Sergey Prokofiev: *Autobiography, Articles, Reminiscences*, ed. S.I. Shlifstein (Moscow, n.d.)

RAVEL

Roger Nichols: *Ravel* (London, 1977)
A. Orenstein: *Ravel: Man and Musician* (New York, 1975)

REICH

Steve Reich: *Writings about Music* (Halifax, NS, and New York, 1974)

SATIE

Rollo Myers: *Erik Satie* (London, 1948)
Pierre Daniel Templier: *Erik Satie* (London, 1971)

SCHOENBERG

Benjamin Boretz and Edward T. Cone, ed.: *Perspectives on Schoenberg and Stravinsky* (Princeton, NJ, 1968)
Carl Dahlhaus: *Schoenberg and the New Music* (Cambridge, 1987)
Ethan Haimo: *Schoenberg's Serial Odyssey* (Oxford, 1990)
René Leibowitz: *Schoenberg and his School: The Contemporary Stage of the Language of Music* (New York, 1949, reprinted 1975)
George Perle: *Serial Composition and Atonality: An Introduction to the Music of Schoenberg, Berg and Webern* (Berkeley, Calif., 1962, 2nd ed. 1968; London, 1962, 2nd ed. 1968)
Charles Rosen: *Schoenberg* (London, 1975)
Josef Rufer: *The Works of Arnold Schoenberg* (New York, 1963)
Arnold Schoenberg: *Style and Idea*, ed. Dika Newlin (New York, 1950), ed. Leo Black (London, 1975)

H. H. Stuckenschmidt: *Arnold Schoenberg* (London, 1977)
Karl H. Wörner: *Schoenberg's 'Moses and Aaron'* (New York, 1964)

SHOSTAKOVICH

Norman Kay: *Shostakovich* (London, 1971)
David Rabinovich: *Dmitry Shostakovich* (Moscow and London, 1959)
S. Volkov, ed.: *Testimony* (London, 1979)

SIBELIUS

Robert Layton: *Sibelius* (London, 1965)
Erik Tawaststjerna: *Sibelius*, vol. 1 (London, 1975)

SKRYABIN

Faubion Bowers: *The New Scriabin: Enigma and Answers* (New York, 1973)

STOCKHAUSEN

Jonathan Cott: *Stockhausen: Conversations with the Composer* (London, 1974)
Jonathan Harvey: *The Music of Stockhausen: An Introduction* (London, 1974)
Michael Kurtz: *Stockhausen* (London, 1992)
Robin Maconie: *The Works of Karlheinz Stockhausen* (London, 1976, 2nd ed. 1991)
Karlheinz Stockhausen: *Stockhausen on Music* (London, 1989)
Mya Tannenbaum: *Conversations with Stockhausen* (Oxford, 1987)
Karl H. Wörner: *Stockhausen: Life and Work* (London, 1973)

STRAUSS

Norman Del Mar: *Richard Strauss: A Critical Commentary on his Life and Works*, 3 vols. (London, 1963–72)

STRAVINSKY

Louis Andriessen and Elmer Schönberger: *The Apollonian Clockwork* (Oxford, 1989)
Benjamin Boretz and Edward T. Cone, ed.: *Perspectives on Schoenberg and Stravinsky* (Princeton, NJ, 1968)

Robert Craft, ed.: *Stravinsky: Selected Correspondence* (London, 1982–5)
Paul Griffiths: *Stravinsky* (London, 1992)
Igor Stravinsky: *An Autobiography* (New York, 1936; London, 1936, 2nd ed. 1975)
—: *Poetics of Music* (Cambridge, Mass., 1942)
— and Robert Craft: *Conversations with Igor Stravinsky* (New York, 1959; London, 1959)
—: *Memories and Commentaries* (New York, 1960; London, 1960)
—: *Expositions and Developments* (New York, 1962; London, 1962)
—: *Themes and Episodes* (New York, 1966, 2nd ed. 1967; London, 1972, in *Themes and Conclusions*)
—: *Retrospectives and Conclusions* (New York, 1969; London, 1972, in *Themes and Conclusions*)
Vera Stravinsky and Robert Craft, ed.: *Stravinsky in Pictures and Documents* (New York, 1978; London, 1979)
Pieter van den Toorn: *The Music of Igor Stravinsky* (New Haven, 1983)
Stephen Walsh: *The Music of Stravinsky* (London, 1988)
Eric Walter White: *Stravinsky: The Composer and his Works* (London, 1966; Berkeley, Calif., 1966)

TIPPETT

Ian Kemp, ed.: *Michael Tippett: A Symposium on his 60th Birthday* (London, 1965)
—: *Tippett* (London, 1984)
Michael Tippett: *Moving into Aquarius* (London, 1959)
—: *Music of the Angels* (London, 1980)

VARÈSE

Fernand Ouellette: *Edgard Varèse* (New York, 1968; London, 1973)
Louise Varèse: *Varèse: A Looking-Glass Diary*, vol. 1 (New York, 1972)

VAUGHAN WILLIAMS

Michael Kennedy: *The Works of Ralph Vaughan Williams* (London, 1964)

WALTON

Frank Howes: *The Music of William Walton* (London, 1965, 2nd ed. 1973)

WEBERN

Herbert Eimert and Karlheinz Stockhausen, ed.: *Anton Webern*, Die Reihe vol. 2 (Bryn Mawr, Penn., 1958)
Demar Irvine, ed.: *Anton von Webern: Perspectives* (Seattle, 1966)
Walter Kolneder: *Anton Webern: An Introduction to his Works* (London, 1968; Berkeley and Los Angeles, 1968)
Hans Moldenhauer: *Anton von Webern* (London, 1978)
Friedrich Wildgans: *Anton Webern* (London, 1966)

XENAKIS

Iannis Xenakis: *Formalized Music* (Bloomington, Ind., 1971)

List of illustrations

Piano Sonata. Alfred A. Kalmus (Universal Edition) Ltd.

164 Two fragments from the published score of Stockhausen's *Klavierstück XI.* Alfred A. Kalmus (Universal Edition) Ltd.

165 Extract from John Cage's *Fontana Mix.* Copyright © 1960 by Henmar Press Inc. Reprint permission granted by the publisher.

167 Opening page from the autograph score of Steve Reich's *Four Organs.* Alfred A. Kalmus (Universal Edition) Ltd.

168/9 An extract from the published score of Stockhausen's *Zyklus.* Alfred A. Kalmus (Universal Edition) Ltd.

171 Scene from the world première of Luigi Nono's *Intolleranza,* Venice 13 April 1961. From the archives of B. Schott's Söhne, Mainz. Photo Cameraphoto, Venice.

172 Cathy Berberian performing Berio's *Recital.* Photo by kind permission of RCA.

173 Luciano Berio. Photo Alfred A. Kalmus (Universal Edition) Ltd.

175 A scene from Harrison Birtwistle's first opera *Punch and Judy,* performed in 1968. Photo Zoë Dominic.

176/7 The first page of Concertato I from Luciano Berio's autograph score of his *Un re in ascolto* (1984). © 1983 Universal Edition S.P.p.A. Milano. Reproduced by permission. All Rights Reserved.

176 Scene from Berio's *Opera,* Florence, 1977. Alfred A. Kalmus (Universal Edition) Ltd. Photo Marchiori, Florence.

178/9 First page from the published score of Berio's *Sequenza III.* Alfred A. Kalmus (Universal Edition) Ltd.

178 Mauricio Kagel. Photo Alfred A. Kalmus (Universal Edition) Ltd.

180 Kagel on the set for his film *Ludwig van.* Alfred A. Kalmus (Universal Edition) Ltd.

182/3 An extract from the published score of Cornelius Cardew's *The Great Learning.* The Experimental Music Catalogue.

185 Hans Werner Henze. Photo Yoichi Ohira/B. Schott's Söhne, Mainz.

Scene from the world première of Hans Werner Henze's *We Come to the River,* 12 July 1976, at the Royal Opera House, Covent Garden. Photo Donald Southern.

189 Richard Nixon arrives at Beijing Airport: a scene from John Adams's *Nixon in China* in the Houston Grand Opera production, Texas, 1987. Photo © 1987 Jim Caldwell. All Rights Reserved.

190 György Kurtág. Photo Felvégi Andrea. Reproduced by permission of the Publishers, Boosey & Hawkes Music Publishers Ltd.

194 Opening page of Brian Ferneyhough's *Etudes transcendantales.* © 1987 by Hinrichsen Edition, Peters Edition Ltd., London. Reproduced by permission of the Publishers.

196/7 An extract from the autograph score of Alfred Schnittke's First Symphony (1969–72). © 1991 by Musikverlag Hans Sikorski, Hamburg. Reproduced by permission of the Publishers, Boosey & Hawkes Music Publishers Ltd.

Index

213